*A Field Guide
for Travel and
Adventure
Photographers*

PHOTOGRAPHY
OUTDOORS

Second Edition

MARK GARDNER
AND ART WOLFE

THE MOUNTAINEERS BOOKS

Published by
The Mountaineers Books
1001 SW Klickitat Way, Suite 201
Seattle, WA 98134

First edition 1995. Second edition: first printing 2002, second printing 2003, third printing 2006

Published simultaneously in Great Britain by Cordee, 3a DeMontfort Street, Leicester, England, LE1 7HD

Manufactured in China

Project Editor: Laura Slavik
Editor: Ann Colowick
Cover, book design, and layout: Mayumi Thompson
Photographs: All photographs by the authors unless otherwise noted.

Cover photograph: *Lake Louise, Banff National Park, Canada* © Art Wolfe
Back cover photograph: *On location, Chile* © Art Wolfe
Frontispiece: *Windsurfer, Maui, Hawaii* © Art Wolfe

Library of Congress Cataloging-in-Publication Data
Gardner, Mark, 1953-
 Photography outdoors : a field guide for travel and adventure
photographers / Mark Gardner and Art Wolfe.— 2nd ed.
 p. cm.
Includes bibliographical references and index.
 ISBN 0-89886-888-2 (pbk.)
 1. Outdoor photography—Handbooks, manuals, etc. I. Wolfe, Art. II.
Title.
TR659.5 .G37 2002
778.7'1—dc21
 2002013968

CONTENTS

ACKNOWLEDGMENTS

The authors wish to thank Dona Reed, Gavriel Jecan, Heather Paxson, Dierdre Skillman, Carl Skoog, Ray Pfortner, and Chris Eckhoff for their help and support in writing this book.

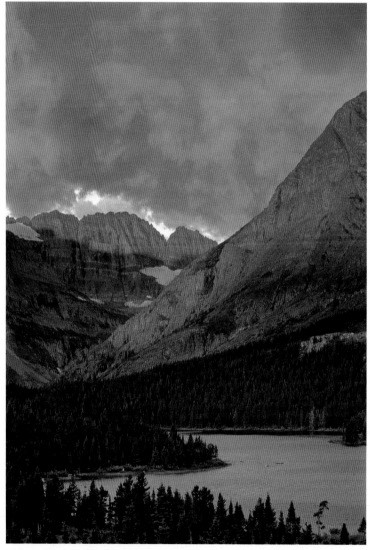

Grinnell Point, Montana (© Art Wolfe)

INTRODUCTION

This book is for camera-carrying adventurers who want to bring back great photographs from their adventures—photographs to hang on the wall, include in slide shows, and perhaps even publish. It is primarily for backpackers, paddlers, skiers, climbers, travelers, and other adventurers who carry cameras in the pursuit of adventure and want to learn to create images that capture the essence of their experience and the world around them. But it is also for serious photographers who hike, paddle, ski, climb, or travel to pursue the adventure of photography and want to get the best shots on such trips.

Whether your adventures take you to nearby parks or exotic lands, whether you carry a simple point-and-shoot camera or a pack full of sophisticated camera gear, this book can help you bring back great shots—ones that let you relive your experience and that evoke a "Wish I were there" or a "Wow!" from the rest of us.

ADVENTURE PHOTOGRAPHY

For the most part, adventure photography is just photography applied to scenes and activities of an adventure, which might be a backpacking trip, a bicycling tour, a climbing expedition, or a wildlife safari. However, adventure photography is different from other kinds of photography in several important ways.

First, you often have less equipment. On most adventure trips, the amount of gear you can take is limited to what you can carry on your back or fit into one or two travel bags along with all the rest of your gear. Thus, you usually do not have the luxury of carrying a full complement of lenses and accessories. Sometimes you may be limited to a camera, a single lens or maybe two, a handful of film, and a few key accessories. So you should choose your gear wisely and learn to get the most out of what you do take.

Second, you often have limited time. Great photography usually requires plenty of time to work on getting the best possible image. But adventures often happen too quickly to allow the luxury of a lot of time for photography. Although you may be able to plan your trip to allow extra time for shooting, you must also take full advantage of the time you do have. Thorough preparation is the key. Before actually taking any pictures, spend time thinking through the shots you want to get, the best ways to make those shots, and the conditions that will allow you to make them. Anticipate where to be and what to do to get the results you want. Then, when you see opportunities for adventure shots, you can quickly take full advantage of them.

Finally, and perhaps most important, in other types of photography you are an observer with a camera, without a part to play in whatever you are photographing. But in outdoor adventure photography, you are both a photographer and a participant. This dual role has an upside and a downside. On the upside, as a participant you have a unique perspective on your subject matter and often are inspired by your emotional engagement with the adventure itself and with your companions. But on the downside, you have to focus not only on taking pictures but also on climbing the peak, running the rapids, skiing from one hut to the next, or doing whatever activity you are engaged in. It can be tough to do both well—and sometimes dangerous. To compound the problem, most adventures include people who are not photographers and who may not have patience for those who are. So be sure to find a safe balance between your participation, your companions, and your photography—one that ensures you enjoy all three.

GREAT PHOTOGRAPHS VERSUS SNAPSHOTS

What makes a great photograph, and how do you make the transition from casual snapshooter to serious photographer? A good photograph is a technically superior record of a place, an event, or one or more persons. However, a great photograph goes beyond mere recording to express a message or theme about your world or experiences. It captures a unique instance in which all the elements of photography come together. Thus, before you can make a great photograph, you must know what you want to express in your photographs, and you must become engaged with the world around you so that you will see opportunities for that expression.

To create a great photograph, start with a strong composition at the decisive moment to capture the essence of what you want to express. Then add light with the right character, which can transform even the most mundane subject. Next, correctly expose the film or digital sensor in your camera to create the image you want, using that film or sensor as both a creative and a recording medium. Finally, make the best possible use of each piece of equipment in your tool kit, paying close attention to all the details that will result in a great photograph.

There are a number of things a snapshooter must do over time to make the transition to serious photographer. Like anything worth doing, that transition takes an investment of time and energy. First, you have to figure out what you want to photograph. What is it about your world and your experiences that you want to record? What images do you want to create, and what themes or messages should those images communicate?

You must learn to see creatively. A first glance or a casual look may

reveal a photo opportunity, but not the best image. To see that, you must visually explore the subject, the light, and the graphic designs the two create. Seeing through your own eyes, however, is not enough. You have to learn to see the world as your camera does and then visualize images as the camera sees them. Once you can do this, your camera becomes a creative extension of your mind and your emotions and not just a recorder of a scene.

It is also important to develop a personal style that shows your subjects, themes, and stories in your own creative way. This requires taking a lot of pictures, gaining experience with your camera, and experimenting to see what you like. You can also read photography magazines and photography books, such as this one, as well as books on graphic design and composition. Look at the work of other photographers in magazines and books on travel, adventure, outdoor recreation, and natural history that emphasize photography, such as *National Geographic*, as well as on posters, in calendars, and in galleries. Study the photographs you like, to understand why you like them and analyze how they were made. Try applying to your own photography what you learn from these examples.

Finally, master the technical side of photography while exploring the artistic side. Cameras, lenses, film, and all the gadgets that fill our bags are only tools. Like any other tools, they do not do anything by themselves. To make great photographs, you have to put your tools to good use. Get a lot of practice, and learn from books such as this one. Learn all the features of your camera. Learn how your different lenses see things, how your film or digital camera sensor behaves, and when to use the various accessories that complement your camera. With practice and experimentation, you will ultimately settle on a way of using your tools to create the images that you want. When using your gear becomes second nature, you can really have fun, make the most of your photo opportunities, and take photographs that you may not even be able to imagine today.

YOUR CAMERA

This book is for users of all kinds of film or digital cameras. You can take many great photographs with a pocket-sized point-and-shoot camera, also called a lens-shutter camera, by making the best use of what you can control. However, a more sophisticated camera provides more creative control and flexibility, making it easier to return with the kinds of photographs you want. Some types of photography, such as high-speed action shots, wild animal portraits, or macrophotography, are possible only with more sophisticated gear. Each chapter of this book is filled with a variety of ideas and tips to take full advantage of the control and flexibility that such cameras provide.

The first chapter in particular covers the key aspects of both traditional and digital cameras that are best suited for outdoor adventure photography, and will help you select the right gear. Because creating a compelling composition and finding the right light are independent of camera type, the next two chapters can help you make better pictures with even the simplest of cameras. The fourth and fifth chapters, on exposure and gear, can also provide help, depending on how much control you have over the camera and the accessories you use with it. The final chapter can help you put all the elements of photography together in the field, no matter what equipment you have.

This book provides advice on using both completely manual and fully automatic cameras. With a manual camera, or with the manual mode on some automatic cameras, you have complete control over variables like shutter speed, aperture, and film speed. This control is great for creativity but can be inconvenient and time consuming. Sometimes you miss great shots while fumbling with the camera. This book will help you take full advantage of this control and will give you a variety of ways to make manual cameras easier to use.

Automatic cameras choose the settings for some or all of those variables for you. That makes them quick and easy to use but often provides much less, if any, control over those variables. This book will help you understand what choices the camera makes so you can make the best use of the camera and take full advantage of the control you do have.

And this book is for users of digital cameras, which also come in both point-and-shoot and SLR versions. For the most part, making photographs with a digital camera is the same as making them with a film camera. The principles of composition, light, and exposure apply regardless of camera type or recording medium. Like film cameras, digital cameras are simply tools for applying those principles and making great images. They work in fundamentally the same way, but they record on digital media rather than film. This difference in media does add new capabilities for photographers. These new capabilities are covered in chapters 1 and 5.

HOW TO USE THIS BOOK

This book is filled with a wealth of information and proven tips that will help just about any adventurer take more satisfying photographs. The first chapter provides a basic understanding of digital photography and of both digital and film cameras. If you already have that understanding and know how to use your camera, then you can skip chapter 1. The second chapter covers composition, the art of creating an engaging, high-impact image—an art that begins with your vision and ends

with the photograph itself. The third chapter discusses the character of light, how to find the best light for the image you want, and how to make the most of the light you have. The fourth chapter reviews how to measure the light and determine the exposure that will give you the shot you want. The fifth chapter will help you get the most out of your camera and key accessories. In addition, this chapter covers important aspects of digital photography in the field. The final chapter brings these four elements together with a variety of tips and ideas for getting better shots during adventures, including better people, action, scenic, close-up, and wildlife photographs.

Photography can seem impenetrably technical. However, the more you understand about the technology, the more artistic you can be and, ultimately, the better pictures you can take. This book is full of suggestions that will make the technology easier to use, or at least keep it from getting in your way. To make the technology as easy as possible to understand and use, we have minimized the use of technical terminology and jargon. Where we use such terms, we define them as simply as possible. Terms that are used repeatedly throughout the book are italicized when first used and are also defined in the glossary at the back of the book. If you do not know the meaning of a term, refer to the glossary. The glossary also includes other important photography terms.

Unlike photography books that sit on the shelf once you have scanned the pictures, this one is meant to be taken along with your camera. Read it through; then toss it in your pack or camera bag, and use it to make the most of your opportunities for adventure photos. It can serve as a reference for things like the proper *exposure compensation* for a particular situation, it can provide hints to help you get the best possible photograph, and it can even give you some ideas for shots to take during your adventures.

This book is meant to be used in conjunction with your camera's owner's manual. Although the first chapter provides an overview of cameras, it will not cover the details of your particular camera. Review your camera's manual before reading this book. If you want to fully understand how to use your particular camera to do something suggested in the book, consult your owner's manual as you read along. Even better, also have your camera handy to try things as you read about them. Most owner's manuals are relatively small; you might want to take both your manual and this book along on your trips.

As a last note before you dive into the book: use your camera to explore your world and enhance the experience of adventure, but do so safely, keeping your eyes and mind open. Good shooting!

Opposite: *Paddler at sunset, Bay Islands, Honduras* (© Mark Gardner)

Photography—Digital and Traditional

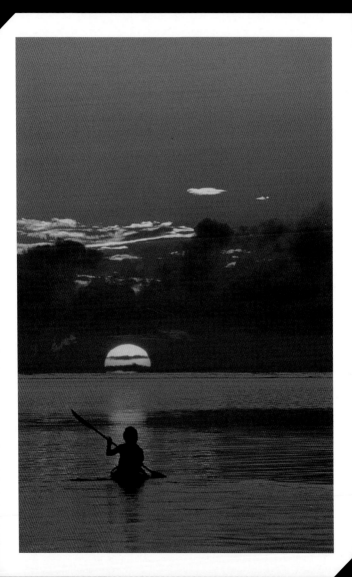

P hotography is basically a two-step process. First, a camera is used to record images on a light-sensitive medium. Then those images are processed for viewing. Processing occurs either in a traditional darkroom (or a "minilab" machine) or in what has become known as a digital darkroom. Because this is a book about field photography, it focuses primarily on using a camera as effectively as possible to record the best images. However, with the increasing availability of both film and digital processing services throughout the world, even in the most remote places, the second step can now be done virtually anywhere. Even expeditions to Mount Everest are shooting with digital cameras, editing the images on solar-powered laptops, and sending them by email via satellite phone. So this book will also cover some aspects of digital processing, especially the ones that you can do while off on an adventure.

The boundary between traditional and digital photography is becoming increasingly blurred. In fact, you can do digital processing of images originally made on film. So if you have invested heavily in a traditional *single-lens reflex (SLR)* system, you do not need to replace that investment with the latest in digital cameras. For the price of a good digital camera, you can get a film scanner. With that you can create digital files of higher quality than today's best digital cameras can make. You can also use a scanning service to create digital files that are of even higher quality. Once you have the digital file, you can then do anything you can do with images made on a digital camera.

DIGITAL PHOTOGRAPHY PRIMER

A digital photograph is an image represented by bits and bytes and saved as a file on an electronic storage medium, such as the *memory card* in a digital camera or the hard drive on a personal computer. It is analogous to a digital document made with word processing software and stored in a file on a computer. A digital photograph can be made with a digital camera that records a scene digitally or with a scanner that records the image already on film or in a print.

Once you have the digital image in a file, it can then be processed with image-editing software on your personal computer or by a professional service. Digital images can be displayed on computer screens or printed on ink-jet printers, as well as sent to photo processing services to be printed by high-end digital printers or in a traditional darkroom. You can even have a service use the digital image file to create a 35mm transparency, which you can use in a traditional slide show. So with

digital photography, you can start with the latest in technology and return to traditional photography.

Making great images via digital photography does require some understanding of computer technology. You will need to learn at least the basics of the software and hardware of the digital darkroom. The software and hardware to do sophisticated digital photography are becoming increasingly powerful, easy to use, and relatively inexpensive. With a moderate investment of time and money, you can do amazing things. But, as in film photography, you can also use professional labs or services to create, edit, and output your digital images, especially when quality is important, as when making exhibition prints.

Digital Images

The *pixel* (picture element) is the basic building block of a digital image. Each pixel is a set of digital bits that stores information about color and *tone*. A digital image consists of thousands, or sometimes millions, of pixels stored in a file. When a digital image is viewed, pixels are represented as dots or squares and arranged on a screen or printed page by the software in your digital camera, computer, or printer. To look like a traditional photograph, the image must have enough pixels to give the appearance of continuous tones rather than separate dots.

In addition to there being enough pixels to make a realistic-looking image, each pixel must be able to store enough information to match the full range of colors and tones that you can see—at least 16 million combinations of color and tone. To represent all these combinations, each pixel must be at least 24 bits. Anything less results in images that look more like posters or simple graphics than photographs. The higher the number of bits per pixel, referred to as *bit depth* or color depth, the higher the quality of the resulting image.

The *resolution* of a digital image is the number of pixels in the image, and is typically expressed as $h \times v$, where h is the number of pixels along the horizontal axis and v is the number of pixels along the vertical axis. For example, a low-resolution image might be 640 pixels \times 480 pixels; a high-resolution image might be 2560 \times 1920. Achieving the look of a traditional photographic print requires a high-resolution image. So in general, the higher the resolution (greater number of pixels), the better and larger the photograph you can make from the file. However, the higher the resolution, the larger the resulting file will be. A larger file takes up more disk space or memory and takes longer to edit, send over the Internet, or print on an ink-jet printer.

Digital images are typically stored in one of two file formats: *JPEG* and *TIFF.* There are other formats in use, but JPEG and TIFF are by far the most common. The JPEG (Joint Photographic Experts Group) format stores images in a compressed form to minimize the amount of memory required. A JPEG file is ideal for display on a computer screen and for use on the Internet. However, compressing the file can diminish the quality of the image. The TIFF (tagged image file format) can store uncompressed images and is much better for making high-quality prints. However, TIFF files are typically much larger than JPEG files.

Digital Input

Digital photographs are created with some form of input device that converts the light reflected from a scene or an image into a digital image. These devices fall into three categories: digital cameras for photographing scenes, flatbed scanners for scanning printed images, and film scanners for scanning transparencies or negative film. Digital cameras use a sensor array, typically a *charge-coupled device (CCD),* to convert the light reflected from a scene into the pixels of a digital photograph. A flatbed scanner works much as a photocopier does. A light in the scanner illuminates the print; the light reflected from that print is then recorded by a sensor array and converted into a digital image. A film scanner works like a slide projector. Light is transmitted through the film or transparency onto a sensor to create the digital image.

The quality of a digital image is directly related to the quality of the input device that created it. Thus, for serious photography, you should use the highest-quality input device possible, which is determined by three factors: resolution, analog-to-digital (A/D) conversion, and dynamic range. As already discussed, resolution is the number of pixels representing the image. In effect, A/D conversion is the number of bits used to represent each pixel. Dynamic range is the range of tones that can be recorded. For serious digital photography, more of all three is better, especially if you want to create the best-looking display prints possible.

Digital Output

The resolution of output devices such as computer displays and ink-jet printers is typically expressed in *dots per inch (dpi).* Most computer displays have a resolution of about 75 dpi, whereas photographic-quality ink-jet printers have resolutions of 300 dpi and higher. Yet, the resolution of the image to be displayed or printed has a fixed number of pixels. Thus, to display a 6-inch × 4-inch image on a 75-dpi computer

screen, the resolution need only be 450 pixels × 300 pixels. However, to print the same 6-inch × 4-inch image on a photographic-quality printer at 300 dpi, the resolution must be at least 1800 × 1200. Conversely, if you had an image with a resolution of 450 × 300, and wanted to create a photographic-quality print at 300 dpi, then the print would be only 1.5 inches × 1 inch. If you made a 6-inch × 4-inch print from the same image, the quality would be unacceptable.

Photos 1-1 through **1-3** show the effect of digital image resolution on print quality. These were made by scanning the same 35mm transparency at three different resolutions. Photo 1-1 is 900 pixels wide by 600 pixels high, with an uncompressed file size of 1.55 megabytes. When printed at the size used in this book, the image is of photographic quality. Photo 1-2 is 450 pixels × 300 pixels, with a file size of 396 kilobytes. The printed image is noticeably softer but still acceptable. Photo 1-3, which is 216 × 144 and 92 kilobytes, produced a print of very poor quality. However, when viewed on a computer screen at the size shown here, all three look fine.

> ### TIP
> If you only want to view an image with a web browser on a computer screen, then create low-resolution images and save them in JPEG files. If you want to produce high-quality prints, create high-resolution images and save them as TIFF files.

Output devices also vary in the number of colors they can display and the way they display them. Thus, images may look different when output to different types of screens or printers. For example, images displayed on a typical personal computer screen do not look as sharp or as realistic as prints made on high-quality ink-jet printers.

The resolution of an image can be enhanced by the process of *interpolation,* which is performed by the software of digital cameras, scanners, and printers, or single-image editing software on a personal computer. Resolution enhanced in this way is sometimes referred to as digital or interpolated resolution. Interpolation works by increasing the number of pixels in the image and then giving the new pixels characteristics based on the characteristics of the original pixels around them. Increasing resolution this way can increase the size of the prints that can be made from the image. However, the quality of the image decreases as print size or the amount of interpolation increases. Interpolation is fine for images displayed on computer screens but, in general, is not acceptable for display prints.

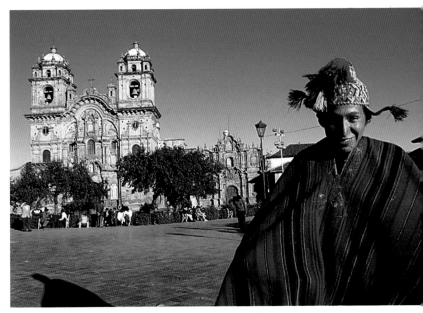

Photo 1-1: *Central plaza, Cuzco, Peru—high resolution* (© Mark Gardner)

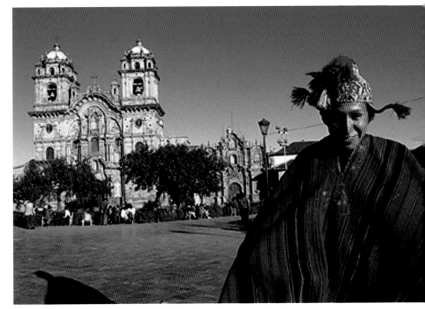

Photo 1-2: *Central plaza, Cuzco, Peru—medium resolution*
(© Mark Gardner)

Photo 1-3: *Central plaza, Cuzco, Peru—low resolution* (© Mark Gardner)

DIGITAL PHOTOGRAPHY VERSUS TRADITIONAL PHOTOGRAPHY

With anything new, there is inevitably a debate about new versus old. The debate over digital and traditional photography will go on for some time. Digital photography provides an important new tool kit for the serious photographer. The question is not whether to use digital photography or traditional, but just what part of that new tool kit you should utilize and how much of your digital work you should do yourself. At a minimum, you should take advantage of digital technology to make large display prints from film or transparencies. Such prints far exceed the quality of those made with traditional darkroom technology, and they are often less expensive.

However, assembling your own digital darkroom provides an unprecedented level of creative control that is worth the investment. Over time, that investment will be repaid by savings on fees paid to professional labs to create custom prints or perform other services. And even better, you do not have to wait for the typical lab's turnaround time of one to several days. You can try something and see the results in the amount of time it takes to display or print the image. If you travel with a digital camera and a laptop, you can even take your digital darkroom with you on the road, as discussed further in chapter 5.

If any digital-versus-traditional debate is warranted, it is whether to use a digital camera or a traditional one. Both can make excellent images in the hands of a skilled photographer. Both have their advantages and disadvantages. To resolve this debate, think about the types of photography you want to do and the constraints imposed by the conditions in which you will be photographing. Then make your own decision about which is best for you. In the end, serious photography of a wide range of subjects in a wide range of situations may require that you have several cameras, both digital and traditional.

CAMERAS

The camera is the basic tool of the craft of photography. In any craft, having the right tools and knowing how to use them are critical to getting good results. Most cameras work basically the same way. Each has a lens or an opening through which light passes to record an image, which is then processed for viewing. Great photographs can be made with the simplest of cameras. However, having the right tool enables the craftsperson to create great photographs more often and more predictably. The rest of this chapter will focus on choosing the right tools; the rest of the book will cover using those tools.

You do not necessarily have to rush out and buy a new camera. The best camera is often the one that you already have. It is paid for, and you probably have at least some familiarity with the way it works. You can use the principles discussed in this book to improve the images you make with that camera. Using those principles with the camera you have will also help you determine what type of camera you should buy next.

A quick glance through a photography magazine reveals the overwhelming array of choices available today. Most of the choices, however, are cameras designed primarily for casual photography. They do not provide the creative control, durability, or optical quality needed to consistently make great travel or outdoor adventure images. These cameras are often fully automatic, with fixed lenses, so they make all the decisions for you except where to point the lens. As you will see in the following chapters, good photography is about making good decisions. Unfortunately, even the best fully automatic camera may not be nearly as good a decision maker as you are.

Thus, the choices narrow considerably when you consider cameras appropriate for serious photography. Such cameras provide complete control over *exposure* settings, focus point, use of flash, lens *focal length,* and other features. Many are also fully automatic, but let you control some or all of their settings. In addition, they have high-quality optics that reliably

produce clear images, even for larger display prints, and they are durable enough to withstand the rigors of travel and outdoor activity.

Point-and-Shoot versus Single-Lens Reflex

Only a handful of compact *point-and-shoot cameras,* digital or film, provide the minimum capabilities needed for serious photography. Compact point-and-shoot cameras are inherently more limited in capability than single-lens reflex (SLR) cameras. The viewfinder does not look through the lens as it does in an SLR. Since you do not see what the camera sees, unintended objects sometimes appear in your photographs, and it is impractical to use accessories like polarizing filters (see chapter 5). Most point-and-shoot cameras do not provide manual exposure controls and do not have interchangeable lenses, so you are confined to the lens provided with the camera. And they may not support the attachment of a more powerful flash or other useful accessories, like remote shutter release.

However, point-and-shoots do have the advantage of being very compact and lightweight, as well as generally less expensive. They may be the only appropriate option when space and weight are serious considerations, as on treks or climbing expeditions, although their compactness may make them harder to use when you are wearing gloves. The right point-and-shoot camera also makes an excellent backup for an SLR camera. When choosing a point-and-shoot camera, look for the following features:

- weatherproofness or splashproofness
- built-in *fill flash*
- zoom lens, 28–105mm or higher
- tripod socket
- ability to accept screw-in filters and accessory lenses
- self-timer
- automatic and manual exposure control
- selectable ISO setting or exposure compensation

SLR cameras provide a much higher level of capability, and thus greater creative control and flexibility, than do point-and-shoot cameras. However, they are generally bulkier, heavier, and more expensive than point-and-shoots. Taking a full SLR system on a trip can be a real pain, especially if you have to carry it yourself for any distance. But the reward of more creative options and greater control may make it worth the trouble.

An SLR made by a major manufacturer will support a wide range of lenses and accessories to create a complete system. An SLR is typically

sold as a camera body only, to which a lens must be added to complete the camera. Buying the body and lens separately makes an SLR more expensive than a point-and-shoot, but it significantly enhances the flexibility of the camera. Most major manufacturers supply lenses in a range of focal lengths from 14mm or so (extreme wide-angle) to 600mm (super telephoto). (Lenses will be discussed further in chapter 5.)

A range of focal lengths of about 17mm to 400mm will cover just about any situation encountered in travel and adventure photography. Shorter and longer lenses are designed for specialists, and are not worth the extra expense or bulk. Lenses for SLRs are available in fixed focal lengths and as *zoom lenses,* which cover a range of focal lengths in one lens. Today's professional-level zoom lenses use exceptional optics and make outstanding images. So get two or three zoom lenses, of the highest quality you can afford, that together cover the range you need.

When considering an SLR camera system, look for the following features, which will be more fully discussed in chapter 5.

- automatic and manual exposure control
- exposure compensation
- *spot metering* mode
- depth-of-field preview
- auto-balanced through-the-lens (*TTL*) fill flash
- remote shutter release
- *multiple exposure*
- self-timer
- tripod socket
- accessory TTL flash
- availability of a full range of interchangeable lenses

Digital versus Film

Both digital and film cameras come in both point-and-shoot and SLR models, and all the pros and cons already discussed apply. But there are several new pros and cons to consider.

Digital cameras tend to be more expensive than comparable film cameras. In particular, digital SLR camera bodies are significantly more expensive than their film-camera counterparts. When you use a digital camera, you do save the cost of processing film and making prints or slides to view your images. However, getting the full value of a digital camera requires the use of a personal computer and a photographic-quality printer, the cost of which may more than offset the savings in processing. As discussed in more detail in chapter 5, the current limitations of digital technology restrict the kinds of photographs that can be enlarged to display size. For example, making high-resolution images of high-speed action is currently

impractical with all but the most expensive digital SLR cameras.

Digital cameras do offer a significant advantage over film cameras: immediacy. With a digital camera, you can immediately, or at least within a minute or two, view the image you just made. You can see the results of the decisions you made to create that image. If you got the image that you expected, then you shoot the next one. If not, then you make different decisions to improve the image, and try again. Perhaps best of all, you can discard images that did not work, without paying to have them processed or having anyone else seeing them.

You can also share your images right away with the people around you. Photography quickly becomes a social event or a source of entertainment. Both your companions and the other people you encounter often enjoy seeing an image that you just made of them. And, as discussed further in chapter 5, you can even use the Internet to share your images with people who are not with you. If people are an important part of your outdoor adventures, either as companions or as friends made along the way, then the immediate viewing provided by a digital camera may more than compensate for the added expense and the drawbacks (see chapter 5).

Because of the new capabilities provided by digital technology, a new category of camera has emerged that is a hybrid of point-and-shoot and SLR. You can use these small, lightweight cameras fully automatically, as you would a point-and-shoot. In addition, they also include a range of features that in film photography are found only on SLRs, such as support for accessory flashes, sophisticated *metering* systems that include spot metering, and full exposure control. So you can use them as you would an SLR. They do not have interchangeable lenses but do come with a full-range zoom lens built with high-quality optics from well-known suppliers. These cameras are an excellent alternative to a digital SLR camera at a significantly lower cost.

When considering the purchase of a digital camera, look for the following features, which will be more fully explained in chapter 5.
- high resolution, 4 *megapixels* or more
- 4×–7× *optical zoom* lens
- viewfinder and *LCD screen*
- manual exposure control
- selectable *white balance*
- spot metering mode
- auto-balanced TTL fill flash
- hot shoe for accessory TTL flash
- ability to accept filters and accessory lenses
- remote shutter release

- multiple exposure
- self-timer
- tripod socket

• • •

With film, you do have to wait and pay to view your images. But film cameras are proven technology that not only works well, but currently can also provide a higher-quality digital image than all but the most expensive digital cameras. Traditional cameras are also generally more flexible than their digital counterparts, allowing you to make good images in a broader range of situations than you can with a digital camera.

Film cameras are available in a variety of formats, from the smallest and newest format, the Advanced Photo System (APS), to what is known as large format. Film format is the size and *aspect ratio* of the image made on the film. By far the most popular is the 35mm format, which is actually 36mm long by 24mm high. APS is much smaller and, for a variety of reasons, not suitable for serious photography. Larger formats are also available, including "medium" format, which uses roll film that is 6 centimeters or approximately 2¼ inches wide, and "large" format, which uses sheet film, 4 inches × 5 inches or larger. These larger formats, often used by professionals, make much larger images on film than the 35mm format, so they can make much larger display prints without sacrificing quality. However, these larger formats require the use of cameras that are generally too expensive, bulky, and heavy to be appropriate for travel and adventure photography. The ubiquitous 35mm format remains the best film format overall for such photography.

Eventually, digital cameras will surpass the overall capability of film cameras. But for the next few years, film cameras will continue to be the best overall choice for serious photography. If you buy a new camera, get a 35mm film SLR system from a well-known manufacturer. You can add a digital camera body later, when prices come down and capabilities improve, while preserving your investment in lenses and accessories. But no one camera can do it all. Most serious photographers own several kinds and pick the best one for the situation. So you might also get a waterproof, high-quality point-and-shoot as a second or backup camera. And if you want to try digital, then get one of the new, full-featured models, as recommended earlier in this chapter, from a well-known manufacturer.

Opposite: *Torres del Paine, Patagonia, Chile* (© Gavriel Jecan)

Composition

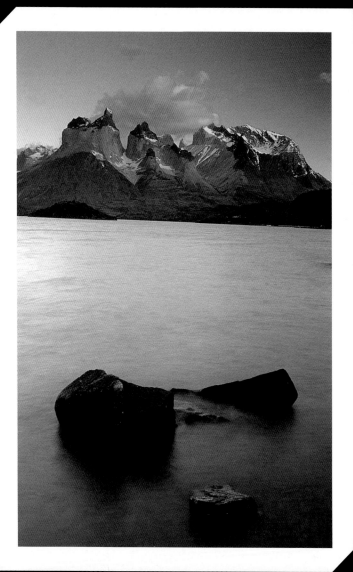

omposition is the act of creating an engaging image, one that reaches out and grabs the viewer—or at least piques his or her interest. Regardless of what kind of camera you use, composition is a key difference between snapshots and high-impact photographs. A strong composition is elegantly simple yet filled with just the right amount of energy to involve the viewer. It evokes an emotional reaction or communicates a single message and can overcome most technical imperfections.

ELEMENTS OF COMPOSITION

Composition is an active process that begins with determining your purpose in taking the picture and ends with pressing the shutter-release button. In between, you emphasize the subject, eliminate distractions, and maximize visual impact. This chapter shows you how to use this process to create more satisfying photographs with any type of camera.

Emphasize the Subject

The process of composing a photograph starts with the subject. Good composition must have a clear subject, center of interest, or theme, which could be as obvious as a charging grizzly bear or as subtle as the chill of a winter landscape. The lack of a subject is the primary cause of boring or confusing photographs that leave viewers wondering why someone bothered to take the picture or, worse, show it.

Once you have settled on the subject, do not be too quick to point and shoot. Rather, take some time to really see and analyze. Ask yourself what it is that you like about that subject. What do you want to capture on film? What message do you want to convey? What reaction do you want to evoke from anyone viewing this photograph?

Many aspects of a subject or scene can be appealing. Some are obvious, like the exuberant faces of your climbing companions, the mystic beauty of an ancient temple, the power of a charging elephant, or the energy of a bustling market. However, other subjects have more subtle appeal, like the textures of lichen-covered rocks, the patterns of color in a flower-filled meadow, the rhythms of the grain in weathered wood, the sublime colors of sunrise over a misty lake, or the flowing shapes of water-sculpted rocks. These take more time to see, but taking that time is critical to effective composition.

Keeping in mind your subject and the aspects of it you want to capture, you can now begin the process of eliminating everything that detracts from it and maximizing the visual impact of your photograph.

Eliminate Distractions

Distracting elements that you do not notice when you shoot have a mysterious way of appearing in the resulting photograph. Unfortunately, they can be visual magnets that draw the viewer's attention away from the subject. Common distractions can easily compromise an image that is otherwise quite powerful, but they are easily avoided.

A camera does not "see" the way the human eye sees. This limitation, if understood and managed thoughtfully, can be used to your creative advantage. When you look at your subject, you tend to see what is important to you. Your mind subconsciously filters what your eyes record, eliminating all the extraneous material and emphasizing the subject. When you view a burst of spring wildflowers, you see their beauty. You often do not notice the surrounding weeds, the dead sticks beyond, the odd wilted petal, or the one bug-eaten leaf that would detract from that beauty—unless you really look for them.

> **eliminating distractions**
>
> • Get subject sharply focused
> • Keep background out of focus
> • Look for background highlights and merges
> • Sweep edges of frame

• • •

Your camera, however, records everything displayed in the viewfinder or LCD screen—and more. No matter how expensive or automatic, a camera cannot do what your brain does. It will record the beautiful wildflowers, but it will also record the ugly dead sticks, wilted petals, and bug-eaten leaves. The resulting picture may show the beauty that you saw, but often that beauty is lost amid a visual jumble that will leave you wondering why you wasted the film. For the camera to capture what you saw or what you want others to see, you have to consciously emphasize what is important to you and eliminate everything else. To compose an effective photograph, you must simplify the visual chaos that surrounds you.

Your camera also has a much more limited ability to record a scene than you do. Film records a more narrow range of tones than your eyes can see, so in your photographs shadows may appear much darker and highlights much brighter than you remember them. Film may also record colors differently than you see them, sometimes rendering them warmer, cooler, or brighter, affecting your photograph in

subtle but significant ways. Sensors in digital cameras can be just as imperfect.

Photographs compress to a two-dimensional plane what you see in three-dimensional space. Consequently, more distant objects within a scene may appear to merge with closer objects in a photograph. For example, a dark moose may get lost in the dark hillside that was several hundred yards behind it, or a sapling 20 to 30 feet beyond the animal may appear to be growing out of its head. This is a problem especially common in pictures taken with telephoto lenses, which appear to compress the distance between nearer objects and farther ones. You may not notice distracting or confusing objects unless you look for them. Use your position to clearly separate important objects in your photograph, especially to separate the subject from any potentially confusing objects that are behind it.

Your eyes put virtually everything they see into focus, but your camera has a limited range of distances in focus—or *depth of field* (see "Aperture" in chapter 4). Some part of your photograph may be out of focus. Small points of light in an otherwise dark background become large, distracting highlights when the background is out of focus. The worst offenders are light reflected from drops of water and the sky peeking through small gaps between leaves in dense forest canopy or other dark objects. The contrast limitations of film compound the problem. Areas in the background that seemed only a bit lighter when you took the photograph often appear bright white in your photograph.

Other background objects that are not quite in focus distract from the subject because your viewer tries to put them in focus and figure out what they are. People's faces are especially distracting because your viewer will wonder who they are rather than appreciate the intent of your photograph. Try a larger aperture, as discussed later in this chapter, to blur any objects in the background that might become distracting.

Your camera records only a slice of what you can actually see, a slice bounded by the four edges of your viewfinder. You have to decide what to include within those edges and what to exclude. You must also think about how the edges themselves interact with what you position inside them. An object that is partially in the picture, cut off by the edge of the *frame,* can be distracting. The viewer will wonder what it is and whether it is supposed to be in the picture. Either put enough of the object in the frame to make it instantly recognizable, or eliminate it completely. This simple guideline is complicated by the fact that the viewfinders of most cameras show only 90 percent to 95 percent of what will actually be captured in a photograph. Consequently, things you did not see in the viewfinder may appear in your picture. Consult

your owner's manual for the percentages of the frame that your viewfinder shows in both the horizontal and vertical dimensions. Then factor these in when composing an image.

Avoiding distracting elements is easy if you take the time. When photographing, we tend to focus both our lens and our eyes on the subject, often ignoring the rest of what is in the viewfinder. To avoid unintended distractions, pay as much attention to the background and the edges as you do to the subject. Before pressing the shutter-release button, check the entire image by looking beyond the subject and sweeping the edges of your viewfinder with your eyes. If your camera has a *depth-of-field preview button,* use it. Try to imagine what the scene in your viewfinder will look like in your photograph. Look for shadows and highlights that will become distractingly black and glaringly white on film, as well as for unintended edge effects and merging of objects. The corrections are usually as simple as moving a few feet or opening up the aperture one *f-stop.* But you have to see the distractions to be able to avoid them. So slow down, take your time, and your composition will improve dramatically.

Maximize Visual Impact

The key to effective composition is to pull the viewer quickly into the photograph with something of interest and then keep the viewer's interest with just enough tension, energy, or movement to keep the mind and emotions working. Too little tension, energy, or movement results in a static image. Too much results in a confusing image that can drive viewers away from the photograph.

Sometimes the subject itself may be so spectacular that just doing a good job of isolating it is sufficient. Even a bad shot of a visitor from outer space emerging from its spaceship should grab all but the most numbed viewer. More often, the subject may get attention, but something more is needed to create impact. Simplicity, size, contrast, and color can all contribute to that impact.

> **maximize visual impact**
> - Choose a clear subject
> - Simplify the image
> - Fill the frame
> - Look for background contrast

Simplicity. Most important, simplify the image. The power of many images is lost because there is too much going on in the photograph.

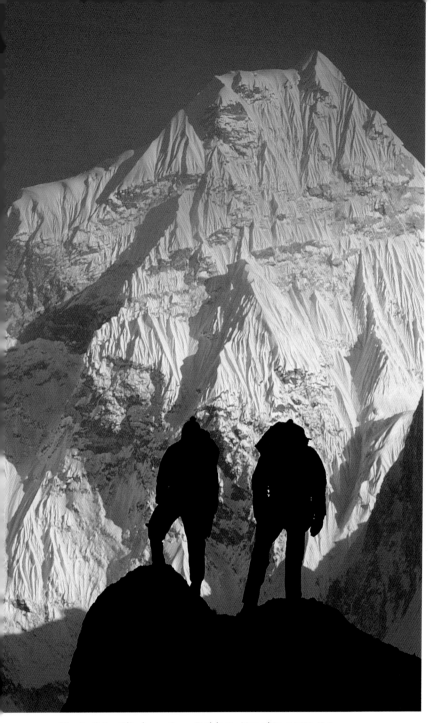

Photo 2-1: *Climbers, Ama Dablam, Nepal* (© Art Wolfe)

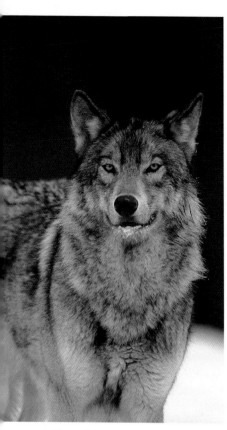

Photo 2-2: *Gray wolf, Canada*
(© Art Wolfe)

Incorporate only the subject and the parts of a scene that enhance the subject, and eliminate everything else. If you are shooting a portrait of a bugling elk, then fill the frame with him and eliminate everything else. If you are shooting a big scene, then include only enough to tell the story as simply as possible, nothing more. **Photo 2-1** is made more powerful by its simplicity: just two climbers and the mountain. Anything else in the image would have significantly reduced its power.

Size. Size alone can grab attention. Fill the frame as much as possible by moving closer, zooming in, or switching to a longer lens. There is no doubt that the wolf in **Photo 2-2** is the subject of the image. A tiny subject, no matter how exciting, can get lost in the rest of the picture. But beware of filling the frame so completely that the viewer loses all sense of scale or place. Often it is better to leave something else in the image to show how big or small the subject is, or to leave enough of the surroundings to show the subject in a context that makes it even more meaningful.

Contrast. Contrast can make your subject stand out from the rest of the image. Lighter-toned, brighter-colored objects seem to come forward in a photograph, while darker objects seem to recede. Thus, a bright, well-lit subject is best shown against a darker background, as in Photo 2-2. The reverse, a dark silhouette against a bright background as in Photo 2-1, also works and is great for emphasizing shapes. Other types of contrast can also be effective. A rougher texture stands out from a smoother background, as does a warm subject from a cool background, an in-focus subject from an unrecognizably blurred background, or a unique object from a uniform background, as the zebras stand out in **Photo 2-3**.

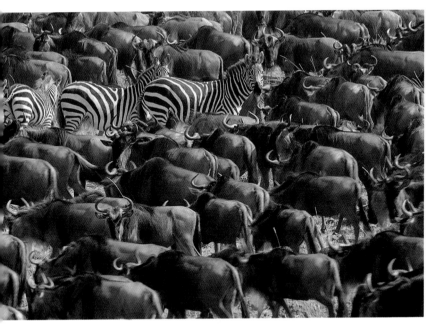

Photo 2-3: *Wildebeest and zebras, Masai Mara, Kenya* (© Art Wolfe)
This is a shot of a pattern. Using a 600mm telephoto lens with a 1.4× extender, I zoomed in and eliminated all the edges of the wildebeest herd. To create a focal point for the pattern, I zoomed in on several zebras, which, following the rule of thirds, I placed in the upper left for a more dynamic composition. The direct light was somewhat diffused by the hazy African afternoon. This softened the image and eliminated harsh shadows, so the individual animals become more prominent within the composition. (AW)

Use your position to create contrast by placing your subject, or the most important parts of your image, against a contrasting background. To be dramatically darker than the subject on film, the background does not have to look dramatically darker to you. Just placing a well-lit subject against a background that is in the shadows is sufficient. Use your *light meter* to take readings from both the subject and the background and find enough difference to make the subject stand out (see chapter 4).

Color. Color itself is also important. Bright colors, especially the primaries—red, yellow, and blue—create more excitement and energy and seem to come forward in a photograph. More muted pastels and earth tones have a quieter, more relaxing effect and seem to recede. Placing a color with or against its complement—red with green, orange

with blue, or yellow with purple—enhances the effect of color. For example, the visual impact of the wildflowers in **Photo 2-4** and the kayaks in **Photo 2-5** is quite striking.

Photo 2-4: *Poppies and lupine, Central Coast, California* (© Art Wolfe)
To make this image, I used a 20mm wide-angle lens to capture the entire land-scape. To ensure that the closest flowers and the distant mountains were in focus, I stopped down to f/22 and set the focus to the hyperfocal distance. I also used a split neutral-density filter to get a proper exposure, aligning the dark part of the filter with the distant mountain and the white clouds, which were more brightly lit than the colorful foreground. (AW)

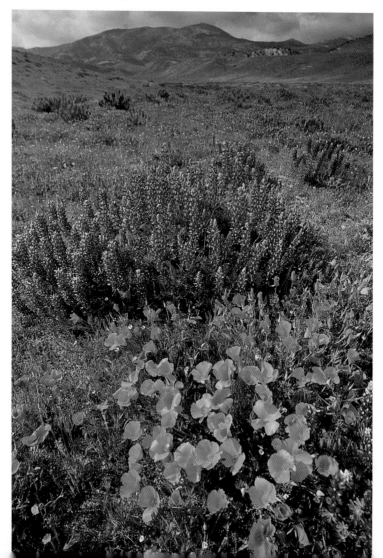

TECHNIQUES TO ENHANCE COMPOSITION

Once you understand the elements of composition—emphasizing the subject, eliminating everything that distracts from it, and maximizing the visual impact of your photograph—you are ready to begin the process of composition. This process involves deciding where to position your camera, what lens length to use, what *shutter speed* and aperture to use, and how to arrange the elements in the viewfinder.

Position Your Camera

Find the perspective that best shows your subject and eliminates distractions. Do not just take your picture from the spot where you first noticed your subject. Try other camera positions first.

 Point of view. Move closer to make the subject bigger in your viewfinder, perhaps filling the frame so that there will be no doubt what the subject is. Or back away so that some of the subject's surroundings are also included, to tell a more complete story. Do not move too far away, though. Many otherwise good compositions are weakened by the subject's being too small. Move around to determine what camera position offers the best framing of the subject. Or, if the subject is active, wait for it to move into the best position. Use camera position to select the best light and background, as well as to

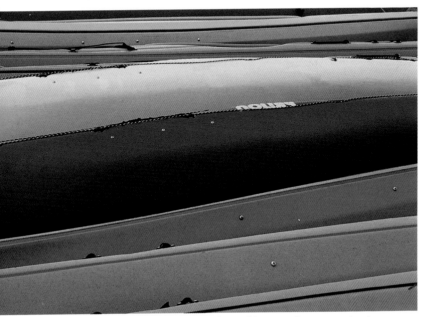

Photo 2-5: *Kayaks, Lopez Island, Washington* (© Mark Gardner)

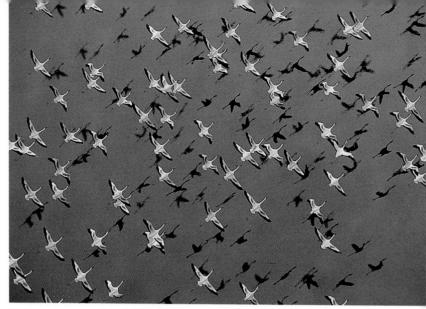

Photo 2-6: *Lesser flamingos, Kenya* (© Art Wolfe)

eliminate any distracting elements that might detract from the power of the photograph or, worse, compete with the subject itself for your viewers' attention. Look around before you shoot. Often, just moving a few feet can mean the difference between a mediocre snapshot and an attention-grabbing image.

For example, if you want to photograph a doe and a fawn grazing at the edge of a small, wooded pond, should you position yourself across the pond from the animals to capture their reflection? Or should you position the deer between yourself and the water so that the water provides an attractive backdrop? Which position is better depends on which photograph you want. The first position might be better if you want a photograph of a wooded scene in which the deer and their reflections are only a part of that scene. The second position might be better if you want a portrait of the deer themselves. Either way, you get a different picture depending on where you position your camera.

Angle of view. In addition to your position, also consider the angle of view. Simply shooting at eye level, which is most commonly done, may not always work best. Changing the angle of view may create a much more interesting composition. For different effects, try shooting down on the subject for a bird's-eye view or up at the subject for a bug's-eye view, like the shot of the birds flying in **Photo 2-6** or the ground-level view of the tortoise in **Photo 2-7**. Climbing trees and crawling on the ground can result in unique shots. People are not used to viewing subjects from these perspectives; thus, these angles can be

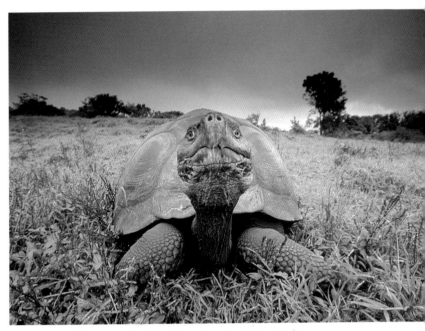

Photo 2-7: *Galapagos giant tortoise, Ecuador* (© Art Wolfe)

very effective in getting a viewer's attention. But be careful: such views can also be disconcerting if they are too different from reality or your viewer's expectations.

Always analyze the possibilities before you start shooting. Move around, looking through your viewfinder, to find the perspective that works best. Try different positions and angles for different effects. No one point of view is correct, but one may be better than another for getting the photograph you want.

composition checklist

- Select your subject or theme
- Best camera position?
- Lens focal length?
- Aperture for needed depth of field?
- Shutter speed to show or freeze motion?
- Vertical or horizontal format?
- Position subject within the frame?
- Check background and edges for distractions
- Wait for the decisive moment

Choose Your Lens Length

Lens focal length can have a big effect on composition by determining what is included in the photograph and how objects appear in relation to each other.

Normal. So-called *normal lenses,* those around 50mm in focal length for a 35mm camera, record a scene much as your eyes do. The relative sizes of objects and the spatial relationships between them look about the same in the photograph as they do in the field.

Wide angle. Lenses with a shorter focal length, about 15mm to 35mm, are referred to as *wide-angle lenses.* They provide a broader view and are used to tell a story or record a bigger scene with a foreground and a background. They create a sense of expansiveness and openness by increasing the apparent distance between objects in the scene. They create a sense of depth by exaggerating the convergence of lines as they recede into the background and by making foreground objects appear larger, and background objects relatively small. Wide-angle lenses also provide greater depth of field (see "Depth of Field" in chapter 5), which allows much more of a scene to be in focus. Wide angles are great for showing a subject in the foreground in the context of its background surroundings, as in **Photo 2-8** of the moose grazing in the foreground with Denali in the distance.

Telephoto. Lenses with a longer focal length, referred to as *telephoto lenses,* magnify the subject and provide a narrower view, isolating a single object or a small part of a bigger scene. They seem to compress the depth of the scene, resulting in flatter but more intimate compositions. Their apparent decrease in depth of field is ideal for placing an in-focus subject against a background that is out of focus, as in the portrait of the wolf in Photo 2-2.

Telephotos with midrange focal lengths, about 75mm to 150mm for a 35mm camera, are ideal for tighter shots of a single subject, especially a person. Such lenses can isolate the subject without too much compression while maintaining a comfortable distance from the subject.

Telephotos with longer focal lengths, 200mm or greater, are ideal for taking a small slice out of a big scene or emphasizing a subject you cannot approach. Their narrow field of view eliminates surrounding distractions and isolates the subject. Their compression of depth, which makes distant objects seem very close to the ones in front, can create some interesting effects. For example, if you use a telephoto lens to photograph trekkers viewing dramatic peaks in the distance, the peaks appear to loom over them, as in Photo 2-1, when in fact the peaks might be quite far away. With a wide-angle lens, the peaks would appear much farther away and much less dramatic.

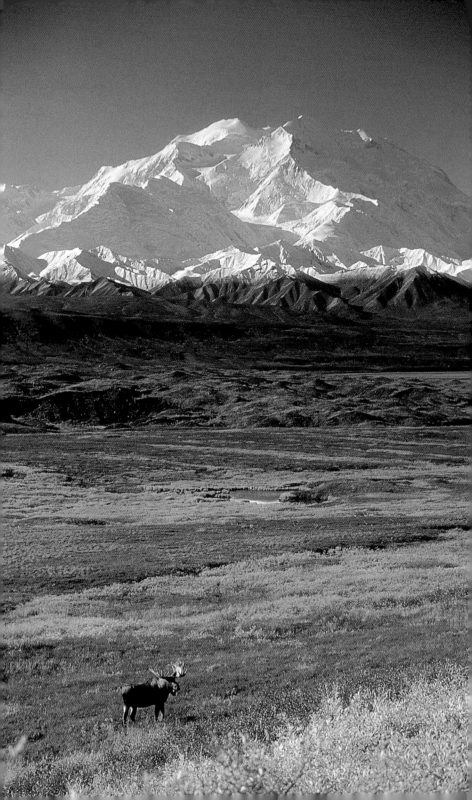

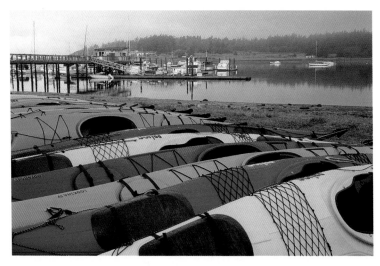

Photos 2-5 and 2-9: *Kayaks, Lopez Island, Washington* (© Mark Gardner)
This is an excellent example of how you can create two very different images of the same subject by using different points of view and lens lengths. I shot Photo 2-9 with a wide-angle lens in front of the kayaks to capture the entire harbor. I made Photo 2-5 from the opposite side of the kayaks, using a telephoto to isolate a colorful graphic composition. The results are very different. Photo 2-9 is a photo of a scene with kayaks, while Photo 2-5 is more a photo of lines of color than it is of kayaks. (MG)

However, this compression can result in distracting merging of objects, which can ruin an otherwise great shot. For example, a branch or tree far beyond a bear you are photographing may appear to be growing right out of its head in the resulting image. Or objects well beyond your subject that are about the same tone or color may look like part of the subject, resulting in a confusing image. Look for potential distractions behind your subject. With a telephoto's narrow field of view, even a slight shift in your position can eliminate them.

When photographing your subject, try different lenses or different focal lengths of your zoom lens, which combines a range of focal lengths into one lens. You can make very different yet equally effective compositions of the same subject from the same vantage point simply by shooting with a variety of lenses or focal lengths. For example, if you want to tell a story by showing the whole scene, then select a wide-angle lens, such as was used for **Photo 2-9**, of kayaks at

Opposite, Photo 2-8: *Bull moose, Denali National Park, Alaska* (© Art Wolfe)

rest in a misty harbor. If you want to show a slice of the scene with a strong graphic design, like the same kayaks in Photo 2-5, select a telephoto. These represent the two ends of focal-length choices. Between these extremes lie subtle differences that can make for better photographs.

Choose Your Exposure

Exposure choices can also have a big effect on composition. A variety of *aperture* and shutter-speed combinations can provide the correct exposure (see chapter 4). Thus, the particular aperture and shutter speed you select should be dictated primarily by their effects on composition. Careful selection of aperture and shutter speed provides a lot of creative control that you can use to your advantage.

Aperture determines depth of field, or how much of your photograph is in focus (see chapters 4 and 5), and shutter speed determines the effect of motion in your photograph. When you want to control depth of field, first select the aperture that provides the depth of field you want; then set the shutter speed to get the exposure that you want, or if you have an automatic camera, use *aperture-priority mode* (in which you select the aperture and your camera selects the appropriate shutter speed). When the effect of motion is more important, first select the shutter speed; then set the aperture, or use *shutter-priority mode* (in which you select the shutter speed and your camera selects the appropriate aperture). If neither is more important than the other, first set the aperture to f/8 or f/11 (see chapter 4), then set the shutter speed, or use *program mode* (in which the camera selects both aperture and shutter speed).

Aperture. Wide apertures, f/5.6 and wider, result in a relatively shallow depth of field, with the subject in focus against a blurred background. These apertures are ideal for isolating an object or small piece of a scene. To best emphasize the subject, the background should be a different color or tone from the subject. For example, a well-lit subject in front of a darker, blurred background really stands out, as does the wolf in Photo 2-2. However, be careful of background highlights. Little spots of light that do not look like much to you will become big, distracting hot spots in an out-of-focus background. Use your depth-of-field preview button, if your camera has one, to check for these (see "Depth of Field" in chapter 5).

Narrow apertures, f/16 and smaller, result in a much greater depth of field, sometimes extending to infinity. These apertures are ideal for telling a story or packing a lot of information into an image, such as a big landscape in which you want both the foreground and the background

to be in focus, as in Photo 2-8. Unfortunately, small apertures dictate slower shutter speeds, which may require use of a tripod or some other camera support to ensure a sharp photograph.

Managing depth of field is a balancing act. The aperture should be wide enough to allow all the important parts of your photograph to be in focus. Key parts of the image that are not in focus may be distracting and may diminish the power of the photograph. On the other hand, the depth of field should be narrow enough to put the unimportant parts of the scene, especially in the background, out of focus, thus isolating what is most important. A background that is in focus may draw your viewer's attention away from the subject. Before shooting, check the depth of field by using the depth-of-field preview button on your camera or the *depth-of-field scale* on your lens. Then open up or *stop down* the aperture as needed to get the right depth of field.

Shutter speed. Fast shutter speeds, 1/125 second or faster, freeze the motion of the subject, the camera, or both in most situations. Freezing the motion of very fast-moving subjects, such as downhill skiers or cyclists at full speed, may require even faster speeds. Slower shutter speeds record motion as a blurring of the subject if it is moving, or a blurring of the entire picture if the camera is moving. Eliminating this blurring when using slower shutter speeds requires the use of a tripod or other camera support (see "Eliminating Camera Movement" in chapter 5). Whether you show your subject's motion as an instant captured in time or a blur of implied motion as the subject whizzes by depends on your purpose.

Capture Action and Motion

There are three ways to show action or motion in your photographs.

Freezing motion. The first technique is to use very fast shutter speeds to freeze the subject's motion, as in **Photo 2-10,** of the breaching whale. This might be most effective when you want to show facial expressions, straining muscles, or a unique instant in time, such as a kayaker cresting a waterfall, a skier turning on a gate, or a grizzly bear fishing for salmon. Anticipation is the key to getting this type of shot, especially of a high-speed subject like a flying bird or a running animal. If you can see the moving subject in your viewfinder, you have probably missed the shot, especially if the subject is relatively close to you. You actually have to press the shutter-release button just before or just as the subject enters the viewfinder. Stopping the motion of a very fast subject, such as a skier or a flying bird, requires a shutter speed of 1/500 second or faster. Even faster shutter speeds, 1/1000 second or faster, may be required when the subject is close, accelerating rapidly

(as a bird taking flight), or moving perpendicular to your line of sight. Slower speeds, 1/60 or 1/125 second, can be used when the subject is moving toward or away from you and is relatively far away. When in doubt, use the fastest shutter speed possible. **Table 2-1** provides guidelines for different subject speeds and directions of movement. With automatic cameras, use shutter-priority mode, select a fast shutter speed, and let the camera pick the right aperture.

Photo 2-10: *Breaching whale, Point Adolphus, Alaska* (© Art Wolfe)

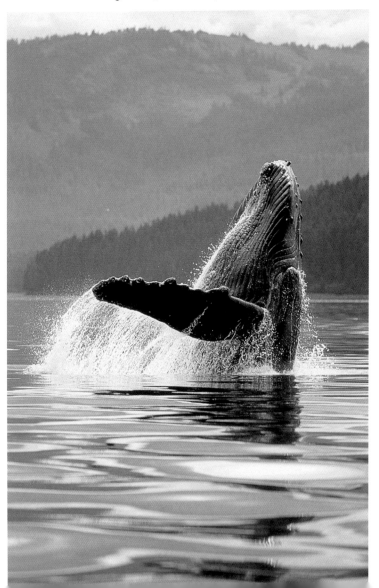

table 2-1. minimum shutter speeds to freeze motion*			
Subject Speed	Direction of Movement Shutter Speed		
	↓	↘	→
Slow: walking, paddling, cross-country skiing	1/60	1/125	1/250
Medium: jogging, trotting, bike touring	1/125	1/250	1/500
High: running, flying, downhill skiing	1/250	1/500	1/1000
*Note: These guidelines are for a subject 25 to 30 feet away from you. If the subject is 10 to 15 feet away, double the speeds; if the subject is 50 to 60 feet away, cut them in half.			

Blurring motion. The second approach is to slow the shutter down to capture an impression of motion itself, like the blur of the water as it runs over the stationary rocks in **Photo 2-11**. This image is much more appealing than the same scene with the water frozen in place by a faster shutter speed. Shutter speeds of 1/15 second or slower blur the subject's motion and are effective at showing the explosion of birds taking to the air, the speed of a running animal, or the graceful flow of a waterfall. When using this approach, be sure to use a shutter speed slow enough to significantly blur the motion. If the subject is only slightly blurred, then you have a bad picture. In these types of shots, the boundary between subject and background is also harder to discern. So be careful not to lose the subject in the background; look for a background that will make the subject stand out. If possible, use a solid tripod to prevent overall blurring from camera movement.

Panning action. The last approach is to *pan* or track the action with your camera, as in **Photo 2-12**. While you follow the moving subject with your camera, depress the shutter-release button as you move with the subject. In the resulting photograph, the subject will appear relatively sharp and the background blurred, implying that the subject is whizzing by the viewer. Try shutter speeds of about 1/30 second to 1/2 second, and use a tripod to track the subject's direction of movement without camera wobble. The faster shutter speeds in this range freeze the subject against a blurred background. The slower shutter speeds blur the background as well as the subject. Panning works best when the subject is moving perpendicular to the camera's line of sight.

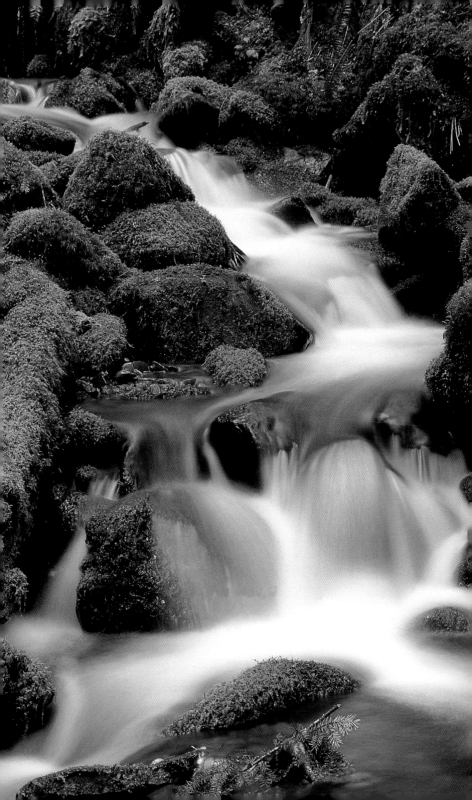

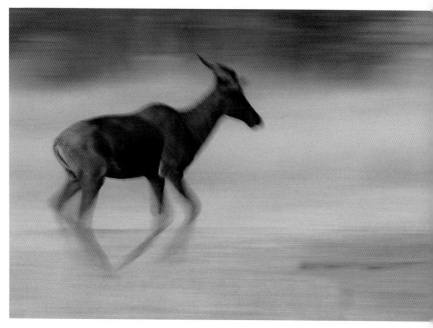

Photo 2-12: *Tssessebe, Okavango River, Botswana* (© Art Wolfe)

Choose a Vertical or Horizontal Format

Once you've framed your subject by finding the best camera position, lens focal length, and exposure, you must choose either a horizontal or a vertical orientation for the frame. The 35mm frame is actually a 24mm by 36mm rectangle, with an aspect ratio (relationship of width to height) of 3:2. That shape is evident when you look through the viewfinder. Digital cameras also typically have an aspect ratio of 3:2 and create an image with a rectangular frame. A horizontal format orients the rectangle with the long axis running from left to right, whereas a vertical format orients it with the long axis running up and down. Which orientation you choose will affect the final image. For example, in Photo 2-1, the peak might not seem to loom so high over the trekkers if the image were in a horizontal format.

The horizontal format emphasizes the horizontal axis, creating a sense of width or depth. It is ideal for big landscapes, travel shots in which you have a person looking into the scene, and action shots in which there is horizontal movement. The vertical format, on the other

Opposite, Photo 2-11: *Hoh Rain Forest, Olympic National Park, Washington* (© Art Wolfe)

hand, emphasizes the vertical axis, creating a sense of height. It is ideal for shots of trees, landscapes with a lot of elevation, and action shots in which the movement is up or down.

Do not shoot horizontals just because it is easier. Choose the orientation, vertical or horizontal, that best contributes to your composition. Select the orientation that best emphasizes the subject or theme of your photograph and eliminates any distractions. Or try both orientations, to create two different, but perhaps equally pleasing, images of the same subject.

Position the Subject in the Frame

The position of the subject or of key parts of a scene within your photograph can also add to the effectiveness of a composition. The center of the frame is often the weakest location, even though it is usually most convenient when you put your viewfinder's sights on the subject and fire away. Placement of the subject in the center can result in a static image, locking the viewer's eye in the middle with no place to go.

However, placement of the subject too near the edges of the frame can be distracting and even confusing to the viewer. Avoid cramming the subject too close to an edge, especially if the rest of the image is full of other things that might also catch the viewer's attention. Avoid having the frame's edge cut off so much of an object that the viewer will wonder what it is and whether it is supposed to be in the picture. Avoid having the front of a moving subject touching the frame's edge

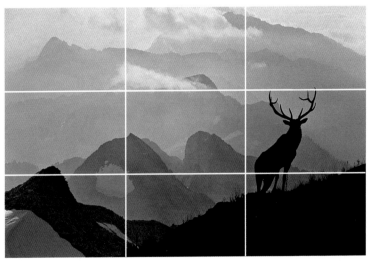

Photo 2-13: *Elk, Banff National Park, Canada* (© Art Wolfe)

unless there is something very interesting following the subject.

The most interesting positions are off center but away from the edges. Imagine vertical and horizontal lines dividing the space within the viewfinder roughly into thirds, as shown in **Photo 2-13**. The intersections of these grid lines are the positions with the greatest visual interest. Those positions are more dynamic than the center and less confusing than the edges. As a guideline, commonly referred to as the rule of thirds or the golden mean, place your subject—or the most important parts of the subject, such as the zebras in Photo 2-3 or the eyes of the wolf in Photo 2-2—at or near these intersections whenever possible. Place a moving subject at an intersection point, traveling into the frame.

To strengthen a more complex photograph, incorporate paths for the viewer's eye to follow. These can support the subject, leading the viewer's eyes right where you

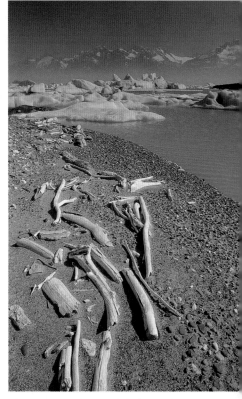

Photo 2-14: *Bleached driftwood, Alaska* (© Art Wolfe)

want them to go, as do the pieces of driftwood in **Photo 2-14**. They can also create a sense of movement or interaction between the key parts of a bigger scene, adding a sense of depth. For example, placing the moose in the foreground of Photo 2-8 with Denali in the background connects both parts of the image and provides a path for the viewer's eye to travel. Although images of only the moose or only Denali would be good, combining the two creates a much more dynamic image. The paths for the eye can be explicit lines, such as the curves of a road, tree branches framing a peak, fences, stairways, or converging perspective lines. Or they can be implied, like the line along which people within the photograph are looking, a moving object's line of travel, a series of objects that recedes into the background, or imaginary lines connecting important objects in a scene. Be careful how you use these paths. They can detract from a composition as much as they

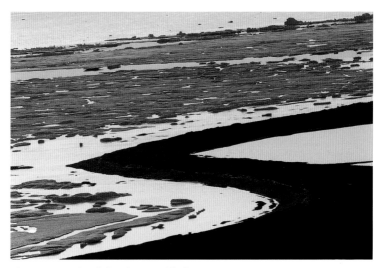

Photo 2-15: *Arctic landscape, Alaska* (© Art Wolfe)

can complement it. In particular, watch out for lines that lead the viewer out of the photograph, unless something else is firmly anchoring the viewer in the frame.

In addition to providing paths for the eye to follow, lines can have more subtle effects. Diagonal lines create a sense of tension or movement, whereas horizontal lines are more tranquil. Curves imply fluidity and sensuousness, as in **Photo 2-15,** which is a strong image because of the graphic design, not the subject itself. Simple shapes made from diagonal lines, like triangles and diamonds, can add even more dynamism. Such lines or shapes can be explicit, but more often they are implied by the positions of objects within the photograph. Thus, two objects arranged along a diagonal line create more visual interest than if arranged horizontally. Three objects creating a triangle have even more power. An example is the triangle created by the paragliders soaring over the Alps in **Photo 2-16**.

Other elements can be incorporated into your photograph to add to the effect you want to make. For example, bold colors are usually more evocative, as in the kayaks in Photo 2-5, with reds connoting heat or passion and blues connoting coolness or serenity, while soft pastel colors are more harmonious and subtle in their effect, as seen in the mountain ridges in **Photo 2-17**. Textures can add a sense of touch, allowing the

Opposite, Photo 2-16: *Paragliders soaring over the Alps, Switzerland* (© Mark Gardner)

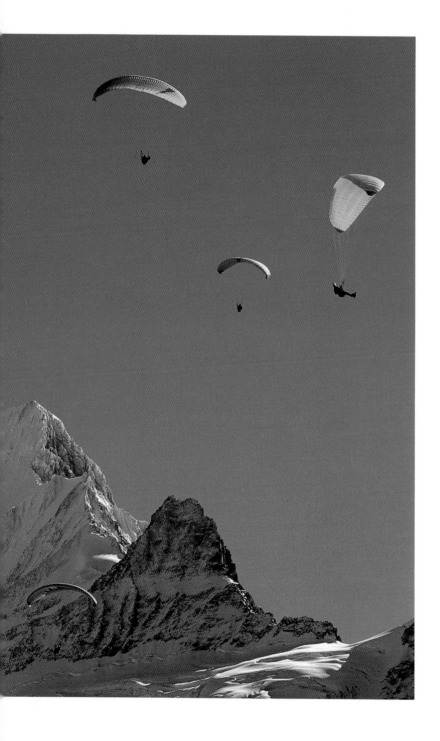

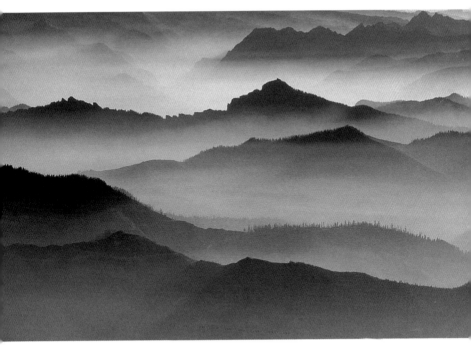

Photo 2-17: *Mountain ridges, North Cascades, Washington* (© Art Wolfe)

viewer to "feel" the subject. Finally, patterns of lines or shapes can add appealing rhythms and interesting abstractions, as in Photo 2-17 and **Photo 2-18**. The appeal of these photos is as much the strong graphic designs as it is the subject matter itself. In fact, a good graphic design can transform a potentially boring scene into an appealing image, and can even be the subject of the image itself. So always be looking for good graphic designs as well as interesting subjects.

Capture the Decisive Moment

Just as the right camera position is important, sometimes the right moment in time can make the difference between a good snapshot and a powerful image. The breaching whale in Photo 2-10 captures such a decisive moment. A shot taken a few seconds earlier or later would not have resulted in such a powerful image. These moments, such as the moment when a foraging bear lifts its head to look at you, a cyclist comes flying around a corner, or the rising sun bathes your subject in warm light, offer opportunities to capture something special in your photographs. To make the most of these opportunities, you have to be ready for them, especially when things are happening fast. Quick reactions as

well as cameras with autofocus lenses and power winders can help, but decisive moments often happen too quickly for you to count on these alone to capture them.

Anticipating decisive moments is the key. Slow down to study your subject's movement, to watch what is going on around the subject, to

Photo 2-18: *Sand dunes, Australia* (© Art Wolfe)

analyze the play of the light. By waiting and watching, you develop a sense for what is about to happen and will more likely be ready for it when it does. Try to visualize the images you want, making compositional and technical decisions well ahead of time. Then be on the lookout for these images or the conditions that can create them, and have your camera ready to shoot.

This anticipation is especially important when things are moving or changing quickly. For example, simply reacting to a fast-moving downhill skier, raising your camera, and pressing the shutter-release button as he or she whizzes by you will most likely result in a great shot of the snow. At those speeds, if you can see the decisive moment in your viewfinder, you may well miss it in your photograph. If you watch the movement, position yourself before the skier gets to you, preset focus and exposure, and snap the picture just as the subject enters or is about to enter the frame, you are more likely to get the shot.

As in finding the best position from which to shoot, take your time. Do not just fire away. Rather, slow down, observe, and analyze. You will be much better able to pick the right time to get the best photograph. If the decisive moment does not happen when you expect it, just wait; it will happen.

Opposite: Volcanic eruption, Hawaii (© Art Wolfe)

Natural Light

L ight, of course, makes photography possible. Without it we could not enjoy the beauty and adventure of the outdoors, much less bring back pictures of our experiences. While there certainly has to be enough light to properly expose your film or *digital sensor,* it is the character, or quality, of the light that really makes the photograph. With the right light, rich in character, even a mundane subject can make an outstanding image. Learning to find the best light, to use the light you have to your advantage, and even not to photograph in the wrong light are the next steps toward making better photographs. This chapter covers the characteristics to look for in light, as well as the times and places to find them. The quantity of light needed to make a photograph is covered in chapter 4. The principles covered here are applicable to any camera type. Bad light will make a bad image even with the latest in digital technology or the fanciest SLR camera.

In outdoor and adventure photography, light comes primarily from one source: the sun. Other sources, such as flash (see chapter 5), fires, flashlights, or the moon (see chapter 6), can be used to augment sunlight

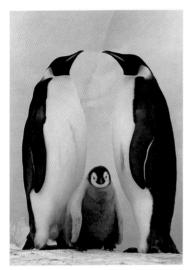

Photos 3-1 and 3-2: *Emperor penguins, Antartica* (© Art Wolfe)
I took advantage of the pleasing low-angle light of the setting Antarctic sun by positioning myself with the sun behind me, and the penguins in front. I used an 80mm telephoto lens, which allowed me to isolate the subject against an out-of-focus background. Normally I avoid front lighting, but the combination of the warm, even light, which complemented the soft shininess of the penguin's plumage, and the touching composition resulted in a great image. (AW)

Photo 3-3: *Bicycling in flower fields, Washington* (© Mark Gardner)

and sometimes even replace it. Such light sources can create interesting effects, but their application is usually too limited and too complicated for most outdoor excursions.

The light used to make a photograph travels from the sun through the earth's highly variable atmosphere, reflects off the scene you are shooting (unless the sun itself is your subject), goes through your camera's lens, and finally hits the film or sensor in your camera. Along the way, the quality of the light is affected, sometimes dramatically, by its direction in relation to the subject, the time of day, any manipulation of the light that you might add, and even the film you use.

The light reflecting from a scene can be even or contrasty, bold or subdued, harsh or soft, and warm or cool, and can vary in color from red to blue. These characteristics evoke different emotional responses and create different moods, which can enhance the impact of your photograph. For example, subdued, bluish light creates a quieter, more somber mood, as in **Photo 3-1,** in which the penguins are illuminated by the light reflecting from the surrounding ice; whereas bolder, warmer light creates more excitement and energy, as in **Photo 3-2,** in which the penguins are bathed in warm sunlight. In general, the most appealing photographs are usually made in light that is somewhat even but with enough contrast to add depth, not too bold, softer to take the hard edge off of shadows, and warmer, with a hint of golden orange or red, as in **Photo 3-3**. Unfortunately, the right combination of characteristics does not happen all the time.

To take advantage of the right light, you must first learn to see it. For most of us, most of the time, light is the medium, not the message. Our

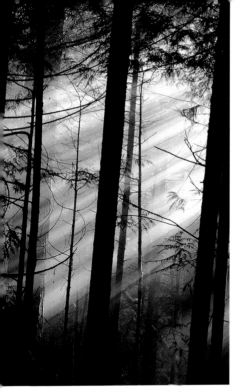

Photo 3-4: *Old-growth forest, Washington* (© Art Wolfe)

brains tend to ignore the light per se and focus only on whatever it reveals. To become a better photographer, look not only at your subject but also at the light itself. Look for its various characteristics, paying attention to where and when you find them. Photograph similar subjects in different types of *natural light* to develop a sense for how light's character can affect your pictures.

Sometimes the light and its interaction with the atmosphere can create appealing images. For example, the sunlight filtering through the haze in the old-growth forest in **Photo 3-4** results in an ethereal image. So in addition to looking for the right light illuminating your subject, also look at the light itself and its effects on the subject.

CONTRAST

Film and digital sensors record light differently from the way your eyes do. Consequently, they can change the light's character in the final image, sometimes enhancing the effect you want, sometimes detracting from it. For example, film can increase contrast, make colors more snappy or subdued, add warmth or coolness, change the color cast, and alter textures. Not only is it critical that you find the right light, but you must also understand how your film or sensor interacts with that light if you are to make better photographs. Experiment with different types of film to learn about these effects and discover what you like.

Although contrast is a key to good photography, extreme contrast is a common cause of bad photographs. *Contrast* is simply the difference in brightness between the lightest part of a picture and the darkest. With high contrast there are deep, dark shadows and bright, white spots, called highlights. Low contrast has a narrow range of tones without the extremes of dark shadows and highlights. Contrast is most extreme when the sun is high overhead on a summer day, especially inside forests or on snow and sand. Contrast is much less on overcast

days or when the sun is very low in the sky, unless the scene you are shooting includes a lot of sky.

On a bright, sunny day, when contrast is highest, you can usually see the full range of tones in a scene. You typically see the detail both in the shadows and in the bright highlights, unless you are looking right into the sun or you quickly look from one extreme to the other. Film and digital sensors, on the other hand, record a much narrower range of tones than you can. They will not record the detail that you can see, either in the shadows or in the highlights, or in both. Consequently, little if any of what you could see in the scene's shadows or highlights will show up in your photograph. Rather, those areas will appear as unrecognizable black and white spaces that can weaken an otherwise good composition. Bright highlights, in particular, will draw the viewer's attention away from the subject. A more subtle difference is that soft edges will appear harder and more pronounced, perhaps obscuring a subject's fine details and textures.

Digital cameras record a wider range of tones than film, but that range is still typically narrower than what you can see. Thus high contrast on sunny days may be less of a problem for digital cameras, but it is still an issue. So even with a digital camera, be mindful of the contrast in the scene you are photographing, and think about how that contrast will be recorded.

Even though some films and digital cameras can record greater contrast than others, contrast that is too high will overpower just about any film or digital sensor. If you can see dark, distinct shadows on a bright, sunny day, and you squint heavily when emerging from the shadows into the sun, then the contrast is probably too high for your film or your digital camera. For best results, keep contrast extremes and bright highlights out of your photographs. For example, if you are photographing a subject in the shadows on a sunny day, then eliminate the brightly lit areas from your viewfinder. Or wait for light that has less contrast, closer to the range that your film can record, and avoid the high contrast of midday when the sun is shining. Then you can use contrast to your advantage, instead of having it ruin your photographs.

DIRECT LIGHT

Direct light is, very simply, light that travels from the sun or another light source directly to your subject without being significantly altered along the way. *Indirect light,* on the other hand, illuminates your subject after being reflected and scattered by things like clouds, tree canopies, and even the atmosphere itself, which reflects light into open shadows. Direct

light is typically more intense and harsher than indirect light, and its direction has a notable impact on your photograph.

When photographing in direct light, do not simply follow the old adage of keeping the sun behind you with the light coming over your shoulder. Before shooting, try different camera positions. Light hitting the same subject from different directions can create very different images. A saguaro cactus lit from the front makes an interesting image, but when it is lit from the side, you can feel its sharp spines, and when it is lit from the back, you are also struck by its distinctive shape.

Front lighting. *Front lighting,* in which the light source is in front of the subject and behind the photographer, lights your subject evenly, with virtually no shadows. It is great for showing detail and color, as in Photo 3-2, but can produce flat images, because there are no shadows to add depth and show textures.

Sidelighting. *Sidelighting* can produce much richer images, as in **Photo 3-5**. Light coming from either the left or right of the subject casts shadows that define the shapes and textures of an image. These shadows make photographs, which are inherently flat, seem more three-dimensional with a greater sense of depth. They can create stronger, more interesting graphic designs, adding more drama to the image. The textures that they reveal can add a tactile quality. For example, in Photo 3-5, the low-angle light is coming from the left, illuminating the antler but not the sand, which is in a shadow. The darker sand creates depth and makes the bright antler stand out. If front-lit, the image would not have been nearly as appealing or dramatic.

However, such shadows can be distracting if contrast is too extreme and what looked like soft shadows to your eyes become black holes in your photograph. Light coming

Photo 3-5: *Moose rack, Alsek River, Alaska* (© Art Wolfe)

Photo 3-6: *Black-tailed deer, Olympic National Park, Washington*
(© Art Wolfe)

from a direction somewhere between the front and the side can be a good compromise, illuminating more of the subject but avoiding harsh shadows. Flash and reflectors (see chapter 5) can be used to fill in shadows, reducing the contrast to a range the film can record and often creating a more appealing photograph.

Backlighting. *Backlighting,* in which the light source is behind the subject and in front of the photographer, is the trickiest to work with but can produce very dramatic images, as in **Photo 3-6** or **Photo 3-7**. Whereas front lighting fully illuminates a subject, leaving no shadows,

Photo 3-7: *Windsurfers, Alaska* (© Art Wolfe)

backlighting has the opposite effect. It enhances contrast, creating silhouettes that emphasize your subject's shape. Backlighting can also surround your subject with a halo, called rim lighting, adding a feeling of magic to your photograph, as shown by the deer in Photo 3-6. As with sidelighting, flash and reflectors can be used to light the front of your backlit subject while retaining the glowing rim light, often creating unique images (see chapter 5).

Top lighting. *Top lighting,* which occurs during midday, when the sun is overhead, is lighting from the least appealing direction and is usually worth avoiding. Contrast is usually highest when the sun is directly overhead, often too high for film to record. Overhead light is typically very harsh and creates unappealing shadows on the faces of animals or people, often making them look as if they have black eyes. Like front-lit photographs, top-lit photographs often look flat because there is little or no shadow to add depth to the scene.

Spotlighting. *Spotlighting* is a special type of direct lighting in which a beam of light shines through an opening in clouds, forest canopy, or some other barrier to illuminate the subject, as it does the skier in **Photo 3-8.** Just as in theater, a single beam of light makes the subject stand out against darker surroundings, drawing attention to it. Look for spotlighting inside forests, during clearing storms, and in other conditions, especially when the sun is low in the sky, just after sunrise or before sunset. You can also create spotlighting on smaller subjects by using fill flash and underexposing the background (see chapter 5).

Photo 3-8: *Cross-country skier, Mount Rainier National Park* (© Mark Gardner)

INDIRECT LIGHT

Indirect light is light that bounces off something else before reaching the subject. Such light, also called bounce light, can take on a range of characteristics, depending on how it is reflected or scattered as it travels to the subject and what it is reflecting from. At one end of the spectrum, light reflecting from a mirror or another bright, reflective surface may be much like direct light in character, though somewhat less intense. If you see distinct shadows of objects lit by reflected light, as may occur on bright snow or sand, then treat the light as if it were direct light. However, if shadows are less distinct, then treat the light as indirect. At the other end of the spectrum, light shining through fog or clouds may be so scattered that by the time it reaches your subject, it is very diffuse, seeming to come from all directions and leaving no shadows at all.

Indirect light, found on overcast days and in shadows, illuminates your subject more evenly than direct light, creating no deep shadows or harsh highlights that may be distracting. Contrast is much lower than in direct light, allowing you to capture a more subtle range of tones and more detail in your subject. Indirect light is also much softer, eliminating the hard edges created by direct light. Colors are more saturated, more intense, because there is no harsh glare to wash them out.

The clouds, fog, and precipitation that might otherwise keep you indoors can create ideal conditions for outdoor photography. The indirect, diffuse light found in such conditions often produces the most satisfying images, especially when you want to emphasize a subject's

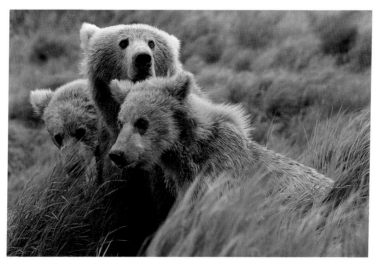

Photo 3-9: *Brown bears (sow and cubs), Alaska* (© Art Wolfe)

more subtle textures and details. It is great for close-ups and portraits, as well as for landscapes if you minimize the amount of white sky in the picture. For example, the photographs of the bears, **Photo 3-9,** and the tropical rain forest, **Photo 3-10,** were taken on overcast days. They would have looked very different if taken under sunny skies; given the contrast limitations of film, they probably would not have even been worth taking.

However, indirect light also takes on the color of whatever it is reflecting from and will subtly change the color of whatever it is illuminating. For example, the penguins in Photo 3-1 have a cool, blue cast because they are lit by sunlight reflecting from blue ice. And the Kayapo mother and child in **Photo 3-11** have a warm glow created by light reflecting from the clay-colored ground in front of them. On overcast days, the light filters through gray clouds and, consequently, takes on a cool, gray cast. Light in open shade on sunny days takes on a cool, bluish cast.

Photo 3-10: *Monteverde Cloud Forest Reserve, Costa Rica* (© Art Wolfe)

Our eyes often do not see these color shifts until we look at the final images. So look carefully for them when photographing in indirect light. Once you learn to see the changes, you can use them to create better photographs. For example, the photograph of the Kayapos in Photo 3-11 is far more appealing than one taken in direct sunlight, which would have left dark shadows under their eyes. However, such color changes can also detract from your photographs by creating an image that seems unnatural. If you want more natural-looking photographs, use different types of film and filters or adjust the white balance on your digital camera to counteract these changes (see chapter 5). For example, a *warming filter* would return the cool, blue penguins in Photo 3-1 to a more normal-looking color.

Indirect light is less intense than direct sunlight, so it may dictate the use of slower shutter speeds, a tripod, or faster film (see chapter 5).

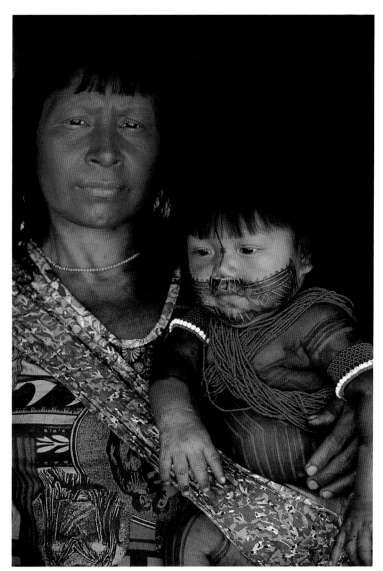

Photo 3-11: *Kayapo mother and child, Xingu River region, Brazil* (© Art Wolfe)
Shooting portraits with a wide-angle lens often intimidates a subject. So I used a
400mm telephoto lens to create a tight portrait of this Kayapo mother and child
from a less intimidating distance. They were standing in the doorway of their home,
but just a few feet from bright, tropical sunshine. I took advantage of the light
bouncing off of the light-colored ground in front of them, which illuminated them
with a warm, soft light to create this intimate portrait. (AW)

ANGLE OF LIGHT/TIME OF DAY

When there are no clouds hiding the sun, the character of sunlight varies considerably throughout the day as the sun's angle to the horizon and its interaction with the earth's atmosphere change. Shooting at different times of day can result in photographs of the same subject that are quite different and that have different emotional impacts. For example, compare the photograph of Wonder Lake and Denali **(Photo 3-12)** taken before sunrise with the photograph of the same scene **(Photo 3-13)** taken much later in the day.

Differences in the light's character divide the day roughly into six periods: the time before sunrise, the hour or so after sunrise, midday, the hour or so before sunset, the time after sunset, and night. The best times for photography on sunny days are generally during what photographers refer to as the *magic hour:* the half hour or so before and after sunrise or sunset. The length of each period varies with latitude and season. At lower latitudes, nearer the equator, sunrise and sunset come and go very quickly, so the periods when the light is best for photography are very short. The magic hour is reduced to the magic fifteen minutes. The sun stays overhead most of the day, creating a long midday period with harsh light and too much contrast. At higher latitudes, nearer the poles, the optimal periods before and after sunrise and sunset last far longer, at times almost all day. In temperate regions during summer, when the sun is much higher overhead, the light during most of the day is harsh, with too much contrast. The periods of best light are short. Nearer winter, as the angle of the sun recedes, these periods become much longer, reaching a peak in midwinter.

Time before sunrise. During the period from the time the first rays of the sun begin to light the sky until just before the sun rises, the source of light for photography is not the sun itself but the sunlight reflected from the atmosphere. Thus, the light is indirect and very diffuse, with low intensity and contrast, but it changes rapidly as the sun nears the horizon. Colors are softer and more pastel, although the sky may be awash in fantastic color or filled with flaming clouds, which help make great landscapes (see Photo 3-12).

When the sun is still well below the horizon, long before sunrise, the light is relatively cool, with a bluish tint. As it nears the horizon, the light becomes warmer, with an orange-to-pink tint, as the sky reddens. The sky itself is several f-stops brighter than the earth, a condition that is great for shooting silhouettes but may require the use of a *graduated neutral-density filter* (see chapter 5). Because light intensity is low, a slow shutter speed, a steady tripod, and a *shutter-release cable* are needed (see chapter 5).

Hour after sunrise. After sunrise, from the time the sun first peeks

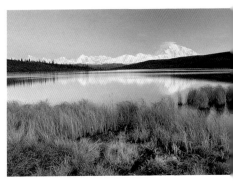

Photos 3-12 and 3-13: *Wonder Lake, Denali National Park, Alaska*
(© Art Wolfe)
These two photos show how a different angle and time of day can create very different images. Both were taken with a wide-angle lens and a split neutral-density filter, aligning the dark edge of the filter with the horizon. This allowed me to get an even exposure on the snowy mountain and the muted foreground. In Photo 3-12, the frosted blades of grass provide a sharp contrast to the soft, moody backdrop. In Photo 3-13, I moved farther back from the edge of the lake to let the foreground have more presence and add color. (AW)

over the horizon until an hour or so later, the sun's rays provide strong direct lighting at low angles, which is ideal for showing textures, creating strong graphic designs, and giving depth to photographs. Light intensity is higher than before sunrise, and it is increasing. Shutter speeds may be faster, although a tripod may still be needed. Contrast is still relatively low, usually within the film's range unless you include the sun in your photograph.

Because of the interaction of the low-angle light with the earth's atmosphere, the light at this time is much warmer, with a slight yellowish or reddish tint, and emotionally more appealing than at other periods of the day. Compare the color of the light on Denali in Photo 3-12 with the rest of the image. Colors are much richer during this period than at other times of the day; reds and earth tones in particular may even seem to glow. Great light with relatively even contrast makes this an ideal time for just about any type of photography.

Midday. The worst time for photography is usually when the sun is high in the sky, unless a cloud cover is diffusing the harsh overhead light. The light is cooler, with a bluish tint, and colors are washed out by the sun's more intense glare. The light's direction—from above—creates flat landscapes and casts unnatural shadows on faces. Contrast is more extreme, often exceeding the range that film can handle and

resulting in distracting shadows and highlights in your photographs.

However, it is still possible to take good photographs during midday. You can simply avoid the harsh, direct top light by shooting smaller subjects in the shadows, remembering to use a warming filter or warmer film (see chapter 5) to counteract the cool, bluish light found there. If no shadows are available, wait for clouds to obscure the sun, or create your own shadow with a jacket, a commercially available light diffuser, or even your body. Fill flash (see chapter 5) will warm up your subject and fill in the shadows created by midday's high contrast and top lighting. A *haze filter* or, better, a *polarizing filter* will reduce the harsh midday glare and return the richness to colors.

Hour before sunset. The light late in the day mirrors that found early in the morning. The light of late afternoon, starting an hour or so before the sun sets, is very similar to that of early morning after sunrise. However, changes occur in reverse order, and colors are often bolder and redder because of the atmospheric haze that has developed during the day. It is usually easier to make better photographs during this period because you have plenty of time to find the

Photo 3-14: *Alpenglow on Mount Everest, Nepal* (© Art Wolfe)

right composition well before the best light appears. Photo 3-13 is a wonderful scene illuminated by the warm, low-angle sidelighting that occurs at this time.

Time after sunset. The light from just after the sun sets until darkness prevails is also similar to early morning before sunrise. Do not be too quick to pack your gear as soon as the sun goes down. Some of the day's best light, such as alpenglow, often occurs a half hour or so after sundown. For example, **Photo 3-14** shows the delicate alpenglow on Mount Everest. In **Photo 3-15,** the sun has set below the horizon but is lighting the clouds and sky very dramatically. The resulting color in the sky and the silhouette of the windmill result in a powerful image.

Night. At night, the light provided by stars and, particularly, the moon is great for landscape photography. Except during the full moon, light levels at night are too low for us to see much of anything, but our cameras can record an image if we use very long exposures (see chapter 4). Because we cannot really see night scenes with our eyes, these shots create unique, often eerie images, never actually seen by anyone. The light created by or coming from some subjects also can create wonderful photographs when captured at night. For example, lightning, fireworks, holiday lights, and glowing lava **(Photo 3-16)** all make better images at night. Night exposures are usually very long, sometimes taking many

Photo 3-15: *Windmill at sunset, Palouse region, Washington* (© Art Wolfe)

hours; thus, a tripod and a shutter-release cable are required. Such long exposures, unfortunately, create a variety of problems, covered in chapter 4.

DRAMATIC LIGHT

To make dramatic photographs, look for dramatic light. Unfortunately, such light does not happen often, and it is usually fleeting. But it can create the unique, compelling images that all photographers dream of. Because such light comes and goes quickly, anticipation is the key to taking advantage of the drama it creates. Knowing your composition and exposure in advance gives you the time to focus on capturing the drama, rather than on fumbling with gear or running around trying to find the right location. Know what to look for, keep your eyes open, and keep your camera ready.

Dramatic light occurs when the sunlight's character is significantly, and usually briefly, affected by its interaction with the earth's atmo-

Photo 3-16: *Volcanic eruption, Volcanoes National Park, Hawaii* (© Art Wolfe)

sphere. Such light, rich in character, can occur at various times but is most often found in two situations.

The magic hour. During the magic hours discussed in the previous section, the rapidly changing light creates evocative images, such as the predawn photograph of Wonder Lake, Photo 3-12. The photograph of the emperor penguin family, Photo 3-2, was also taken with the sun just above the horizon. Haze and moisture in the atmosphere can enhance the effect further, especially at sunset.

Storms. During building or clearing storms, when weather is changing dramatically and rapidly, as in **Photo 3-17,** light can take on unusual colors. The appearance of rainbows, lightning, and rays of light coming through the clouds (sometimes called "God beams") can be an added bonus. Look for patterns of light and dark created on the landscape by

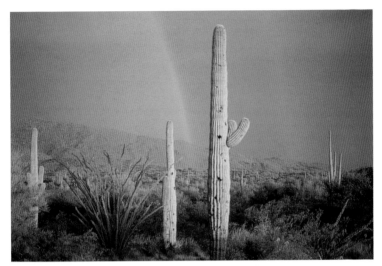

Photo 3-17: *Saguaro Cactus, Sonoran Desert, Arizona* (© Art Wolfe)

shifting clouds. Such patterns can create unique images. The combination of the magic hour with dramatic weather, such as thunderstorms at sunset, can result in once-in-a-lifetime photographs.

best light/worst light

best
- Magic hours around sunrise and sunset on sunny days
- Midday on overcast days
- Dramatic light of changing weather

worst
- Harsh overhead lighting (at midday) on sunny days

Opposite: *Big Sur Coast, California* (© Art Wolfe)

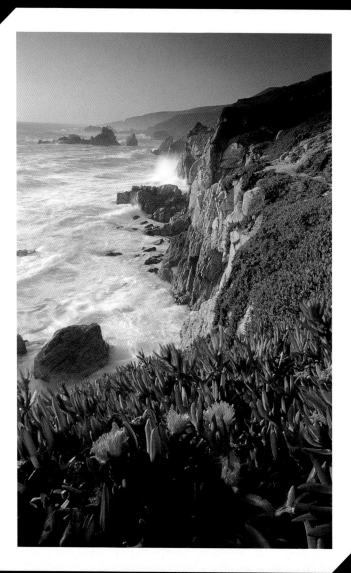

E xposure is simply the amount of light allowed to strike the film or digital sensor to create an image. The "correct" exposure is the one that makes the subject or most important parts of your photograph look as you want them to look. *Overexposure,* too much light, makes those areas lighter than you want them to be; *underexposure,* too little light, makes them darker than you want. Note that the correct exposure is not necessarily the one that your camera's light meter recommends or the one that best reproduces what you actually see. On many occasions, to get the effect you want, you will let in more or less light than your meter suggests. For example, letting in less light will make billowy white clouds look like a threatening storm. Letting in more light can make a darkening twilight sky look pastel.

Four simple tools are required to make a correctly exposed photograph: film or a sensor to record the image, an aperture to let light through the lens, a shutter to control the length of time the film is exposed to the light coming through the lens, and a way to estimate the intensity of that light. All of these tools are contained in a small toolbox—your camera. This chapter reviews the use of your camera's aperture and shutter speed to control the amount of light that reaches the film or sensor. It also reviews two ways of measuring light intensity, which determines how much light you have to let in to get the right exposure.

The process of determining exposure is a series of decisions that starts with determining how you want your photograph to look and ends with pressing the shutter-release button. In between, you, with the help of your camera, make decisions on what *film speed* to use, how to measure the light, how to evaluate that measurement in relation to what you want your photograph to look like, and finally what aperture and shutter speed to use. Once you understand the tool set, this decision process becomes much easier, and getting good photographs becomes much more consistent.

Today's cameras with automatic exposure (AE) can make some or even all of these decisions for you. Sometimes your camera will make correct decisions, but many times it will not. Even if the camera makes technically correct decisions, it will not necessarily make decisions that give you the image you want. To effectively use automatic exposure, you still need to understand exposure principles and how to apply them. You may let the camera do much of the decision making for you, but at least you will understand what the camera is doing and when to override the automatic settings. As long as you leave it all up to your camera, you will often miss the unforgettable images that are possible when you fully control the creative process.

CONTROLLING EXPOSURE

The size of the lens aperture, the length of time the shutter stays open, and the film speed—or how sensitive the film or digital sensor is to light—control exposure. Typically, exposure is expressed as an aperture and a shutter speed for a particular film speed. The correct exposure is the combination of aperture and shutter speed, for a given film speed, that gives you the photograph that you want.

Aperture, shutter speed, and film speed are all measured in *stops*. A stop is a relative measure in which each whole unit represents twice the preceding value and half the next value. For example, the series 1, 2, 4, 8, 16, 32 is a range of stops, in which 2 is twice as much as 1 but half as much as 4, which is twice as much as 2 but half as much as 8, and so on. The better you can think in terms of stops—of doublings and halvings—the easier managing exposure will be.

Aperture

The aperture is the size of the lens opening through which light travels to the film. The larger the opening, or aperture, the more light gets in. Lenses have a range of openings, called f-stops, with a typical sequence of f/2.8, f/4, f/5.6, f/8, f/11, f/16, and f/22, often with increments of one-third or one-half stop in between. The larger the number of the f-stop, the smaller the aperture. For example, an aperture of f/2.8 is a much larger opening, and thus lets in far more light, than an aperture of f/16. The f-stops form a doubling and halving scale; each successive f-stop lets in half the light of the preceding one, and twice as much as the next one. For example, f/4 lets in half as much light as does f/2.8; f/5.6 lets in half as much light as f/4; f/8 lets in half as much light as f/5.6; and so on.

In addition to determining how much light is let in through the lens to the film, the aperture selection also determines, in part, the depth of field, the zone in front of and behind the subject in which everything is in focus. The area in front of and beyond this zone will appear out of focus. How big you want the depth of field to be often dictates what aperture you choose when taking a photograph, as discussed in chapter 2.

As you decrease the size of the aperture by increasing the f-stop number, known as stopping down, the depth of field increases. For example, the depth of field increases when you stop down from f/5.6 to f/8, and is the greatest at f/22. As you increase the size of the aperture by decreasing the f-stop number, known as *opening up*, depth of field decreases. For example, the depth of field narrows when you open up from f/8 to f/5.6. To illustrate, **Photo 4-1,** taken with an aperture of f/5.6, has a shallow depth of field. As a result, the face of

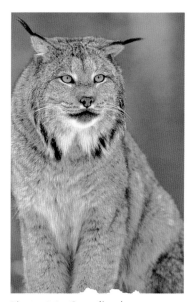

Photo 4-1: *Canadian lynx, Montana* (© Art Wolfe)

the lynx is in focus, but the background is not. **Photo 4-2,** taken with an aperture of f/22, has a large depth of field. The entire image, from foreground to background, is in focus.

Shutter Speed

A shutter is simply a curtain covering the film or distance sensor. When you press the shutter-release button, the shutter is opened for the length of time indicated by the shutter speed setting. The shutter speed determines the length of time that light is allowed to strike the film or sensor. Shutter speed settings typically range from 8 seconds or longer to 1/4000 second or less, with speeds of 4 seconds, 2 seconds, 1 second, 1/2 second, 1/4 second, 1/8 second, 1/15 second, 1/30 second, 1/60 second, 1/125 second, 1/250 second, 1/500 second, 1/1000 second, and 1/2000 second in between. Each shutter speed setting in this sequence represents a stop of light. That is, any given shutter speed lets in twice as much light as the next faster speed, and half as much light as the next slower speed. For example, 1/500 second lets in twice as much light as 1/1000 second, but half as much as 1/250 second. Or 1/60 second lets in almost twice as much light as 1/125 second, and half as much as 1/30 second.

Most cameras also have a *B* or *bulb setting,* which keeps the shutter open for as long as you hold down the shutter-release button, either manually or with a cable extension.

In addition to controlling how long light is allowed to strike the film, shutter speed also determines the effect of motion on your photograph. Slower shutter speeds let in more light and are therefore more useful in dimmer light. However, the longer the shutter stays open, the greater the effect that motion, either by the camera or the subject, will have on the image. Thus, photographs taken at slow shutter speeds, say 1/30 second or slower, may appear blurred if the camera or the subject was moving when you pressed the shutter-release button. Faster

Opposite, Photo 4-2: *Torres del Paine National Park, Chile* (© Art Wolfe)

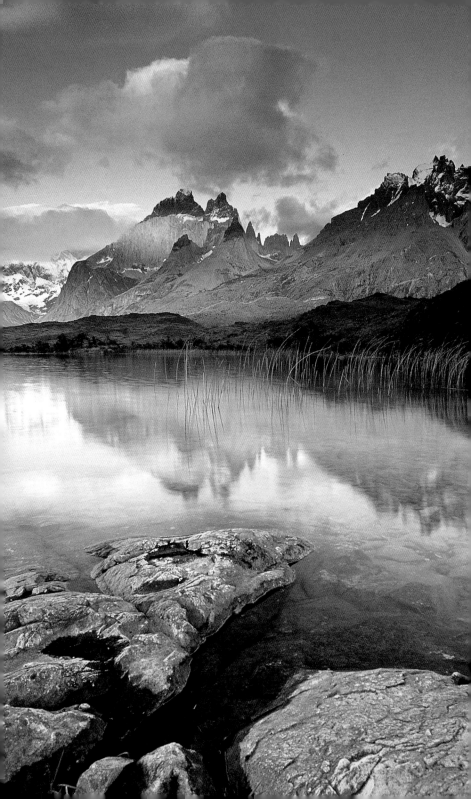

shutter speeds freeze motion, often producing sharper photographs, but let in less light. How you want, or do not want, motion to affect your photograph usually dictates the shutter speed that you select, as discussed in chapter 2.

Film Speed

Film is a light-sensitive medium that can record an image when its exposure to light is controlled. Film speed is the film's sensitivity to light, or how much light is needed to produce an image, and is indicated by the film's *ISO rating*, formerly called the ASA rating. (The acronym ISO stands for the International Organization for Standardization.) The higher the ISO rating, the more sensitive the film is to light, and the smaller the amount of light required to make the photograph you want. Films suitable for outdoor photography span a range from ISO 25 to ISO 400. A film with a speed of ISO 400 is four stops more sensitive than one of ISO 25. That four-stop difference translates to a sixteenfold difference in the amount of light needed to record an image. Slower films have lower ISO numbers, such as 25 or 50, and require more light. Faster films, with higher ISO numbers, such as 400, are more sensitive and require less light to make a photograph of the same scene. The stops in between are ISO 100 and ISO 200. There is also a film speed of ISO 64, which is one-third stop faster than ISO 50.

The sensors in digital cameras also have varying degrees of sensitivity to light, typically expressed as ISO or film speed equivalents. The higher the speed, the more sensitive the sensor is and the less light is required to make a particular image.

So why all the choices? Why not just use an ISO 400 film or digital setting all the time to make the process simpler? Unfortunately, there is a trade-off between speed, or sensitivity to light, and image quality. Faster films tend to be grainier and less sharp than slower film, but because they require less light, they allow you to shoot at faster shutter speeds. Slower films are sharper and less grainy but require more light, so they often require slower shutter speeds, which in turn require a tripod to avoid a blurred image.

The same is true in digital cameras: the more sensitive the camera is to light (the higher the ISO setting), the more noise (meaningless or extraneous digital information) is introduced when the digital sensor records the image. This noise reduces the quality of the resulting photograph, as will become apparent in a larger print.

Most professionals use as slow a film or digital setting as possible to maximize image quality, resorting to high-speed films such as ISO 400 in only the dimmest light. A medium-speed ISO 100 film often provides

the best compromise between speed and sharpness. Yet ISO 200 and 400 films can make excellent photographs. Today's ISO 400 films are comparable to ISO 100 films of the past, which were satisfactory at the time. Experiment with different film speeds or different ISO settings on your digital camera to decide what you like.

Reciprocity

The amount of light reaching the film or digital sensor in your camera, or the exposure, is determined by two variables, aperture and shutter speed for a given film speed ISO setting. Both are calibrated in stops, or doublings and halvings, and work together in a reciprocal relationship. That is, to get the same exposure, a change in one variable can be offset by changing the other variable an equal number of stops in the opposite direction. This relationship, called *reciprocity,* means that a variety of aperture-and-shutter-speed combinations can produce the same exposure. For example, a setting of 1/8 second and f/22 lets in the same amount of light as 1/30 second and f/11 or 1/125 second and f/5.6. All three combinations provide the same exposure.

This relationship is very useful in making exposure choices. Once you have an initial exposure setting, you just work in stops to get the combination of aperture and shutter speed that gives you the photograph you want. For example, suppose that you determine, by using your camera's light meter, that an exposure of 1/60 second and f/8 will provide the amount of light you want. You could increase shutter speed to 1/250 second, reducing by two stops the amount of light let in. To get the same exposure, you then must add back two stops of light by opening up the aperture from f/8 to f/4. Or you could stop down from f/8 to f/22, a three-stop decrease. To get the same exposure, you then add back three stops by decreasing the shutter speed to 1/8 second.

Deciding which combination of aperture and shutter speed to use, then, depends on the photograph you want. When you are more concerned about the effect of motion, as when shooting wildlife or action, first select the shutter speed that you want and then select the aperture that provides the correct exposure. If you are using automatic exposure, use shutter-priority mode, in which you select the shutter speed and your camera selects the aperture. When depth of field is more important, as when shooting landscapes, first select the aperture you want, and then the shutter speed. If you are using automatic exposure, then use aperture-priority mode, in which you set the aperture and the camera selects the right shutter speed.

For example, you want to photograph your camp and the surrounding peaks during a backcountry camping trip, as in **Photo 4-3**.

Photo 4-3: *Campsite, Southeast Alaska* (© Mark Gardner)

Using your camera's light meter, you determine that the correct exposure needed to make the image that you want is f/5.6 and 1/1000 second, which is great for freezing action. However, you decide that you need to maximize depth of field to ensure that all the peaks and the foreground are in focus, and that shutter speed does not really matter because the mountains are not going to move. Thus, you stop down—reduce the size of the aperture—from f/5.6 to f/22, which decreases by four stops the amount of light let in. To let in the amount of light you want, you simply decrease the shutter speed by four stops to 1/60 second. This combination lets in the same amount of light but provides the depth of field that you need.

Another example: you want action-stopping photographs of a group of mountain bikers pedaling in southern Utah, as in **Photo 4-4**. Using *exposure guidelines,* you determine an initial exposure, also called a base exposure, of 1/125 second and f/16. However, this shutter speed will not freeze the high-speed motion of the mountain bikers. It will result in a blurred photograph. To stop the motion, you increase the shutter speed to 1/500 second, which lets in two stops less light than 1/125 second. To get a correct exposure, you add two stops of light back by increasing the aperture to f/8. This combination provides the same exposure as the initial combination of 1/125 second and f/16, but gives

you the motion-stopping effect that you want. Photo 4-4 also illustrates the effect of distance when shooting action. The rear wheel of the bicycle on the left is slightly blurred from the motion, while the cyclists farther away from the camera are sharp.

Reciprocity is also helpful in determining what film speed you should use. For example, you are taking pictures of fast-moving white-water kayakers, and you decide that you need a shutter speed of 1/500 second to stop their motion. Unfortunately, it is a bit dreary out, so you would need an aperture as big as f/2 to get a proper exposure with ISO 100 film, but your lens has a maximum aperture of only f/4, two stops less than needed. How can you let in enough light and still use a fast shutter speed to get the action-stopping shots you want? Switch to a film that is two stops faster, a film that requires two stops less light to make the same photograph. The answer: use an ISO 400 film.

Photo 4-4: *Mountain biking, Utah* (© Mark Gardner)
To get this action shot, I lay on the ground, with a wide-angle lens on my camera, and had the mountain bikers ride past on both sides of me. The trick for this kind of shot is to shoot at a fast enough shutter speed to freeze the movement of the cyclists, and to have sufficient depth of field to ensure that all the riders and the landscape are in focus. So I pushed ISO 100 film to 200, which let me shoot one shutter speed faster, and set the aperture to f/16, which provided sufficient depth of field. (MG)

Unfortunately, if you have a completely automatic camera, like most newer film or digital point-and-shoot cameras, you have little control, if any, over these parameters. The camera reads the speed of the film you load in, and then it sets the aperture and the shutter speed according to its meter reading. Although this is often convenient, you lose a lot of creativity. Some automatic cameras do provide a menu through which you select the type of photograph you are taking, such as action, portrait, or scenic. This menu, in effect, provides you with some control over exposure choices. For example, if you select an action shot, the camera will pick a shutter speed fast enough to stop the action. Consult your camera's manual to learn how to make such choices with your camera.

Most SLRs and some point-and-shoot cameras allow you to set all three parameters: aperture, shutter speed, and film speed. Doing so can sometimes be more time-consuming, but it provides complete creative control over exposure. Newer SLRs often can also be used completely or partially automatically. Some cameras can automatically set the film speed by reading the bar code printed on the film canister; refer to your camera's manual. Some newer SLRs have a program mode, in which the camera sets both shutter speed and aperture, providing the convenience of a point-and-shoot camera but reducing creative control. In shutter-priority or aperture-priority mode, you select shutter speed or aperture, and the camera automatically sets the other variable, providing some convenience and, in some cases, all the creative control you may need.

EXPOSURE GUIDELINES AND LIGHT INTENSITY

A photograph is made with the light that the scene you are photographing reflects through your lens onto your film or digital sensor. Correct exposure lets in the right amount of this reflected light. To determine correct exposure, or a combination of shutter speed and aperture that will let in sufficient light for your film speed, you must determine the intensity of the reflected light that will reach your film. There are two ways to do this: by following exposure guidelines and by using your camera's light meter.

Exposure guidelines provide inexact but often useful combinations of shutter speed, aperture, and film speed for general light conditions, such as bright sun or heavy overcast. Your camera's light meter provides a more exact way to measure light intensity and gives you more precise creative control. However, exposure guidelines can be very useful when the situation might fool your light meter, when you do not have time to use the light meter, or when it is not working.

The Sunny–f/16 Rule

On a bright, sunny day just about anywhere in the world, the proper exposure for most front-lit subjects or scenes is an aperture of f/16 and the shutter speed nearest to 1/ISO, where ISO is the speed of the film in your camera. For example, if you are photographing a stand of red-leaved trees, using ISO 100 film, with the sun shining directly on them from over your shoulder, the correct exposure is f/16 and 1/125 second (the shutter speed nearest 1/100 on most cameras).

You can use reciprocity to find other combinations of aperture and film speed that let in the same amount of light let in by the combination of f/16 and 1/ISO. For example, with ISO 100 film, f/22 at 1/60 second, f/11 at 1/250 second, f/8 at 1/500 second, f/5.6 at 1/1000 second, and f/4 at 1/2000 second are all equivalent to f/16 at 1/125 second. Thus, if you want to freeze the motion of your subject, use an aperture of f/8 and a shutter speed of 1/500 second. If you want to maximize depth of field, use f/22 at 1/60 second.

The *sunny–f/16 rule* applies only to subjects that are medium in tone—that is, not too dark and not too light. A light-toned subject, such as a polar bear on snow or a seagull on a sandy beach, reflects more light than a medium-toned subject. Consequently, you have to reduce the amount of light reaching your film by one stop to get a proper exposure. The sunny–f/16 rule then becomes the light–f/22 rule—f/22 at 1/ISO, or any combination of aperture and shutter speed that lets in the same amount of light. For ISO 100 film, that would be f/22 at 1/125 second, or any equivalent combination, such as f/11 at 1/500 second.

Dark subjects, such as black bears or very dark rocks, on the other hand, reflect less light. Consequently, to get a correct exposure, you have to increase by one stop the amount of light reaching the film. The sunny–f/16 rule becomes the dark–f/11 rule—f/11 at 1/ISO, or any equivalent combination of aperture and shutter speed. For ISO 100 speed film, that would be f/11 at 1/125 second, or any equivalent combination, such as f/16 at 1/60 second.

The sunny–f/16 rule also applies only to front-lit subjects or to scenes with a bright sun shining directly on them. If the subject is sidelit, resulting in less light reflected to the camera, then add one stop of light to the sunny–f/16 exposure. The correct exposure at 1/ISO is then f/11. If the subject is backlit, with the sun behind the subject, then add two stops of light to the sunny–f/16 exposure. The correct exposure at 1/ISO is then f/8.

The sunny–f/16 rule really works as long as you can see distinct shadows. During the hours of full sunlight, just set the aperture and the

shutter speed according to the sunny–f/16 rule, remembering to make any necessary adjustments as described in the preceding paragraphs. For example, if you are photographing a camping trip with ISO 400 film, try exposure settings of f/16 at 1/500 second. If you are high in the mountains with a lot of bright snow and sky filling your viewfinder, try f/22 at 1/500 second. Or if you want a shot of your camping companions with the sun behind them, try f/8 at 1/500 second.

The sunny–f/16 rule does not work, however, if you cannot see distinct shadows. For example, if the sun is obscured by high clouds or your subject is in a shadow, then you must add more light for a proper exposure. **Table 4-1** gives the base exposure settings, under a variety of light conditions, for a scene that is mostly medium-toned.

table 4-1. exposure guidelines*						
Light Conditions	Shadows	ISO 100	ISO 400	Front Light	Side Light	Back Light
Sunny snow or beach	Distinct	1/125	1/500	f/22	f/16	f/11
Bright sun	Distinct	1/125	1/500	f/16	f/11	f/8
Hazy sun	Soft	1/125	1/500	f/11	f/11	f/8
Cloudy bright	None	1/125	1/500	f/8	n/a	n/a
Heavy overcast	None	1/125	1/500	f/5.6	n/a	n/a
Open shade	None	1/125	1/500	f/5.6	n/a	n/a

*Note: These guidelines are for a medium-toned subject well after sunrise and before sunset. Add one stop of light if the subject is dark; subtract one stop of light if the subject is light.

• • •

You can use the table for other film speeds. Set the shutter speed nearest 1/ISO, and use the same aperture settings dictated by the light conditions. For example, use a shutter speed of 1/60 second for ISO 50 or 64 film, and 1/250 second for ISO 200 film. Use reciprocity to determine other combinations of aperture and shutter speed that produce the same exposure but provide the depth of field or the motion effect that you want.

Guidelines for Low Light

Most light meters are not sensitive enough to take readings in very *low light*. Use the exposure guidelines shown in **Table 4-2,** and bracket your shots (bracketing is discussed later in this chapter). Remember to

work in stops, using reciprocity, if you need to use a shutter speed or an aperture different from the one given in the table.

table 4-2. exposure guidelines for low light *	Film Speed	
	ISO 100	ISO 400
Subject	Shutter Speed–Aperture	
Dawn and dusk	1/8–f/8	1/30–f/8
Sunrise and sunset	1/30–f/8	1/60–f/11
Skyline at dusk	1/15–f/5.6	1/30–f/8
Subjects lit by campfires	1/2–f/4	1/15–f/4
Moonlit landscapes without moon	8 min–f/4	2 min–f/4
Moonlit snowscapes without moon	4 min–f/4	1 min–f/4
Full moon with telephoto lens	1/125–f/8	1/500–f/8
Quarter moon with telephoto	1/60–f/5.6	1/125–f/8
Aurora borealis	1 min–f/4	1/15–f/4
Well-lit street scene at night	1/8–f/4	1/30–f/4
Lightning	B–f/5.6	B–f/11

*Note: These are rough estimates. Bracket these settings with exposures one-half to one stop higher and lower.

Using exposure guidelines is an inexact art. You may want to bracket your exposures by one-third or one-half stop on each side of the listed exposure to ensure that you get a correct exposure. For example, if the base exposure is 1/125 second at f/8, then shoot another frame halfway between f/5.6 and f/8, and a third halfway between f/8 and f/11. If you notice that you are consistently over- or underexposing your photographs, try adding or subtracting one-third or one-half. Over time you will develop a feel for the guidelines and will learn what adjustments you have to make under different light conditions and for subjects with different tones to get the exposure you want.

If your camera has a light meter, use it. However, these guidelines are the only way to choose an exposure when your light meter is not working. They are also useful in situations when your light meter might be fooled, which happens more often than you might think. These include extreme backlighting, low light, and scenes filled with a lot of contrast, as on bright, sunny days.

These exposure guidelines are also useful when you are photographing fast action with no time to determine exposure. They work especially well for *print film* because of its wide exposure latitude, which allows you to vary the exposure by one to two stops and still get a correctly exposed

print. Exposure guidelines do not work well under rapidly changing light conditions, for photographing very small subjects, in early morning or late evening, or for precise control of exposure.

METERING TO MEASURE LIGHT INTENSITY

Your camera's light meter provides a better way to estimate the intensity of light than do exposure guidelines in most situations. Used properly, it provides you with the information you need to make better decisions about exposure settings. However, if you do not use the meter properly or do not properly interpret what it is telling you, you often will not get the photograph you wanted. Once you understand where to point your camera to take a meter reading, and what that reading is telling you, you can choose the exposure setting that will give you what you want.

How the Camera's Light Meter Works

All in-camera light meters work by measuring the light reflected from the scene at which the camera is pointed. This reflected light travels through the lens (abbreviated TTL) to the light meter, which, because it measures the light coming through the lens, measures the same light that will fall on your film after you press the shutter-release button. Once your meter has measured this reflected light, you or your camera selects a shutter-speed-and-aperture combination that matches the light level determined by your meter to provide a correct exposure. Consult your owner's manual to learn how this works with your particular camera. From this base exposure, you may adjust the shutter speed and the aperture, depending on how you want motion and depth of field to affect your photograph, as discussed earlier.

Because the meter measures reflected light, the meter reading depends on the overall intensity of the light striking the scene and on the tone of whatever is filling the viewfinder. A meter reading on a bright, sunny day will be very different from a reading on a darker, overcast day. Pointing your camera at something that is very dark, like the fur of a black bear, will result in a very different reading from pointing it at something that is very light, like fresh snow—even when the intensity of the light falling on those objects is the same.

There are three basic types of meters: *center-weighted meters,* spot meters, and matrix meters, also called *evaluative meters.*

Center-weighted meter. This type of meter assigns more importance to the light in the center of the scene, usually outlined by a large circle in the middle of your viewfinder, than the light from the surrounding area. Center-weighted metering works best when you can fill the viewfinder or that circle with the same tone or a simple mix of tones.

Spot meter. A spot meter reads only a very narrow area in the center of the scene and ignores the surrounding area. Spot metering is best when you want to take a reading from one object or a particular area within the scene. It provides the most creative control and is widely used by professional photographers.

light meters

When using your camera's light meter, remember:
- Whatever fills the middle of your viewfinder will dominate the meter's light reading.
- Whatever dominates the light reading will be seen by your light meter as a medium tone. It will try to turn light and dark objects to medium tones.

Matrix or evaluative meter. This type of meter reads the middle area much as a center-weighted meter does, but it also divides the surrounding area into zones that are evaluated in relation to each other and to the middle area. Matrix or evaluative metering is best when light conditions are changing rapidly or the mix of tones is complex and contrast is high, as well as when using fill flash.

• • •

Most older cameras have some form of center-weighted metering. Most newer automatic SLR cameras have a center-weighted metering mode, a matrix or evaluative mode, and sometimes even a spot-metering mode. Most automatic point-and-shoot cameras have some type of matrix or evaluative meter. Review your camera's manual to understand exactly how your camera's light meter evaluates a scene.

Regardless of the type of meter that you have, whatever is filling the middle of your viewfinder will influence the meter reading the most. If your subject is in the middle of the scene and fills most or all of the viewfinder, it will dominate the reading. If, however, it takes up a small part of the viewfinder and is off center, the background will dominate the reading. To use your camera's meter reading to get a correct exposure, you have to pay attention to the tone of whatever is filling up the center of your viewfinder.

Light meters should really be called "gray meters." They are all calibrated to read a *medium tone,* one that is neither dark nor light but right in the middle. In a tonal range from white to black, this would be medium gray. In nature, a gorilla's fur would be a very dark to black

tone, as in **Photo 4-5**. Fresh snow, as in **Photo 4-6,** would be a very light to white tone. The gray bark of a tree, as in the foreground of **Photo 4-7,** would be a medium tone.

Any color can be medium-toned, neither very dark nor very light. For example, the blue midnight sky is a very dark tone, the blue sky adjacent to the sun at noon is a very light tone, and the northern blue sky at midmorning is a medium tone. The medium-toned gray tree bark gives about the same meter reading as the medium-toned blue northern sky.

Because of this medium-tone calibration, your camera's light meter will not necessarily determine the correct exposure. It only determines the exposure that will make the scene medium-toned, regardless of whether the scene is filled with darker or lighter objects. If the scene you are photographing, or at least the part filling up the center of your viewfinder, is mostly medium-toned, the exposure determined by your light meter will result in a photograph that looks about like the scene itself. If the subject or scene is very dark, as in Photo 4-5, your light meter will suggest an exposure that makes it look medium-toned. The resulting photograph will be overexposed; black objects will appear gray, not black. If the scene is mostly very light, like the snow-covered scene in Photo 4-6, your light meter will again suggest an exposure that makes it look medium-toned. The resulting photograph will be underexposed; the snow will look gray, not white.

Photo 4-5: *Mountain gorillas, Parc National des Volcans, Rwanda* (© Art Wolfe)

Metering on the Subject

Taking a meter reading is often referred to as metering. There are two ways to take a meter reading. In the first, you simply point the camera at the subject or the most important part of the scene, centering it in your viewfinder, which means that you are "metering on the subject." If you have a spot meter, this

approach is easy; simply take a reading when the small inside circle in the viewfinder is on the object. For other types of meters, fill as much of the viewfinder as possible with the subject. If your subject does not fill up much of the viewfinder, your meter will primarily measure the light reflected from the background. To get a valid meter reading, fill the viewfinder by moving in closer, zooming in, or switching to a longer lens.

Once you have a meter reading and have determined exposure, return to your shooting position, zoom back out, or switch back to the original lens. If you do not want the subject or the most important part of the image to be in the center of your photograph, move the camera into its final position after you have taken a reading and determined exposure. If you are using automatic exposure (AE), lock the exposure setting before repositioning your camera (see your camera's manual).

After you have metered on your subject, you then must determine the subject's tone. If it is medium-toned, like the lynx in Photo 4-1, then you simply set the exposure indicated by the light meter and fire away. If not, then you must adjust the exposure by using exposure compensation.

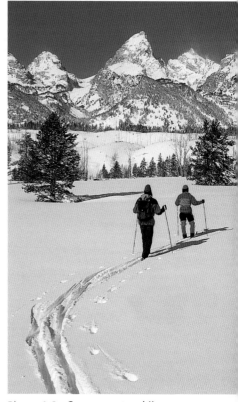

Photo 4-6: *Cross-country skiing, Teton National Park, Wyoming* (© Mark Gardner)

TIP

To create a silhouette, meter on the sky on either side of the subjects that you want silhouetted.

Exposure compensation. Exposure compensation is an increase or decrease in exposure to adjust for the calibration of your camera's light meter. Not adjusting for the meter's calibration is a common cause

Photo 4-7: *Penan hunters, Sarawak Rain Forest, Borneo* (© Art Wolfe)

of bad photographs. You adjust for your camera's "gray-meter" calibration by adding light to light and dark to dark. That is, for subjects or scenes lighter than medium tone, like the snowy scene in Photo 4-6, you add light by using a slower shutter speed, bigger aperture, or both. For subjects or scenes darker than middle tone, like the gorillas in Photo 4-5, you subtract light by using a faster shutter speed, smaller aperture, or both.

Table 4-3 provides exposure compensation guidelines for *slide film*, which can record only a five-stop tonal range. Simply add or subtract stops as indicated by the table, depending on the tone of whatever is filling up the center of your viewfinder. Double the adjustments when shooting with print film, which works differently from slide film. For example, instead of adding one stop when photographing a light tone, add two stops.

table 4-3. exposure compensation guidelines			
Tone Filling the Viewfinder	**Number of Stops to Add or Subtract**	**Shutter Speed**	**F-stop**
White	+> 2 stops		
Very light	+ 2 stops	1/30 second	f/4
Mostly light	+ 1½ stops		
Light	+ 1 stop	1/60 second	f/5.6
Partly light	+ ½ stop		
Medium	0 stops	1/125 second	f/8
Partly dark	− ½ stop		
Dark	− 1 stop	1/250 second	f/11
Mostly dark	− 1½ stops		
Very dark	− 2 stops	1/500 second	f/16
Black	−> 2 stops		

There is, however, one caveat. Few subjects in nature are completely white or black. In the terms of Table 4-3, most white subjects are really "very light," and black subjects "very dark." Shadows define the detail in very light subjects, while highlights do the same in very dark subjects. If you want to capture this detail, such as the texture of the snow or the swan's individual feathers, when using slide film, then do not use more than two stops of exposure compensation. Sometimes one and a half stops is even better. Use two or more stops only when you want the subject to be a completely white or black shape, as when you are creating silhouettes.

Exposure compensation can be achieved by changing the aperture, opening up or stopping down, when you do not want shutter speed to change. For example, if you are metering on the fur of a dark brown bear and the meter indicates a base exposure of f/5.6 at 1/125 second, then subtract light by decreasing the aperture by one stop to f/8.

Alternatively, you can change the shutter speed when you do not want depth of field to change. For example, if you are photographing a snowscape, as in Photo 4-6, and your meter indicates an exposure of f/22 at 1/60 second, then reduce the shutter speed to 1/15 second, adding two stops of light to ensure that the snow will be white in your photograph.

You can also adjust both aperture and shutter speed to obtain the appropriate exposure compensation. For example, to subtract one and a half stops of light from a base exposure of f/16 and 1/125 second, you could subtract one stop by increasing the shutter speed to 1/250 second and subtract the other half stop by reducing the aperture to a size halfway between f/16 and f/22.

You can also adjust your camera's ISO setting, increasing it to subtract light and decreasing it to add light, and meter as you normally would. For example, increasing the setting from 100 to 200 effectively subtracts one stop of light, and decreasing it from 100 to 50 adds a stop of light. Remember to reset the ISO setting for the film speed you are using when you do not need exposure compensation.

Use your camera's automatic exposure compensation capability, if it has one, when you want to make an adjustment for a series of shots. If you use a fully automatic point-and-shoot camera, this may be the only way to use exposure compensation. Again, do not forget to reset the exposure compensation when it is no longer needed. Refer to your camera's manual.

How much exposure compensation is needed depends, to some extent, on your camera's light meter or on the type of meter you are

using, if your camera offers more than one type. These guidelines are most appropriate when using center-weighted and spot meters, especially when only one tone fills the center of the viewfinder. A different exposure compensation may be needed when using matrix or evaluative meters, which compare different areas within the viewfinder to determine exposures. If you have this type of meter in your camera, consult your owner's manual for the manufacturer's recommendations, and experiment to see what works.

Metering on a Medium Tone

In the second way to take a meter reading, meter on a medium-toned object or a medium-toned area that is in the same light as the subject or the most important part of the scene. Simply point your camera at that object or area, filling the viewfinder as much as possible, then determine the exposure you want. When you meter on a medium tone, all the lights and darks will appear as they should, or as you wanted them, and no exposure compensation is needed.

An object in the scene. Finding a medium tone outdoors is usually easy. Most tree bark, vegetation, animal fur, the northern blue sky about forty-five degrees above the horizon, and rocks are more or less medium tone. For example, the big tree in the foreground of Photo 4-7 is a medium tone, and the rest of the scene, which is a bit darker than medium tone, is in the same light. Thus, you can meter on that tree, set the exposure, and then recompose to photograph the scene you want.

A gray card. A small *gray card* available in photography stores may also be useful, but it is not always convenient to carry or to use on outdoor trips. To meter, simply hold or place the card in the same light as your subject, point the camera at the card, filling the viewfinder, and determine exposure. However, the light reading from a gray card can change, depending on the card's angle to the sun's rays. So follow the directions that come with the card on how to hold it.

A calibrated object. You can also meter on an object that you have calibrated to medium tone by taking meter readings on the object and a gray card in the same light. Just about anything that you frequently take with you on trips, such as a jacket, a pack, or another item made of fleece, wool, or cotton, will work, as long as it is in the same light as your subject when you take a meter reading. Avoid things made of shiny materials, such as coated nylon or metal, as well as things that are very dark or very light.

To determine the object's tone, take meter readings on both it and a gray card in the same light. If it gives the same meter reading as the gray card, then it has a medium tone. On trips, meter on that

object, making sure that it is in the same light as your subject, and simply use the meter reading as is. No exposure compensation is necessary. If the object is lighter or darker than medium tone, then add or subtract the appropriate exposure compensation. For example, if you are metering on a fleece jacket that you have calibrated to be one-half stop darker than medium tone, then subtract one-half stop from your meter reading to get a correct exposure. If your meter suggests f/5.6 and 1/125 second, set the aperture to an opening half-way between f/5.6 and f/8.

metering

Metering your subject:
- Fill viewfinder with subject or most important part of the scene
- What tone is filling the middle of the viewfinder?
 - If *medium*, use your light meter's exposure settings
 - If *light*, add light by decreasing shutter speed or increasing aperture
 - If *dark*, subtract light by increasing shutter speed or decreasing aperture

Metering a middle tone:
- Fill viewfinder with a medium tone in the same light as your subject
- Use your light meter's exposure settings

You can also use the palm of your hand. Most people's palms, regardless of race, are approximately one stop lighter than medium tone. Fill your viewfinder with the palm of your hand, holding it in the same light as your subject, and take a meter reading. Because it is one stop lighter, add a stop of light to your meter's reading to get a correct exposure. If your meter suggests f/5.6 and 1/125 second, then add a stop by increasing the aperture to f/4 or decreasing the shutter speed to 1/60 second. Without this adjustment, your hand would appear darker than it really is in the resulting photograph. If your palm seems lighter or darker than most, simply compare a meter reading on your palm with one on a gray card in the same light, then apply that amount of exposure compensation.

This substitute-metering approach has several advantages. First, you get to choose the tone that you want to be medium in your photograph. Thus, it provides more creative control. Second, your light measurement is more accurate in high-contrast situations, such as extreme backlighting,

that could fool your light meter. Third, it is often easier; you just have to find something that is medium-toned and big or close enough to fill your viewfinder. It does not even have to be in your photograph. As long as it is in the same light as your subject, you meter, set exposure, and then move your camera back into position to get the shot you want. Again, if you are using automatic exposure, lock the exposure setting before repositioning your camera (see the owner's manual).

Metering is now a simple matter of choosing where to point your camera. You do not have to take a meter reading from the scene that will become your photograph. In fact, often you will not want to.

For example, say you want to photograph your climbing team on the summit of the peak you have just climbed. You want to show their exuberant faces as well as the surrounding alpine scenery. You frame your shot with a partly cloudy sky in the upper third of the frame, bright snow-clad peaks in the middle third, and your sunlit climbing partners in the bottom third. Your camera's light meter reading will probably be dominated by the bright snow and cloudy sky. Because your meter wants to make everything gray, if you use the meter reading from this scene to set the exposure, the snowy peaks will be gray instead of white, and your friends' faces will probably be unrecognizably dark or underexposed.

To get a reading that will give you the results that you want, point your camera at your friends, moving in closer or zooming in if necessary. If they are more or less medium-toned, you simply use the meter's reading. If not, then use exposure compensation for the differences in tone by adding or subtracting light. Once you have your reading and exposure set, reposition the camera to take the shot you want. Alternatively, you can meter on some nearby gray rocks that are in the same light as your companions, set your exposure, and reposition your camera for the shot. Again, if you are using automatic exposure, be sure to press the AE lock before repositioning your camera.

Finding a Medium Tone

To take useful light readings, both you and your camera's light meter must be able to read a medium tone as a medium tone. If your pictures are consistently under- or overexposed, either you or the meter is not properly calibrated.

Learning to read a medium tone. To calibrate yourself, you must learn to recognize a medium tone when you see one and, when there is no middle tone, to tell how much darker or lighter than medium a particular tone is. Several exercises can help you do this.

- Take meter readings from a gray card or some other medium-toned object, such as the blue northern sky about forty-five degrees above

the horizon at any time between midmorning and midafternoon. Compare them with readings from various tones that are in the same light as the gray card or, if you are using the northern sky, that are fully lit by the sun.

- Shoot a series of pictures in which you meter what you think is a medium tone. Take one photograph at the exposure suggested by your light meter, then one at one-half stop under that exposure, then one stop under, one-half stop over, and one stop over. Then compare the five photographs to see if what you thought was medium-toned actually was. You can repeat this exercise for light and dark tones to get a feel for how much lighter and darker they are than a medium tone.

- Take notes in the field on what you metered when you took a particular photograph and on the exposure settings, which are meaningless unless you know how you metered the scene. Eventually you will develop a good feel for what is a medium tone.

• • •

When photographing outdoors, examine the scene you are shooting, looking for the darkest tone that is in the same light as your subject. Then find the lightest tone in the same light as your subject. These now represent the endpoints of a tonal scale for that scene. Finally, look for a tone that appears to be about halfway between the two end tones, and meter on it. For example, in **Photo 4-8,** the ice in the foreground and the snow on Everest are the lightest tones, the rocks in the foreground and the shadow in the left background are the darkest tones, and the river rocks in the middle are in between the two. This method is essentially how most matrix or evaluative light meters work. They compare the tones of different zones or segments in the scene that fills the viewfinder. If you have a spot meter, you can easily compare the tones yourself and exercise greater creative control than you could with a matrix meter.

Calibrating your camera's light meter. Camera light meters are often inaccurate even though they were calibrated by the manufacturer. But then, so was your car's gas gauge. When it reads empty, you know from experience that you still have, for example, an eighth of a tank left. So you make that mental adjustment and keep on driving. Likewise, you need to know how far from medium tone your light meter reads so that you can make any adjustment needed for a correct exposure, especially when using slide film. Small deviations from a medium-tone calibration can have a big impact on slides but a relatively small impact on print film

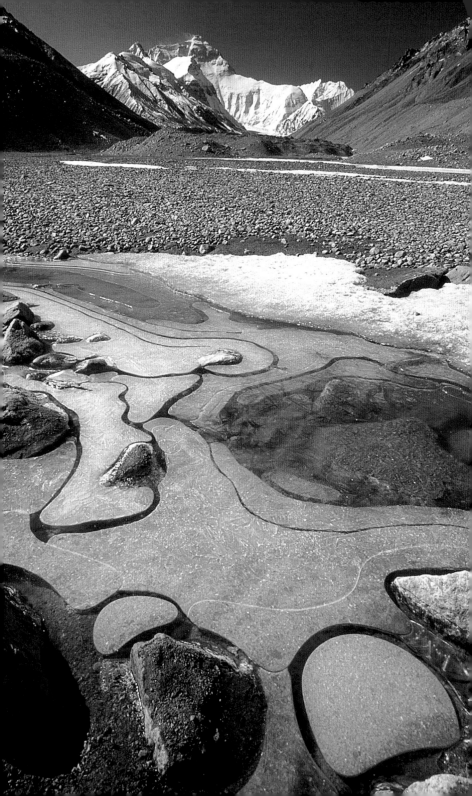

or digital images because the proper tones can be restored when printing the image.

To calibrate your camera's meter, use the sunny–f/16 rule. On a bright sunny summer morning, position a gray card, or any other medium-toned object, directly in the sunlight. With the sun shining over your shoulder onto the gray card, point your camera at the card, filling the viewfinder. If your camera is loaded with film, set your shutter speed to the setting nearest 1/ISO. For example, with ISO 50 film, set the shutter speed to 1/60 second, or with 1SO 100, to 1/125 second. If your camera is not loaded with film, set your film speed to ISO 64 and the shutter speed to 1/60 second.

Now, set the aperture to f/16. If your camera's meter indicates that this is the correct exposure, then your meter is properly calibrated. If not, then adjust your film speed (ISO) until a correct exposure is indicated. Your meter is off by the number of stops you had to adjust the film speed to get a correct exposure at an aperture of f/16.

To compensate, simply make the same adjustment whenever you load your camera with film. For example, with ISO 64 film, suppose you reduced the film speed to ISO 50 to get a correct exposure at f/16. That means your meter is off by one-third stop. You should reduce the film speed by one-third stop whenever you take pictures. For ISO 50 film, set the film speed to ISO 40; for ISO 64 film, set it to ISO 50; for ISO 100, set it to ISO 80; and so on. For an even more precise calibration, repeat the exercise with all the different films that you use, because your camera may need to be adjusted differently for each one.

Situations That Fool Your Camera's Light Meter

Your camera's light meter is easily fooled in some situations. For example, sunny, high-contrast scenes filled with well-lit areas—called highlights—and dark shadows often provide meter readings that will not produce the photograph you want. Depending on how you take the meter reading, highlights can become glaring white areas and dark shadows can become dense black areas in your photograph. When photographing such scenes, keep the limitations of your film in mind when metering and determining exposure. Film and digital cameras cannot record the full range of light found in such high-contrast scenes.

As a general guideline, when shooting with slide film, meter on an object or area in the well-lit part of the scene, a technique referred to as

Opposite, Photo 4-8: *Mount Everest from Rongbuk Valley, Tibet* (© Art Wolfe)

metering the highlights. This eliminates any bright white spots or areas in your photograph that will detract from your composition and lets the shadows turn very dark to black. For example, the well-lit peak in the distance on the cover of this book is such a highlight. To determine exposure, meter that peak with a spot meter, probably adding one-half to one stop of light to the reading. If you metered the entire scene with a *matrix meter,* the rest of the scene would be more medium toned, and the background peak would be overexposed.

With print film, do the opposite: meter the shadows. As long as you do not burn out the highlights completely, the printing process usually produces a photograph that looks about right, although you may have to work with the printer to get exactly what you want.

Images made with digital cameras tend to behave more like print film. So, generally, meter the shadows, although metering the highlights may also work with your particular camera.

Other situations may also fool your camera's light meter. Backlighting, especially when the subject is dark against a much brighter background, can skew the meter reading, even if the subject is right in the middle of the viewfinder. To compensate, add two or more stops of light, or meter only your subject by moving in close, zooming in, or using a spot meter, if your camera has one.

A well-lit subject against a very dark background may also fool the meter, especially if the subject is very light-toned, such as the fly fisherman against the dark background in **Photo 4-9**. The dark background may dominate the meter reading. To compensate, subtract one to two stops of light, or move in close for metering. If Photo 4-9 had been taken using the exposure determined by the camera's light meter, the resulting image would be an overexposed fisherman against a medium-toned background.

Fog, mist, and precipitation can also play tricks on your meter, which may read the light reflecting from the fog rather than the subject. To compensate, add a stop to your exposure determination, depending on how bright the fog is. Or move in close to meter or spot-meter an object not covered by the fog.

Readings from matrix or evaluative meters may also be skewed when a small portion of the viewfinder is very bright or very dark in comparison with the rest of the scene. For example, when you are photographing a rock climber on dark rock, a cloudy, bright sky filling the upper corner of the viewfinder may skew the meter reading enough to underexpose the climber. To get a correct reading, point the camera at the subject, eliminating the sky from the viewfinder. Then move the camera back into position to get the shot you want.

Photo 4-9: *Fly fishing, Idaho* (© Mark Gardner)
While on a fly-fishing float trip in Idaho, I wanted to get a shot that isolated a casting fisher and the brightly colored fly line. So I positioned the caster facing the sunlight and in front of a cliff that was in shadow. Using a spot meter, I then metered the palm of my hand, which I held in the same light and at the same angle as the fisher's face. I then set the exposure, adding a stop of light (because my palm is a stop lighter than a gray card) and setting the shutter speed to freeze the fly line. I checked my exposure to ensure that the background would be dark in the resulting image. (MG)

EXPOSURE IN LOW LIGHT

Early morning, twilight, overcast skies, deep shadows, forest interiors, and other low-light situations often provide a quality of light that produces great images. However, the relatively low light levels during these periods create problems that complicate the exposure puzzle. Shutter speeds may have to be too slow to freeze the action of a moving subject or even to hand-hold your camera. In fact, shutter speeds may be so slow that normal exposure rules no longer apply, especially when using small apertures to maximize depth of field. In addition, light meters may not be sensitive enough to measure such low levels of reflective light. Thus, determining exposure requires you to play tricks with your light meter or to use exposure guidelines.

For example, **Photo 4-10** was taken well after sundown. Determining the right exposure was tricky because of the low light level at

Photo 4-10: *Pinnacles, Nambung National Park, Western Australia* (© Mark Gardner)

dusk. Ensuring that the entire scene was in focus required an aperture setting of f/22, which in turn meant a very slow shutter speed to let in enough light. But the resulting image has a special character that made the effort worthwhile.

Slow Shutter Speeds

At lower light levels, for a given aperture, you may have to use shutter speeds too slow to stop the movement of your subject or your camera. This problem is frequently encountered with slower but sharper films. Even in relatively bright conditions, as on a cloudy bright day or in the shadows on a sunny day, there is just not enough light to use fast shutter speeds with such slow films. If subject motion is not a problem but the required shutter speed is too slow for you to hand-hold the camera effectively, then use some form of camera support, such as a tripod, and a cable release.

Really slow shutter speeds. Shutter speeds of 1 second or more, often required before sunrise and after sunset, result in reciprocity failure; that is, normal exposure rules no longer apply. Determining exposure by normal means results in underexposed images. To counteract reciprocity failure, add one-half to one extra stop of light to get a correct exposure. As a general rule, add one-half stop for 4- to 8-second exposures and one stop for exposures longer than 8 seconds. For more exact adjustments, follow the film manufacturers' guidelines on reciprocity failure, which are usually available with the film or at camera stores. For shutter speeds of many minutes or hours, do not worry about compensating for reciprocity failure.

In addition to reciprocity failure, many films also show a subtle color shift, especially with very long shutter speeds of many minutes

or hours. Film manufacturers suggest color-correcting filters to counteract this shift. Consult their technical data to learn which filter to use. However, for most outdoor photography, do not worry about using such filters. In fact, these color shifts can create some interesting effects.

Increasing shutter speed. If, however, you want to stop subject motion, then you have to shoot at a faster shutter speed. According to the reciprocity relationship, the only way to do that when there is not enough light is to reduce the amount of light required by the film to make the image that you want. That is, you have to shoot at a faster film speed, or higher ISO number. There are two ways to do this.

First, you can switch to a faster film. If an ISO 50 film is not fast enough, switch to an ISO 100 film, which allows you to double your shutter speed. If that is not enough, try ISO 400, which is three stops faster than an ISO 50 film. However, faster films are not as sharp as slower films, so you may not want to use them, or you may not have any faster film with you.

Second, rather than switching to a faster film, you can *push* the film you have. Set the film speed on your camera to the next highest whole-ISO number, which buys you an extra stop of light, or the next higher shutter speed. Then, when you have your film processed, specify a one-stop push. The lab will then process the film as if it were a one-stop-faster film. For example, to push ISO 100 film one stop, set the ISO to 200 on your camera and specify a one-stop push at the lab that will process it, and it will be processed as if it were ISO 200. Most slide films can be pushed one stop with excellent results. Some can even be pushed two stops; experiment to see what works. Pushing your film one to two stops buys you an extra shutter speed setting or two, but may result in some increase in contrast and graininess, although usually less than that exhibited by a faster film.

With digital cameras, simply increase the ISO setting on your camera if it has that capability. But, as with pushing film, shooting at a higher ISO setting may result in images of lower quality, which could become apparent in larger prints.

Metering in Low-Light Situations

When you want to maximize depth of field, you determine exposure by first selecting a small aperture, such as f/16 or f/22, and then taking a meter reading to determine what shutter speed to select for a correct exposure. However, in low-light situations, the required exposure time may be longer than the slowest shutter speed available on your camera. Your meter cannot measure such a low level of light.

To determine shutter speed, use reciprocity. First, open up to the largest aperture, take a meter reading, and adjust your shutter speed for a correct exposure. Next, stop back down to the desired aperture, counting the number of stops between the widest aperture and the final aperture. Finally, decrease the shutter speed by that number of stops, adding additional stops as needed for reciprocity failure.

For example, at an aperture of f/2.8, you meter and determine that a shutter speed of 1 second provides a correct exposure. You then stop down to f/22, subtracting six stops of light. To end up with a correct exposure, you must add back six stops by using a shutter speed of 60 seconds. Because of reciprocity failure, you must also add another stop of light, making the appropriate shutter speed 2 minutes. If that is slower than the slowest speed on your camera, set the shutter speed to B, and use your watch to measure 2 minutes.

If you still cannot determine exposure, use the same method, but meter on something lighter than a medium tone. For example, to get the correct shutter speed, meter on your hand and add one stop, or meter on a white tee shirt and add two stops, again adding any additional stops as needed to counteract reciprocity failure.

If that still does not work, adjust the ISO rating to a higher number, take a meter reading, reset to the correct ISO, and reduce the shutter speed by the number of stops between the ISO rating at which you metered and the correct ISO, adding any additional stops to counteract reciprocity failure. If you use this approach, be sure to reset the ISO rating correctly.

MULTIPLE EXPOSURES

Shooting multiple images on the same frame of film can produce some interesting effects, such as putting a moon into a scene or creating a surrealistic collage. When shooting multiple-exposure images in which one image will overlay a black area on the other image, expose each image normally. For example, when placing a full moon from a dark sky above a landscape with a black sky, shoot the moon, positioned high in the frame, at 1/125 second at f/8 for ISO 100 film. The moon will be properly exposed and the sky below the moon, where the landscape will be in the second image, will be black because there was insufficient light to expose the film. Then reposition the camera with the landscape at the bottom of the frame and plenty of black sky above. Determine the exposure for the landscape, and shoot the second image.

However, when shooting overlapping multiple-exposure images, you must give each shot less exposure than if it were a single image. The more images, the more the exposure must be reduced for each individual shot, as shown in **Table 4-4**. To get a correct exposure, first

determine an exposure for the scene as you normally would. Then decrease that exposure by the number of stops indicated in the table for the number of images that you plan to shoot on the same frame.

table 4-4. exposure compensation for multiple exposures		
Number of Images	Number of Stops	ISO Change
1	0	100
2	– 1	200
3	– 1½	320
4	– 2	400
5	– 2¼	500
6	– 2½	640
7	– 2¾	n/a
8	– 3	800

For example, if the exposure to shoot a single image of a flower field would be 1/125 second at f/8 with ISO 100 film, then to shoot four images on the same frame, the correct exposure for the flower field would be two stops less, 1/250 second at f/11 or an equivalent exposure.

Alternatively, you can multiply the ISO number of the film in your camera by the number of exposures you plan to take. Adjust the ISO on your camera to the setting closest to this number (see Table 4-4), determine exposure as you normally would in either manual or automatic mode, and fire away. Be sure to reset to the correct ISO when you have finished shooting multiple exposures. For example, to shoot four exposures on the same frame with ISO 100 film, set the ISO on your camera to 400 (four times 100), determine exposure, and shoot.

Multiple exposures cannot be made "in camera" with digital cameras, but can easily be done by combining digital images back home with a computer.

WHEN TO BRACKET

Bracketing, or taking a series of shots under and over the initial exposure you determined to be correct, is often pooh-poohed by more technical-minded photographers, overused by many less skilled snapshooters, and highly recommended by film manufacturers. While bracketing should not replace a working knowledge of determining and controlling exposure, it can be very useful in two situations, especially with slide film. With print film, bracketing is usually unnecessary because the negative can be printed in several ways as if it were shot at different exposures.

For a golden opportunity. When you have the shot of a lifetime, and you are not quite sure what the best exposure should be, bracket. If you have spent a lot of time, effort, or money to photograph a glorious sunrise in a faraway place, bracketing is cheap insurance that you will indeed have the best image possible when you get back home. If you encounter a yeti in the Himalayas, or any other truly remarkable subject, bracket. A bad shot of a yeti will be valuable; a great shot will be priceless. Film is cheap compared with the cost of not getting the most out of opportunities like these. But do not overdo it; save some film for the next golden opportunity.

For different effects. When you want to create multiple images of a scene, with different effects or looks, bracket. In many situations, different exposures of the same scene can result in images with very different moods or messages. For example, take a series of sunset or sunrise shots, using a range of exposures from two stops under to two stops over. Then compare the results to see the different effects. Increasing the exposure may result in softer, pastel colors, which are often more restful and cheerful. Decreasing the exposure will give darker, bolder colors, often more dramatic or somber. With a backlit subject, an exposure less than your meter indicates will produce a silhouette, whereas an exposure greater than the meter indicates will produce a normal-looking subject against a bright background. Both photographs will acceptably represent the same subject, but they will produce quite different reactions from viewers.

However, there are many other situations in which the correct exposure works, but even one-third of a stop under or over looks terrible. For example, people, animals, plants, or other familiar objects will look normal, as viewers would expect them to look, in photographs taken with the correct exposure. However, such subjects often will not look natural if they are much darker or lighter than expected. In these cases, determine correct exposure, and save the extra film for additional correctly exposed shots of the same scene from different points of view.

Opposite: *Mustard flowers in a vineyard, Carcassonne, France*
(© Mark Gardner)

C areful use of your camera gear in the field is critical to making great photographs. Even the best composition with a correct exposure will make a lousy picture if you do not handle your gear properly. On the other hand, using your gear to its best advantage often makes the difference between a mediocre photograph and an excellent one. Pleasing composition, the right light, appropriate exposure, and careful field technique add up to excellent photography. This chapter covers a variety of techniques, tips, and guidelines for working with your equipment to get the sharpest, highest-quality pictures possible, ones that you can enlarge and display proudly.

TAKING YOUR CAMERA ALONG

Carrying camera gear, and having easy access to it while you are active outdoors, is one of the tougher challenges of adventure photography, especially if you are carrying other outdoor or travel gear, like food, water, clothing, and rainwear. If you keep your camera buried in your pack, it is easy to carry and well protected—but it is inaccessible. You will take pictures only when you stop for a rest, and you will often be too tired to bother with it even then. Carrying the camera slung around your neck, as you might in town, leaves it unprotected and more of a nuisance. Shoulder bags, which are great for shooting during car trips and relatively sedentary activities, are cumbersome and uncomfortable to carry over long distances, especially while you are active.

Land Travel

For comfort, protection, and accessibility, carry your camera in a padded case, with an extra lens or two, if needed, in a separate lens case, and accessories and extra film in yet another pouch—all loaded onto your backpack's hip belt. Other outdoor gear and extra camera equipment can be stowed inside your backpack. When you are skiing, biking, or otherwise very active, carry the camera case on your chest with a harness that provides the best compromise of accessibility, protection, and stability. Alternatively, carry the essentials—camera, lenses, film, and accessories—in a padded photography fanny pack, which you can wear in front when carrying your backpack or in back when skiing, biking, or engaged in other very active endeavors. For larger amounts of camera gear, use a camera or photography backpack that has enough room for other outdoor gear, as shown in **Photo 5-1**.

Opposite, Photo 5-1: *Torres del Paine National Park, Chile* (© Art Wolfe)

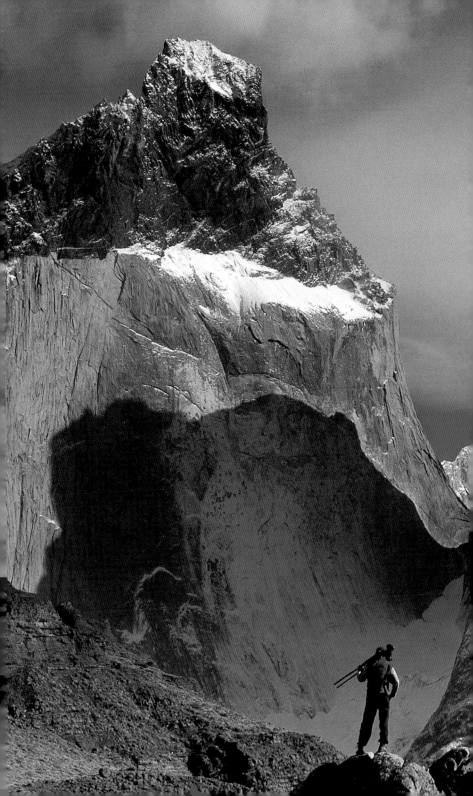

Water Travel

Cameras can be easily protected and yet remain accessible even on boat trips. Padded dry bags keep cameras at hand and dry if used properly. Waterproof hard cases with O-rings are ideal for carrying larger amounts of camera gear. These can be lashed to your boat while traveling. To shoot while you are actually on the water, use a camera designed for underwater use or your regular camera inside a waterproof housing. Waterproof housings are available in a soft, more flexible version and a hard, more protective version. Waterproof cameras and housings can often be rented, especially at popular aquatic destinations.

Air Travel

Traveling by air with camera gear presents additional problems, especially when traveling between countries. Whenever possible, hand-carry your camera gear in a well-padded but nondescript pack or case. To minimize the chances of theft, avoid bags that are obviously camera bags and carry your gear in front of you where you can keep an eye on it. If you must check camera gear through as baggage, bury it deep inside a nondescript bag surrounded by clothing. Use foam or inflatable sleeping pads for extra protection and wrap duct tape around the bag. Hard plastic coolers also work well. Pad your gear and place it inside the cooler. Then, after you have checked in at the luggage counter and the contents of the cooler have been inspected, seal the cooler with ample duct tape.

Essential Accessories

You should also take along a variety of accessories that will help you make better photographs. Using these accessories is described in this chapter.

- tripod
- flash
- lens hood
- 1.4× extender
- filter set
- macro lens
- 2-stop graduated neutral-density filter
- collapsible reflector and diffuser
- extra film and batteries
- cleaning kit with microfiber cloth, blower, and brush
- film leader retriever
- resealable plastic bags and a plastic trash bag

For digital cameras, carry the same and add the following:
- extra memory cards
- lots of extra batteries
- battery charger
- AC adapter
- USB cable

ELIMINATING CAMERA MOVEMENT

Camera movement during shooting is one of the primary causes of blurred pictures. Just holding the camera in your hand can cause significant movement, no matter how still you try to be. The act of pressing the shutter-release button can rotate the camera enough to blur your pictures, especially if the camera is not well supported. Even a stiff breeze can move your camera enough to blur your pictures, especially if you are using a telephoto lens. Some simple techniques, a good camera support, and a few key accessories can minimize these problems and improve your photographs.

Hand-Holding Your Camera

To minimize camera movement while shooting, hold the camera body with your right hand with the index finger positioned to press the shutter-release button. Cradle the bottom of the camera and the lens in the palm of your left hand, using your fingers to turn the focusing and aperture rings. If shooting vertically, swing your right hand up with your left hand underneath, and brace your left elbow against your stomach. When you take the picture, hold your elbows firmly against the sides of your body and gently press or squeeze the shutter-release button with the index finger of your right hand. If you are breathing heavily from exertion or excitement, wait until your breathing and heart rates have returned to normal before you take pictures, or increase your shutter speed as much as possible.

When hand-holding your camera, use the fastest shutter speed possible. As a guideline, use at least the shutter speed closest to $1/f$, where f is the focal length of the lens being used. For example, when shooting with a 50mm lens, the minimum shutter speed should be 1/60 second. For a 105mm lens, the minimum should be 1/125 second. The longer the lens, the faster the shutter speed must be to get a sharp photograph. In practice, this requirement limits the lens length you can hand-hold to about 200mm.

You must at least double that minimum shutter speed when shooting while walking, breathing heavily from exertion, or otherwise moving while photographing. The minimum shutter speed for that 50mm

lens becomes 1/125 second, or faster, the faster you are moving. Conversely, you can cut the recommended shutter speed in half, allowing you to shoot in lower light, by bracing yourself against a solid object like a tree or resting your elbows on a flat surface or a solid object. The minimum shutter speed for that 50mm lens would then be 1/30

Photo 5-2: *Shop window, St. Remy, France* (© Mark Gardner)

second. When there is not enough light to shoot at the minimum shutter speed, open up the aperture, switch to faster film, or use some sort of camera support.

If you have a lens or a digital camera with *image stabilization* capability, then turn that feature on, and hold your camera as described earlier. The image stabilization will result in sharper images at a given shutter speed, and will even allow you to shoot at a shutter speed one to three stops slower and still get an acceptable photograph. However, this capability stabilizes only slight camera shake when hand-holding. It will not help stabilize a moving subject, or the view from a bouncing vehicle or boat.

Camera Supports

Using some form of camera support whenever possible will eliminate camera movement, resulting in sharper pictures and allowing you to shoot at much lower shutter speeds. Without a tripod or other support, images like **Photo 5-2** are virtually impossible to shoot because of the low light level illuminating the scene. No matter how still you think you can hold your camera, a solid support will always do a better job. Without a camera support, the slowest shutter speed that will produce acceptably sharp images is 1/60 second or 1/125 second for most outdoor photographers, perhaps a bit slower if you have image stabilization. The effect of shooting without some form of camera support becomes most evident when you make larger prints for display. A handheld image that looked sharp in a small print will look soft when enlarged.

Most cameras are capable of shooting at much slower speeds than 1/60 second, and thus in much lower light. There are many situations, such as in early morning, on overcast days, or deep inside a forest, in which there is just not enough light, even with higher-speed film like ISO 400, to hand-hold a camera. Thus, without camera support you will inevitably miss a lot of excellent photo opportunities, and many of the best occur when the light is low. Camera supports that work well for outdoor and adventure photography are shown in **Photo 5-3**.

Tripods. A sturdy tripod with a secure tripod head, like the one shown in Photo 5-3, is the best means of supporting your camera while shooting or waiting for the right moment to shoot. A tripod does add weight and can be a nuisance to carry, but the benefits far exceed the extra effort. Using a tripod not only will result in sharper pictures, but will also allow you to take the time to do things right and will eliminate the fatigue of hand-holding what can become a tiresome weight. Without a tripod, it is impossible to get sharp pictures using slower shutter speeds or longer lenses, and it is difficult to focus precisely. Once you

Photo 5-3: *Lightweight camera supports* (© Mark Gardner)

get used to using a tripod in the field, you will not want to shoot without it.

In general, the heavier the tripod is, the better it will support the camera. Use the heaviest tripod and head that you are willing to carry. For field work, a medium-weight (five to eight pounds) tripod and a solid ball head, like the one in Photo 5-1, will support heavier cameras and lenses even in the toughest of conditions. Weight can be reduced significantly without sacrificing stability by using a tripod with graphite legs; however, such tripods are relatively expensive.

Ideally, the tripod's legs should be long enough to put the camera at eye level, should be able to spread 180 degrees, allowing you to get your camera near the ground for close-up shots, and should open independently of each other, allowing you to use the tripod on uneven terrain. The ball head should be removable, be well machined, with a smooth action even when heavily loaded, and have a quick-release method of attaching the camera body.

When it is not possible to carry such a combination, a relatively lightweight "backpacking" tripod can be more than adequate if used properly. However, many such tripods are poorly constructed of cheap materials, do not hold up well in the field, and are a real pain to work with because they are top-heavy and their head movement is typically very limited. Well-made tripods in the two-to-three-pound range with round, extruded legs and a lightweight ball head, as shown in Photo 5-1, are ideal for more active trips when you cannot carry something more substantial. To save weight yet have sufficient stability, get a tripod with shorter but still solid legs, rather than spindly but full-length legs. These lighter-weight models will support the typical camera with shorter lenses or longer but slower lenses like a 75–300mm f/4–f/5.6. They are also ideal for compact point-and-shoot cameras. However,

they are not adequate for serious macro or wildlife photography.

When using a lighter-weight tripod, avoid extending the legs completely or extending the center post. You may have to sit, kneel, or bend awkwardly, but the tripod will be far more stable. If you do have to extend such a tripod completely, you can add stability by adding weight. Simply hang your pack or a stuff sack filled with rocks between the tripod's legs. If possible, have the stuff sack just touching the ground to, in effect, add a fourth leg and even more stability. You can save weight by removing the tripod's center post and mounting the head directly onto the legs, or replacing the center post with a shorter one.

Whatever tripod you have, insulate the legs, either with commercially available tripod leg wraps or with plumbing-pipe insulation wrapped in duct tape, both of which are available at the hardware store. The insulation will provide padding when you are carrying the tripod over your shoulder and will protect your hands from cold metal when you are shooting in cooler temperatures. When using the tripod on snow, put the feet on something made of hard plastic or foam to prevent the legs from sinking into the snow.

Using a tripod to shoot moving subjects with a telephoto lens allows you to shoot at quite slow shutter speeds when the subject stops moving. Set the tension on the ball head loosely enough to move the camera with the action, but tightly enough to keep the camera well supported when you press the shutter-release button. Then you can track the subject's motion and be ready to shoot when it stops. Make sure that your camera is very securely attached to the tripod head, especially if the lens is attached rather than the camera body. Moving the camera around can loosen the connection or, worse, stress and potentially damage the threads in the tripod mount, as well as the lens mount.

Tabletop or pocket-size tripods are lighter-weight but less flexible alternatives to a full-size tripod. These mini-tripods are ideal for climbing, adventure travel, and other activities in which weight and bulk are seriously limited. You can almost always find a rock, a countertop, or another solid surface to put them on. If not, lie on the ground, a vantage point that provides an unusual perspective and is often the best for close-up shots. These tripods are fine for compact point-and-shoots and lightweight SLRs with shorter lenses.

Beanbags. Beanbags can also turn just about any solid object, such as a rock, a fence post, or even your car door, into a camera support. While the support on which you rest the beanbag could hold the camera alone, the beanbag allows you to easily position the camera to get the shot you want, and it cradles the lens, providing additional support. Without the beanbag, you would have to place sticks or rocks

under your lens to position the camera, which is time-consuming and reduces stability.

Several commercial models of beanbags are available, both with and without "beans." These can easily be carried unfilled in your pack or camera bag and then, when needed, simply filled loosely with dirt or pebbles to become an instant camera support. In a pinch, your pack, a stuff sack loosely filled with clothing, your jacket, or even coiled climbing ropes make adequate "beanbags." Beanbags can support just about any camera and even long, heavy lenses.

Clamps. As shown in Photo 5-3, there are a variety of other camera supports useful in outdoor and travel photography when you are shooting with relatively short lenses and lighter-weight cameras. A clamp with a small ball head is a flexible accessory. The clamp can turn a tree limb, a signpost, an ice ax, a pack frame, or just about anything else up to two or three inches wide, into a camera support. It can also serve as a tabletop tripod.

Camera mounts. A variety of ski poles and walking sticks can be fitted with an optional camera mount. Look for ones that can accept or include a small ball head.

Monopods. Monopods, quicker but less stable than their three-legged cousins, are great for action photography and can be used with longer lenses.

Shutter-Release Cable

In addition to some form of camera support, use a shutter-release cable to eliminate any camera movement that you might cause when pressing the shutter-release button—especially when shooting at slower shutter speeds or with your camera precariously perched on a rock or log. Even when your camera is mounted on a tripod, pressing the shutter-release button can rotate the camera, possibly blurring your photograph. Consult your camera's manual for details on how to use a cable with your camera.

If you do not have a shutter-release cable or if your camera cannot accept one, then use your camera's self-timer. Either way, by not pressing the shutter-release button, your own heavy hand will not blur your photographs.

WORKING WITH LENSES

For some considerations in choosing lenses while photographing, refer to "Techniques to Enhance Composition" in chapter 2.

To care for your lenses, keep the glass at both ends of your lenses as clean as possible. A large blower is the best way to remove dust and

other particles that lenses seem to attract like a magnet. If the blower does not work, use a soft, antistatic brush to gently brush away dirt. But do not get too compulsive; a few dust particles will not affect your photographs. For smudges, wipe the glass surface with a very fine lens-cleaning cloth, using a gentle, circular motion. Always start in the center and move outward to the edges. If the weather is not too cold and damp, it may help to add moisture by breathing on the lens first. Avoid cheap lens tissue; an ultrafine cleaning cloth cleans far better and leaves no lint. For really stubborn stains, use a cotton swab or a lens tissue with a drop of lens cleaning solution or alcohol, again wiping gently in a circular motion. However, use cleaning solution sparingly; it may leave a hard-to-remove film on your lens.

TIP

To avoid flare, shade the front of your lens when the sun is shining on the glass.

Lens *flare,* caused by light reflecting off the glass inside your lens—for example, when the sun shines directly on the front of the lens—can ruin an otherwise excellent image. Zoom lenses, filters, very slow shutter speeds, shooting directly at a light source, and scenes with backlight or a lot of reflected light can make lens flare even worse. To minimize flare, use the lens hood made for your lens whenever possible. Be careful with generic, one-size-fits-all lens hoods, which may obscure the corners of your photograph, an effect called *vignetting.* When you cannot use the lens hood, shade the front of the lens with your hand or hat, or shoot from a shady spot. As a final step, remove any filters from your lens unless you absolutely need a particular filter's effect.

Focusing
Focusing your lenses appropriately is critical to producing quality images. However, a variety of factors can complicate this apparently obvious and simple dictum.

Unless a photograph is an obvious abstraction, people expect the subject of the picture—or at least key parts of the subject, such as an animal's eyes—to be in focus. So make sure that the subject or the most important parts of the image are in focus. Proper focus is another reason to know exactly what your photograph's subject is, because you cannot focus properly if you do not know what to focus on.

Autofocus. Autofocus can be very helpful in certain conditions, but it can also be more trouble than it is worth. As long as you can see the

subject through the viewfinder and easily determine when the scene is in focus, then use manual focus. However, when the scene or subject you are focusing on is small or complex, making it difficult to see well through a small viewfinder, autofocus can help you focus more precisely. And your camera's autofocus can help in low light, in part because looking through a dim viewfinder makes it difficult to determine when a scene is in focus. Consult your camera's manual for details on how to use autofocus in your camera.

Focusing screen. If your camera has a split-center prism screen that can be replaced, replace it with a bright matte focusing screen with an architectural grid, which can be used as a compositional aid, helping keep your image parallel to the horizon.

Focus indicator. When focusing manually, use the focus indicator, if your camera has one, to augment your own eyesight; consult your camera's manual. At low light levels, shining a flashlight on your subject may help you focus manually. A headlamp allows you to look through the viewfinder and illuminate your subject simultaneously.

Finally, keep the path through which light travels between your eye and the subject as clean as possible. Wipe the camera's eyepiece clean with a soft cloth, and use a soft brush or blower on the inside of the camera, especially on the reflex mirror and the focusing screen above the mirror. Do not use lens cleaner or alcohol inside the camera. Be sure to remove dark glasses or ski goggles while focusing.

If it is cold out, be sure to turn your head to the side when looking through the viewfinder; otherwise, your breath will fog the eyepiece.

Managing Depth of Field

Although focusing on the right spot is critical, managing depth of field—the distance in front of and behind that spot within which objects are still in focus—is also very important. This can be tricky because you do not see a scene as your camera does. Your eyes essentially have unlimited depth of field, so you tend to see everything in focus, unless you are looking at something that is very close to you. However, lenses have a widely varying depth of field, depending on the distance between the camera and the subject, the size of the aperture, and the focal length of the lens. For example, if the aperture is small, then depth of field will be quite deep; that is, the photograph will have most of the scene in focus, as in **Photo 5-4**. However, if the lens's aperture is large, the depth of field will be shallow; the photograph will have only a very small part of the scene in focus, as in Photo 2-2.

In general, you should adjust the aperture to make the depth of field just large enough to put your subject completely in focus. A smaller

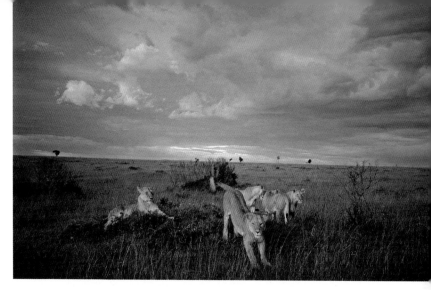

Photo 5-4: *Lions, Masai Mara National Reserve, Kenya (© Art Wolfe)*

aperture, increasing depth of field, will ensure that your subject is entirely in focus but may result in a more distracting background. A larger aperture, reducing depth of field, will leave parts of the subject out of focus. If the depth of field is shallower than the subject, even at the smallest aperture, as when shooting close-ups or using a long telephoto lens, then make sure that the part of the subject closest to you is in focus.

In general, depth of field extends farther beyond the point at which the lens is focused than in front of that point. When the lens is focused within a few feet of the camera, these distances are essentially the same. When the point of focus is farther away, depth of field can extend beyond that point to infinity. Thus, for most scenes or subjects, focus on a spot one-quarter to one-third of the way into the scene, or into the important part of the scene. When you are shooting a subject that is very close to you or when depth of field is very shallow, as it is when you use large apertures, focus on the part of the subject that you most want to be in focus in your photograph.

> **TIP**
> Focus just in front of the most important part of the scene or subject.

Depth-of-field preview button. To manage the depth of field to your best advantage, use your depth-of-field preview button. When you look through your viewfinder, your lens is wide open, which lets in more light and makes focusing and composition easier. However, what you

see is not what you are going to get in your photograph, unless you are actually using the biggest aperture. You cannot see the true depth of field. The preview button reduces the size of the lens opening to the selected aperture, allowing you to see exactly what is in focus in the scene you are photographing. Use the preview button to try a variety of apertures until you find the depth of field that you like. However, at very small apertures, when the depth of field is the widest, the viewfinder will become quite dark when you push the preview button. When this happens, shield your eye and the eyepiece with your hands, and wait for your pupil to adjust to the low light level.

Depth-of-field scale. If your camera does not have a depth-of-field preview button, then use the depth-of-field scale on your lens, or use the *hyperfocal distance* table included in this section. To use the depth-of-field scale, first select an aperture, and focus on your subject. Then look at the scale on your lens barrel. The distance index line indicates the distance to the subject or point of focus. On each side of the index line is a series of lines, each with one end pointing to the distance scale and the other end pointing to an f-number. Each aperture has a pair of lines pointing to two distances on the scale. The depth of field for an aperture is the range between those distances. For example, if a 24mm lens is focused at 10 feet and the aperture is set to f/11, then the depth-of-field scale indicates that everything between about 7 feet and 20 feet will be in focus. If the same lens is focused at 20 feet and the aperture set to f/16, then the depth of field will extend from about 10 feet to infinity. Consult your lens's manual for details on using the scale for your lens. Unfortunately, most popular zoom lenses no longer have a depth-of-field scale on the barrel. If your lens does not have such a scale, then use the hyperfocal table on the next page.

Hyperfocal distance. You can maximize depth of field by focusing at the hyperfocal distance. Then everything from half that distance to infinity will be in focus. This technique can be particularly useful when you are shooting big landscapes or scenics with wide-angle lenses or zoom lenses and you want everything from the immediate foreground to the distant background to be in focus.

Table 5-1 gives approximate hyperfocal distances for a typical selection of focal lengths. First, find in the table the hyperfocal distance for the particular lens length and aperture you are using. Then adjust the focusing ring until the hyperfocal distance on the distance scale lines up with the distance index line. For example, for a 24mm lens with the aperture set to f/22, the hyperfocal distance is about 3 feet. That is, when the lens is focused at 3 feet, everything at a distance of 1½ feet to infinity will be in focus.

With a zoom lens, set the focal length and aperture first, then set the focus to the hyperfocal distance for that particular focal length and aperture combination. For example, suppose a zoom lens is set to a focal length of 50mm and an aperture of f/22. Using Table 5-1, focus the lens to 13 feet to maximize depth of field between 6½ feet from the camera and infinity. If your lens does not have a depth-of-field scale, which many zooms lack, use hyperfocal tables to precisely set the focus to maximize depth of field.

table 5-1. approximate hyperfocal distances*					
Focal Length	f/8	f/11	f/16	f/22	f/32
20	6	4	3	2	1½
24	8	6	4	3	2
28	11	8	6	4	3
35	17	12	10	7	5
50	34	25	18	13	10
70	67	50	34	24	17
85	99	72	50	36	25
*Note: All distances are in feet.					

The physics of lenses dictate that apertures in the middle range of f-stops, between f/8 and f/11, will produce the sharpest overall images. This range is known as the lens's "sweet spot." To maximize the sharpness of your photographs, use your lens's sweet spot whenever possible. Avoid using a very small aperture, f/16 or smaller, unless you absolutely need the extra depth of field, such as in a big landscape where you want both the foreground and background to be in focus. And avoid using a large aperture, f/5.6 or larger, unless you absolutely need the extra light, as when shooting action at higher shutter speeds or in low light.

> **TIP**
>
> Use f/8 or f/11 unless you need maximum depth of field or a very fast shutter speed.

Zooming

If you are using a zoom lens with a range of focal lengths, then zoom the lens in and out to get the best composition. Zoom lenses are great for filling the frame with your subject and eliminating background clutter.

When you use a zoom lens, there is a second sweet spot to con-

sider. Just as the middle apertures produce the sharpest images with any lens, the middle focal lengths of a zoom's range also produce sharper images than focal lengths at the ends of the range. If you find yourself at the far end of your zoom—for example, the 210mm end of a 70–210mm zoom—move closer to your subject if possible, and back off the focal length. Likewise, at the near end, move farther back if possible, and zoom in with the lens.

Digital cameras have two types of zoom: optical and digital. Optical zoom is just like the zoom lens of a traditional camera and works the same way. *Digital zoom* is actually a software process that extracts part of an image and magnifies it. However, this enlargement does not add any new pixels, so, in effect, the resolution of the magnified image is reduced, resulting in a lower-quality image, especially when the image is printed at larger sizes. In general, avoid using the digital zoom if you intend to make enlargements of the image.

If you are using a fixed-focal-length lens, you can still "zoom," but you have to do the zooming with your feet. Move closer to fill the frame with your subject, move back to include more of the subject's surroundings, or move around to get a better angle of view. In any case, do not just stand where you are and snap away. Move around and zoom in and out with your feet to get the best composition.

Filters

A filter can be added to your lens to manipulate the light striking the film and thus create different effects in the resulting photograph. Myriad filters are available today to create myriad effects, from turning a point of light into a brilliant star-burst to filling a clear sky with fog to making sunset seem like late morning. However, these effects are too unnatural for most nature and adventure photographers, and you would use them so little that they are usually not worth the extra bulk or expense. Only a handful of filters are really necessary to solve a few key problems and produce better color outdoor photographs. These include ultraviolet or skylight, warming, polarizing, and neutral-density filters.

Round filters screw onto the front of your lens; thus, you buy each filter to fit a particular lens. However, if you have a variety of lenses that take different-diameter filters, this can get quite expensive. To reduce cost and the amount of gear you have to carry, buy one filter set that fits your largest lens, and buy step-up rings that allow you to adapt the filters to lenses with smaller diameters. To save time, also buy a set of lens caps that fits the filter set. Leave step-up rings attached to each lens, and cover the lens with the bigger lens cap. Then you can quickly switch filters between different-sized lenses.

The use of filters is not limited to 35mm SLR cameras. Several manufacturers make filter holders that can be mounted onto digital cameras and compact point-and-shoot cameras as well. With such a holder, any of the filters described here can be used with a point-and-shoot camera. However, using filters that reduce the light entering the lens, such as a polarizing filter, is practical only with point-and-shoot cameras that have TTL light metering. And because you cannot look through the lens of most point-and-shoot cameras as you can with SLR cameras, you will not be able to see the effect of the filter.

Ultraviolet, haze, and skylight filters. The ubiquitous *ultraviolet (UV)*, haze, and *skylight filters* are probably the most overused and least understood filters used by outdoor photographers. One or the other is often recommended as permanent lens protection from drops and bumps, but adding another layer of glass can increase flare. If your purpose in adding such a filter is protection, use a lens hood instead, which provides better protection and actually reduces flare. Why use one of these filters? They are useful in keeping spray or dust off of your lens, especially during storms. All three will reduce the amount of ultraviolet light that reaches the film, light that you do not see but that the film records as a slight bluish cast. The skylight filter, which is slightly pink, also adds a hint of warmth to the final image. These effects may be useful in some situations, such as higher elevations, but the filters should not be used as a permanent extension to your lenses.

Warming filter. Warming filters are, however, much more useful, and they also provide lens protection. On overcast days or in the shadows on sunny days, the light tends to be bluish and cool. The scene in Photo 5-2 was in the shadows of a narrow lane. The image was shot with a warming filter to counteract the shadow's bluish cast. You often do not see this bluish cast because your brain filters it to match your perception of a more natural light. However, your film will record it. The yellowish amber 81-series filters remove this cool, bluish cast, resulting in a warmer, more pleasing photograph. The 81A returns the scene to a more natural color. The stronger 81B, which is the most popular, adds a bit of warmth and brings out the color. The even stronger 81C really heats up an image.

TIP

Use an 81A or 81B warming filter instead of a UV or skylight filter when shooting in shade or under overcast skies.

These kinds of filters modify the color of the light that strikes your film or digital sensors. If your digital camera has adjustable

white balance, then you can use that to achieve some of the effects of such filters. However, if your camera does not have that capability, then filters can be used, just as with a traditional camera. Even if you can adjust the white balance, a filter may produce better results. Experiment with your camera to see what works best.

Polarizing filter. Polarizing filters also solve several frequently encountered light problems and, if used properly, can enhance the color in a scene. Sunlight is reflected by the atmosphere, water, and the objects that we photograph, creating unwanted haze and glare. Polarizers remove this reflected light, enhancing the color of green vegetation, blue skies, and rainbows, as well as cutting through the haze often found at higher elevations and in reflections from water. They are especially useful when the sun is higher in the sky or your subject is soaked from rain or spray, even on cloudy days. Denali and the bull moose in Photo 2-8 were photographed with a polarizing filter, which helped saturate the colors of the vegetation and the sky, as well as eliminate the glare from the snow on Denali.

The effect of a polarizing filter depends on the direction of your lens, relative to the direction of the sunlight. The effect is greatest when the camera is aimed at a ninety-degree angle to the sun. It is least when the camera faces directly at or away from the sun or when the sky is overcast. Be careful when using a wide-angle lens with a polarizer to photograph a scene with a lot of blue sky. The sky seen by looking at a right angle to the sun will appear dark blue, while the sky nearest and farthest from the sun will appear light blue, an effect that is not very natural. Also be careful not to overpolarize when photographing at higher altitudes. Overpolarizing can unnaturally blacken the sky. If you get this effect and are using the polarizer to cut through haze, adjust the polarizer, or try a UV or haze filter instead.

Polarizers reduce the amount of light reaching the film by up to two stops. That reduction can be a problem when you need to use higher shutter speeds but is useful when you want to slow down the shutter speed in brighter light, as when shooting waterfalls. Do not use a polarizer unless it enhances your photograph. To check what effect one might have, simply hold it in your hand, oriented as if you were about to mount it on your lens. Then turn the outer ring while looking through it to see what happens. If you see an enhancement you like, then take the time to mount the filter on your lens. Otherwise, put it back in your bag.

Neutral-density filter. Split, or graduated, neutral-density (ND) filters, commonly referred to as "grads," are another type of filter worth carrying on every trip. In these rectangular filters, one half is clear and the other half is darker by one, two, or three stops. These useful filters allow you to balance the bright highlights and dark shadows often found in outdoor

scenes, such as sunlit peaks with a shadow-filled valley below, or other situations in which the background is bright and the foreground darker.

For example, **Photo 5-5** was shot with a graduated ND filter. In these situations, which are frequently encountered, especially early and late in the day, it is impossible with slide film, and sometimes even with print film or a digital camera, to shoot the scene as you see it. If you expose for the brightly lit part of the scene, the darker part will be nearly black in the resulting picture. If you expose for the darker part, the well-lit section will become glaringly bright. The only way to shoot a satisfactory image of the entire scene is to expose for the darker part of the scene and use a graduated ND filter to darken the brighter part.

Using these filters is a little tricky but with practice becomes easy. First, point your camera at the darker part of the scene to determine proper exposure. Then put your camera on a tripod or another camera support—this procedure is harder without one—and focus. Hold the filter in front of your lens so that the darker section covers the brighter part of the scene, usually the sky. To be effective, there should be a line or area across the scene with which you can match the boundary between the dark and clear halves of the filter. Matching the line in the scene with the filter's gradation line without having a line actually showing is the tricky part.

To make sure that the filter is positioned properly, set your lens to its smallest aperture, hold down your camera's depth-of-field preview button, and adjust the filter up or down until it is positioned the way you want it. Then return the aperture to the desired setting. You may want to bracket your shots, with the filter in different positions, to get it in the right place. However, avoid shooting at the smallest aperture unless you need to maximize depth of field. By shooting at f/8 or f/11, you will get the best optical sharpness, and the filter's gradation line will not be noticeable.

You can hand-hold a graduated ND filter, keeping your fingers out of the way, or use a filter holder, which allows more precise adjustment but is another piece of gear to carry. With practice, hand-holding is adequate for most situations and eliminates the need to carry the holder. The ND filters are available in two sizes, with one-, two-, and three-stop differences between the light and dark halves and with either sharp or more gradual boundaries between the halves. Start with a larger, high-quality, two-stop filter with a softer, more gradual boundary. Avoid round, screw-on graduated ND filters, because you cannot adjust the location of the boundary between the clear and dark halves.

Polarizing filters and split neutral-density filters work well with both film and digital cameras. As of this writing, no digital camera has

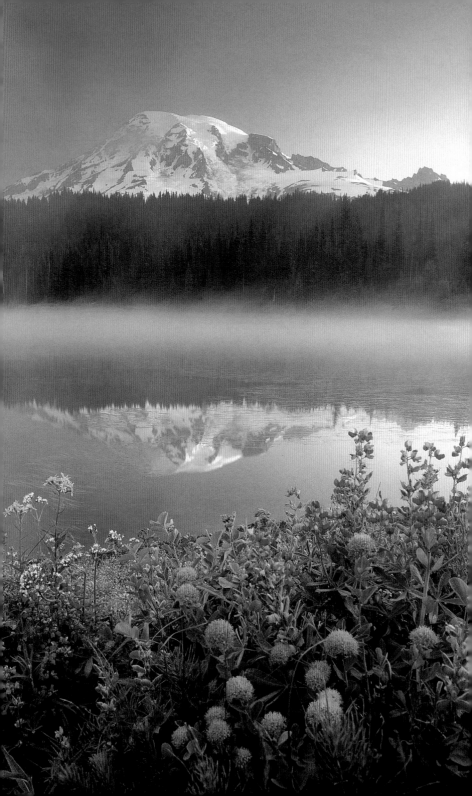

the capability to do what these two types of filters can do. So even if you have the latest in digital technology, you may have to do some things the old-fashioned way.

FILM

Selecting Film

As any visit to a camera store will show you, a bewildering array of films are available today. Most of these films are for specialized applications or for snapshooters. There are only a handful that provide the sharpness, color, and flexibility needed for high-quality outdoor and adventure photography. Unless you are shooting enough to really get to know a variety of films, pick one or two and concentrate on them. Learn their characteristics and when to switch from one to the other.

Prints versus slides. Your first choice is whether to use print (negative) film or slide (transparency, or positive) film. Print film has a number of advantages that make it very popular, especially among snapshooters. First, it is far more forgiving of bad exposure choices than is slide film. An over- or underexposed negative can still produce a satisfactory print. Prints are also much easier for just one or two people to view at once and are fun to arrange in albums that tell a story. However, in the long run, using print film is more expensive than shooting slides. In addition, the printing process takes away some of your creative control. The final outcome is at least to some extent determined by the printer rather than you, sometimes requiring you to work with the printer to get what you want. If you want large display prints, then shoot with print film and find a quality printer.

> **TIP**
>
> When photographing with slide film, try underexposing by one-third stop to saturate colors.

Slide film, on the other hand, is the choice of the majority of serious outdoor photographers. It is sharper and more color-saturated than print film, as well as cheaper over the long run. Slides are easier for larger groups to view, and it is fun to put on slide shows after a potluck dinner. If you hope someday to publish your photographs, keep in mind that virtually all publishers now require transparencies.

Opposite, Photo 5-5: *Mount Rainier and flower meadow, Washington* (© Art Wolfe)

Only a few will accept prints. When you want a print, you can always make one from a slide, although the print may be a bit more contrasty and intense colors may lose some of their punch. However, slide film records a narrower range of tones than does print film. Shadows and highlights that look about right in prints may appear as black areas and white areas in slides. Consequently, slide film requires more careful and accurate exposure choices.

The final, and perhaps most important, reason to use slide film: digital photography. In general, transparencies are better for digital imaging than are prints. Output and image manipulation options for amateurs are rapidly approaching those previously available only to professionals willing to pay the price. For example, as discussed later in this chapter, imaging centers now open in most cities allow anyone to scan a slide onto a computer, edit the image on computer, and print a final image that looks better than a traditional print at about the same cost.

Natural color versus saturated color. A variety of both print and slide films are appropriate for outdoor and adventure photography. These tend to fall into two basic categories: films with higher contrast, supersaturated colors, and a hint of warmth, and films with lower contrast, more muted colors, and a neutral-to-cool color balance. The former are very popular for most outdoor photography, but the latter may be more appropriate for people's faces, snowscapes, and other subjects for which you want even, accurate color rendition. Experiment by shooting several rolls in different situations to determine which you like best.

Slow versus fast. As a rule, use the slowest film possible for the situation because sharpness increases as the ISO number decreases. To illustrate, 35mm films rated ISO 50 can make sharp prints up to 20 inches by 24 inches, while ISO 400 films are usually limited to 8½ inches by 11 inches. For most photography, slower films—ISO 100 or less—are by far the most popular among serious outdoor photographers. For wildlife, action, and handheld photography, ISO 50 films pushed one stop or ISO 100 films, which can be pushed to ISO 200, are their first choice. Most pros do not use ISO 400 films. However, today's ISO 400 films are as sharp as ISO 100 films of a decade ago, which were perfectly satisfactory at the time. Try them for action and general handheld photography, but you may be dissatisfied with their increased graininess.

Professional versus amateur. Many films are available in professional and amateur versions. As with other film options, deciding which works best for you is up to you. Most people cannot tell the difference between

identical photographs taken with the two types. Virtually no one can tell by looking at a photograph which type of film was used. That said, fresh professional films usually perform as expected more consistently. To get the most out of your film and your photo opportunities, use the professional versions. However, amateur versions, which are cheaper, may work just fine for your general-purpose use and for experimentation, when you want to save money. Try them both, then decide for yourself.

Storing and Traveling with Film

Storing and traveling with film can be a real challenge. Keep unused film in a dark, cool place, ideally your refrigerator or freezer. When traveling, your film faces a gauntlet of radical temperature changes, dirt, and X rays. To save space, remove film rolls from their boxes and canisters, which can be recycled. Carry the rolls in resealable, clear plastic bags, which allow for quick identification by you and quick inspection by airport security guards.

When traveling by car, store film in a cooler if possible. Or bury your film in the middle of your clothes bag, which provides insulation, and then keep the bag in the shade.

When traveling by air, hand-carry your film if at all possible, avoiding the X-ray machine. Recent tests have shown that a few passes through the machines in more modern airports, which run bags through on a conveyor belt, will not harm film; so do not be too concerned if you cannot avoid them. However, the effect is cumulative, so minimize the number of times the film is x-rayed. If the machines are the older, large ones into which baggage is loaded, doused with X rays, and then removed, ask that your film be hand-inspected, or put it in lead-lined bags. If you must check your film through as baggage, which is often x-rayed with much more powerful machines, place it in lead-lined pouches in the center of a nondescript bag, surrounded by other gear. It is usually better to send your film ahead or back home once exposed via air express courier. The contents of such packages are typically not x-rayed, but ask to be sure. Do not send film via slower ground courier or mail. Doing so could subject your film to extreme temperatures and other abuse.

Others' quick fingers may pose an additional problem when you travel. Lock your bag's zippers, and wrap duct tape around the bag. Avoid shiny, new bags with a popular brand name emblazoned on the side.

DIGITAL PHOTOGRAPHY IN THE FIELD
Shooting with a Digital Camera

Digital cameras are designed to emulate film cameras. Thus, using a digital camera in the field is basically the same as using a film camera,

and the techniques described in this book apply to digital cameras in one way or another. However, there are a few differences and tips that apply only to digital cameras.

Digital cameras require a lot more power than traditional cameras. It is very easy to go through a dozen or more batteries in a day. Use the latest in rechargeable batteries, such as nickel metal hydride (NiMH), and carry a battery charger if you have access to power, preferably a quick-charging version. Normal alkaline batteries, commonly available throughout the world, will work in a pinch but will not last as long as NiMH batteries. Also, carry an AC adapter for your camera if you have access to power. If possible, get a dual-voltage adapter that can work in either 120- or 240-volt systems. If you are traveling by vehicle or boat, then get a battery charger with a DC cable that can plug into a cigarette-lighter socket.

There are several ways to minimize power consumption when recording or viewing images with a digital camera. First, most digital cameras will turn themselves off after some period of inactivity. If that period is adjustable, set your camera to turn off in the shortest time possible, typically 15 to 30 seconds. Second, using the camera's LCD screen consumes a lot of power very quickly. If possible, reduce the brightness of the display to consume less power. And finally, when shooting, use the camera's viewfinder instead of the LCD, which should then be turned off. And avoid viewing images on the LCD until you can recharge the batteries or use the AC power adapter.

The biggest advantage of using a digital camera is the instant feedback you get when photographing. You can view the image you recorded just seconds ago. With film, you may have to wait days or even weeks. Thus, you can shoot, view the image, and then adjust something to make a better image. For example, you could try different points of view or different exposure settings and then view the resulting images, deleting the ones that are not satisfactory. However, as already noted, this does consume power; so be sure to have plenty of batteries.

When you shoot with a digital camera, there can be a lag between the time you press the shutter-release button and the time you can take the next photograph. This lag time, which can be as long as 30–60 seconds, is the time it takes to record and process the image and then save it on the camera's memory card. The lag time depends on the resolution at which you are recording; the higher the resolution, the longer the lag time. Unfortunately, this limitation makes it difficult, if not impossible, to shoot high-resolution images in rapidly changing conditions or to shoot action with anything but the most expensive digital SLR cameras. The wait can also try the patience of any people that you are photographing.

Recording at the highest resolution also consumes the space on your memory card much faster. For example, a 256-megabyte card holds 17 images at a resolution of 2560 × 1920 pixels, but holds 589 images at a resolution of 1280 × 960 pixels. Memory cards are small, so you can carry a lot of them, but they are also expensive. It is easy to have more invested in memory cards than in your digital camera. If you plan to record high-resolution images, then buy the largest, fastest memory cards you can afford, and take several along. In addition, you can download images to a computer or another storage device and then reuse the memory card, as described later in this chapter.

Because of the time lag and memory consumption, you should set the resolution only as high as you need. To make the highest-quality images, images that can be enlarged and printed for display, you should use the highest available resolution. However, if you do not need the highest quality (see chapter 1), as when shooting snap-shots or images for use on the Internet, then reduce the resolution setting. If you do shoot at the highest resolution, you will need to be much more judicious about when you press the shutter-release but-ton. You might miss a better shot while the camera is storing the image you just shot. When recording high-resolution images, slow down. Wait patiently for the right moment. You can also shoot first at a low resolution; view the resulting images to determine the best composition, light, and exposure; and then reset the resolution to the highest level to make the final image. This approach means you suffer through the lag time only once or twice, but it does consume more battery power.

Shooting for Digital Photography

As discussed in chapter 1, digital photography can start with either film or digital recording media. With film, you will have to wait until the film is processed and the resulting images scanned to create digital files. Digital cameras store images as digital files on the camera's memory card. Either way, you get a digital image that can be transferred to a computer or a service and then edited and printed. Discussing digital processing is beyond the scope of this book; however, there are a num-ber of techniques that you can use in the field to create images more suitable for editing in the *digital darkroom.*

With digital photography, especially with a digital camera, there is a temptation to think you can shoot first and then make the image better by editing on a computer later. Although you can make extraordinary images in a digital darkroom, it is much better to start the editing process with the best image possible. Editing images on a computer takes time

and a certain level of expertise, even with the simplest software. Use the techniques described in this book to, in effect, edit the image in camera by eliminating distractions, shooting in the best light, and so on. Then you can work creatively in the digital darkroom, rather than fix problems that could have been avoided when you made the image. Moreover, digital photography cannot always overcome bad composition, harsh light, or sloppy technique. Making the best possible image in the field will enable you to create better images in the digital darkroom.

However, digital manipulation can sometimes improve images that otherwise might be unsatisfactory. You may not be able to wait for the best light or to completely eliminate some distracting object from the composition. You can compensate for less desirable light and exposure by adjusting the contrast, color balance, color saturation, brightness, and other image attributes with software. And you can relatively easily remove small objects or clean up part of an image that reduces its impact. Thus, the digital darkroom does let you shoot in a wider range of conditions and still produce high-quality images. But there is a caveat. Excessive manipulation of an image by means of software may actually tend to reduce the quality of the image. So do not overdo it, and always make the best image possible in camera.

Combining images. You can often create extraordinary photographs by using image-editing software to combine two or more images. You can even create images that would not be possible with a film camera. However, if you plan to combine images, you should shoot the images with the editing process in mind. That preparation will make the editing easier and will result in a much better final image.

As discussed earlier, film records a much narrower range of tones than you can see. You can sometimes solve this problem by using split neutral-density filters. You can also solve it with digital photography by taking two images of the same scene and then combining them in the digital darkroom. Expose one image to record the highlights, letting the shadows go dark. Expose the other image to record the shadows, letting the highlights go white. Then the two images can be combined in the digital darkroom to create an image that shows the full range of tones and detail of the scene. You can also shoot one image with flash to illuminate a subject in the foreground, shoot the second image with a normal exposure, and then combine the two to create the final image.

Digital photography also enables you to make images that would be difficult or impossible to make in camera. For example, you can make images showing a friend leaping over a yawning chasm, standing

on top of a rock spire, or performing some other amazing feat. To make such an image, first shoot your friend safely performing whatever feat you want in the resulting image. It is best to place them against a plain solid background such as a blue sky or a blank wall. This will make the editing process much easier. Then photograph the yawning chasm the way you want it to look in the final image. If possible, try to photograph the two scenes in the same light. Variations in lighting can be adjusted later, but it can be difficult to do.

A word of caution. Digital image manipulation is still quite controversial. Be careful not to misrepresent manipulated images as real or made by traditional means. If you do manipulate images, always label such images accordingly so that the viewer knows that the images are not straight out of a camera. Such labeling should always be done if the image is meant to represent a natural subject or scene. However, if the manipulation is for artistic effect and is obvious, labeling may not be necessary.

Making a panoramic image. Most film and digital cameras make images with a fixed aspect ratio, usually the rectangular 3:2 ratio of 35mm film. But there are often images of subjects or scenes that would be much more dramatic if made with a panoramic aspect ratio like 3:1— that is, an image three times wider than it is high. Panoramic images cover a much wider angle of view than the typical 35mm image and, thus, are often very effective for big landscapes, such as **Photo 5-6**. Traditionally, such images could be created only with a panoramic camera, as was Photo 5-6. APS cameras have a panoramic mode, but they are, in general, not suitable for serious photography. And specialized panoramic cameras are big, heavy, expensive, and beyond the scope of all but the most serious outdoor photographers.

To make panoramic images without a panoramic camera, you can crop a standard-format image or use special software that creates panoramic images from standard images. If you want to make a panoramic image by cropping, or removing unwanted parts of the image, then shoot as you normally would, but compose the image so that you can easily crop it by using image-editing software or simply by trimming the final print. However, because you are eliminating part of the image, making a given size of print requires you to magnify a smaller image, reducing the quality of larger prints.

Software that combines images to create a panoramic image is readily available and easy to use. Making panoramic images in software often results in higher-quality images than cropping a 35mm or

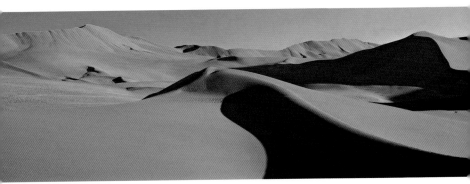

Photo 5-6: *Desert dunes (© Art Wolfe)*

digital image, and it enables you to create dramatically larger panoramics, with an angle of view up to 360 degrees, to include the entire scene surrounding you. To make a panoramic image, you simply take several images from the same vantage point with a 35mm or digital camera. Start at one end of the scene, and take a series of overlapping images that include the entire scene you want in the final image. Use a tripod to keep the camera in the same position for each shot. If you are shooting with 35mm film, process the film; then get a high-resolution scan of each image, and load it onto your computer. If you are shooting with a digital camera, simply upload the images to your computer. The software automatically stitches the files together to make the panoramic image. You then save the resulting file, which can be printed on an ink-jet printer, or sent to a lab for the highest-quality print.

Digital Photography While Traveling

Photo labs, photocopy stores, and Internet cafés provide a variety of services that enable the traveler to do digital photography without taking a digital darkroom along on the trip. While these services are not found everywhere in the world, they are increasingly available in a surprising number of even remote places, especially ones with many visitors. If you are shooting with a digital camera, take a USB cable, an AC adapter, and any software that came with your digital camera. You can then take your camera or sometimes just the memory card into the lab, store, or café, where you can edit your images, have them put on a disk, make prints, email them to friends, or post them on the web.

If you are shooting film, then first get the film processed and scanned to create digital images. Many photo labs throughout the world can do both, providing you with processed film, prints, and digital files within

a day or so. There are also Internet services that will do the same thing. You can send your film in by overnight courier from anywhere in the world. The service will process the film and post the images on its website. You then view the images and have the ones you want printed and saved to disk. You can do this while traveling or wait until you get back home. Once the images are scanned, you can do the same things as if they came from a digital camera. However, this extra step does take extra time and money.

The Internet also provides a great way for you to share your images with friends and family back home while still traveling. You can email your images or post them on one of the many websites that can create a virtual photo album or slide show to be viewed with a web browser. Emailing is simple and cheap, but it is practical to send only a few images with each email. Posting to a website enables you to share more images, but it takes time and effort to set up. Whether you email your images or post them to the web, always send low-resolution images (e.g., 640 × 480 pixels) in a JPEG file format. Low-resolution JPEG images minimize file size and transmission time, yet still look fine on a computer display. High-resolution prints require too large a file to be conveniently emailed or sent over the web. However, you can have the lab store the files on a CD-ROM, which you can ship home or can easily carry while continuing your travels.

If you travel with a laptop computer, you can take some of your digital darkroom with you. You can connect your digital camera to your laptop with a USB cable; then you can store and edit your images without going to a photo lab, an Internet café, or any other service provider. Images can be shared via email or the web by telephone directly from your laptop. It is generally not practical to take a photo-quality printer along. If you want to make prints while traveling, you will have to take your laptop to a lab or store.

WORKING IN BAD WEATHER

As any outdoors enthusiast knows, the weather outdoors is usually less than perfect. It is often hot, cold, humid, windy, raining, or snowing. But uncooperative weather conditions should not stop you from photograph-ing. In fact, some of the best images have been taken in such conditions. For example, rain can add a unique softness to landscapes, and a brooding storm can produce very evocative images. However, it can be a real chal-lenge to get such images in inclement weather without ruining your cam-era gear. Your gear can take just about any conditions you can. But, just as you have to protect yourself from the elements, you must also protect your camera gear appropriately.

Heat

If you can stand the heat outside, then your camera gear probably can, too. Nevertheless, even when it is not all that hot, keep your camera out of direct sunlight as much as possible. Store gear that you are not using inside a padded pack, case, or bag to prevent the sun's rays from heating black cameras and lenses, and keep the gear that you are using shaded. An umbrella held by an extension arm clamped to your tripod is ideal for keeping both you and your gear cool. If you do not have one, work in the shade whenever possible.

Your film is more sensitive to heat and should be protected more carefully. An insulated lunch bag or a small cooler with ice will keep a day's worth of film cool out in the field. Store the rest of your film in a cooler in your car or camp. Even when it is not blazing hot outside, keep your film out of direct sunlight, and avoid putting film in the pocket of a dark jacket or dark pants.

Cold

Working with camera gear in extreme cold is usually tougher on you than on your gear. Touching cold metal with bare skin saps heat from your body very quickly, leaving you cold and miserable, and sometimes freezes your skin, causing plenty of pain. Thus, always wear liner gloves while shooting. Between shots, keep your hands warm by slipping them into pockets or a pair of oversize mittens tied to your jacket. Be careful not to touch the back of the camera with your cheek while shooting; either wear a face mask or insulate the back of the camera with heavy tape or thin foam. Finally, wrap your tripod's legs with pipe insulation or a commercially available leg wrap.

Weak or inoperative batteries are one of the most common problems encountered in cold weather. Most of your camera gear can take the cold, except for batteries. Their capacity diminishes in very cold temperatures. Keep extra batteries warm inside your jacket. Once the batteries in your camera get too cold, swap them with the warm set. Alternatively, you can use an external battery pack, which can be kept warm inside your jacket.

Another common problem in cold conditions is condensation, which forms when warm air hits your cold camera. This occurs when you breathe on the camera as well as when you take the camera inside. If you do get condensation, wait until the camera's temperature has restabilized, then gently wipe it off. To prevent condensation while shooting, turn your head to direct your exhalation away from the camera. Before you go back inside, put your camera inside a sealable plastic bag, squeeze all the air out, and seal the bag. If you do not have a bag,

wrap the camera in your jacket. This will allow the camera to warm up slowly and will keep condensation off the camera itself.

Keeping your camera under clothing and too close to your own body heat can also cause condensation. If there is precipitation or extreme cold, keep your camera under your first layer or two of clothing, which should offer enough protection without allowing the camera to warm up too much or too quickly.

Precipitation

Do not let precipitation stop you from getting great shots. Most cameras, even the more modern electronic wonders, can take a sprinkling of water and keep on clicking. However, too much precipitation, and even high humidity, can cause problems and ruin camera gear. Always take a few resealable plastic bags and a large plastic garbage bag or two to protect your equipment when conditions are really bad. While shooting in the rain or snow, use a lens hood to keep water off the front element, and drape a garbage bag or a commercially available rain cover over your camera. To look through the viewfinder, stick your head under the cover or roll the cover back to expose the eyepiece. Alternatively, cut a hole in the plastic bag for your lens and then place the camera in the bag, with the lens sticking out of the hole. If it is not too windy, an umbrella on an extension arm clamped to a tripod leg is even better. A clear plastic shower cap placed over the camera body also works well when you are using shorter lenses.

Water on the outside of your camera is not much of a problem. Simply wipe it away with a chamois or other absorbent cloth. However, water on the inside can be a real problem. Remove the lens and any caps from the camera. Shake out any remaining water, or carefully wipe out the inside with a cotton swab. Then store everything in a warm, dry place until all moisture has evaporated. In very humid conditions, such as in rain forests, you will have to create such a place by placing your gear inside a sealed plastic bag or other watertight container with an ample amount of silica gel, which is available from camera stores or chemical supply stores. Once the silica gel has done its job, spread it on a cookie sheet and bake it in the oven at a low temperature before using again.

MANAGING LIGHT

Working with Fill Flash

Most outdoor photographers rely on the sun to provide the primary light for their photographs. Unfortunately, the sun is often less than cooperative in providing the best, or even good, lighting. For some

photographs, like big landscapes, the only alternative is to wait, if possible, until the light changes to suit you. However, when the subject is relatively close to your camera, you can use fill flash to overcome the problems caused by an uncooperative sun or to create images, such as the two macaws in **Photo 5-7,** that would not otherwise be possible. Fill flash is a second light source used to complement the light from the primary light source, the sun. It fills in poorly lit and shadowy areas.

In the past, the use of fill flash has been far too complicated for all but the most serious outdoor photographers. However, with recent advances in technology, flash has become a useful and surprisingly simple tool for outdoor photography. In particular, fill flash can enhance your photographs significantly by reducing contrast, stopping action, and warming up your subject. It extends the range of light conditions in which you can take satisfying photos, to include severe side- or backlighting, bright sun at high noon, or deep shadows. In addition, fill flash can enhance your creativity, allowing you to capture action and enhance your subject in ways that would not be possible without the flash.

To look natural, the fill light source—your flash—must not overpower the ambient light provided by the sun. Thus, fill flash should, in general, be balanced with the ambient natural light level. Sometimes it should be a bit brighter than the ambient light, to make the subject stand out from the background. But usually it should be less bright than the ambient light, to leave some shadow on the subject. This balancing is the hard part.

When you photograph people or animals, flash can cause the subject's eyes to glow a bright, unnatural red. This problem, called redeye, is particularly noticeable in photographs taken in relatively low light, when your subject's pupils are open. To avoid red-eye, use a flash that has red-eye reduction, which means that the flash actually fires two or more times. The initial bursts close the subject's pupils; the last burst provides light for the photograph. Additionally, position the flash at an angle to your subject. Either attach the flash to a bracket or hold the flash away from the camera, using an extension cord as described later in this section.

Automatically balanced flash. If your camera is capable of *automatically balanced fill flash* by means of a built-in flash—like virtually all automatic point-and-shoot cameras made today and some SLRs—or by means of a separate unit mounted on your SLR camera's hot shoe, then your equipment can do the hard part for you. In general, these flashes (a type of TTL flash) are smarter than you are, at least when it comes to estimating flash output. They communicate with the camera to get exposure settings

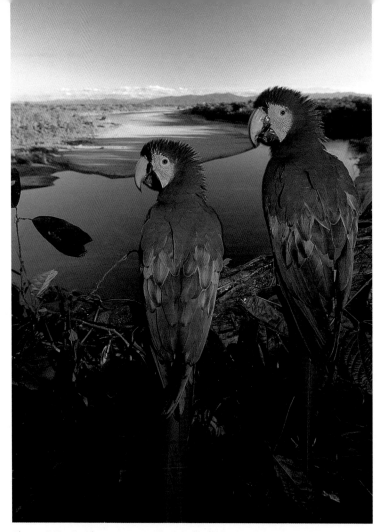

Photo 5-7: *Scarlet macaws, Rio Tambopata, Peru* (© Art Wolfe)
Here I used a 20mm wide-angle lens and positioned my camera near these wild macaws, which had become habituated to people near a remote rain forest research station. The macaws were perched in a shadowed area above the bank of a river. To make the image, I properly exposed for the distant landscape and then used fill flash to bring out the color in the birds. If I had not used fill flash, the birds would be dark shapes and the image would not be nearly as good. (AW)

and ambient light level as read by the camera's through-the-lens (TTL) light meter, and then calculate the appropriate flash output. When you take the picture, the flash reads the light reflecting back to the camera and shuts the flash off when the correct light level has been reached.

If you have one of these smart flashes, just read your owner's manu-

als, experiment, and let the flash do the work. However, sometimes you have to fool the flash with a few tricks to get better pictures. Even though balanced, most of these flashes will produce an unnatural-looking image. Flash is direct front lighting, which, as discussed in chapter 3, can produce flat, unsatisfying photos. Thus, you should reduce the flash output by one to two stops relative to the ambient light level to achieve a more natural look. This will reduce highlights caused by the flash reflecting off bright surfaces, and will leave enough shadow to look as if you did not use a flash. Consult your flash's manual for details on how to do this, and experiment to learn how much reduction you like best. If you have a fully automatic camera that you cannot override, like most point-and-shoots, tape a piece of translucent paper over the flash to physically reduce its output.

If you want a background that is a little darker, to enhance a foreground subject, then use the fill flash as you normally would, but underexpose the background by using matrix or evaluative metering and dialing in exposure compensation in your camera. For example, to underexpose the background by one stop, set the exposure compensation to subtract one stop. Also, try increasing the flash by one stop. If you have only center-weighted metering, meter the background, underexpose it by one stop, and add a stop to your flash setting. Consult your camera's and flash's manuals for further details.

The light produced by flash is typically balanced to match the color and temperature of bright, midday light. During daylight hours, this works just fine. However, early or late in the day, when the natural light is much warmer, this difference can create a very unnatural look. Hold a sunset filter, 85 series gel, or some other warming filter over the flash to better match its output to the color of the natural light.

Through-the-lens (TTL) flash. You can also use just about any automatic TTL flash unit as a fill flash, even if it does not automatically balance its output as just discussed. Automatic flashes are designed to be used as the primary light source indoors or at night. Thus, to use them effectively as fill flash in daylight, you must reduce their output. To do this, first determine the proper exposure without flash for the scene you want to shoot. If you have a camera with automatic exposure (AE) modes, set it to manual mode. Then set the shutter speed and aperture manually. Make sure you set the aperture big enough for your flash's power, and the shutter speed no higher than the maximum shutter speed your camera can use with a flash, usually 1/125 or 1/250 second.

If your camera has a built-in TTL flash, increase your camera's ISO setting one to two stops, but do not change the aperture or shutter speed settings. This is not the same as pushing your film, so process it

normally. Do not forget to reset the ISO number when you are finished using fill flash. If you have a separate unit, increase the ISO setting, or decrease the f-stop one to two stops on the back of the flash. Consult your flash's manual for the best way to reduce its output, and experiment to find out what works best for you.

Accessories. Moving the flash a foot or two away from the camera, if possible, avoids the harsh front lighting of on-camera flash, and may be required if the subject that you want filled in is off center. A number of mounting brackets are available for your flash, or if the subject is not moving around, you can simply hold the flash in your hand, aiming it at your subject. Either way, you will need a cord between your camera's hot shoe and your flash. Finally, bouncing or diffusing the flash's light will soften its effect and reduce distracting highlights, often producing a more satisfying result. Several pocket-size diffusers and reflectors are commercially available, but a white tee shirt, white paper, or aluminum foil will work just fine.

A final note: these flashes are very power hungry, so carry plenty of extra batteries in the field. If possible, carry your flash's manual with you in the field.

Reflectors, Diffusers, and Shadows

Light can also be managed to make better images by using something to reflect, diffuse, or block the light illuminating a subject, as well as by moving the subject out of harsh light into more even light. So before shooting, consider how you might improve the light falling on your subject or move the subject into better light.

Reflectors. You can use a shiny surface to reflect light back onto your subject to eliminate dark shadows and even out the contrast. In effect, this works just like fill flash. When using a reflector, you are filling in the shadows with light bouncing off the reflector. This method is especially good for shooting people and other smaller subjects in sunlight. For field use, the best reflectors are the collapsible disks that are available in several sizes in camera shops. But any reflective surface will do, including aluminum foil or white poster board.

You can also move your subject out of the harsh sunlight into light that is reflected from an object such as a wall, a tablecloth, or even the ground. Snow makes a great reflector. The Kayapo mother and child in Photo 3-11 are standing just inside the shadows and being lit by light reflecting from the ground. Be careful with the color of the reflector, as the reflected light will take on the color of the reflector, which may be slightly, but noticeably, different from the light falling directly on the subject.

Diffusers. You can keep harsh, direct sunlight from reaching a subject by placing a piece of loosely woven fabric between the sun (or any other light source) and the subject. This reduces the harshness of the light on the subject and evens out the contrast, making a much more appealing photograph. For field use, the best diffuser is a collapsible disk with a white mesh fabric, available in camera stores in several sizes. These disks fit easily into a backpack, so get the largest size you can handle. However, any neutral-colored mesh fabric will do, such as mosquito netting, an umbrella with a thin, light fabric, or the gauze from your first aid kit wrapped across a frame (be sure to replace the gauze in the kit).

If you do not have a diffuser or your subject is too big, move your subject into light that is being diffused by an awning, a trellis, or even vegetation. This approach is especially useful when photographing people who can walk into better lighting. Again, be careful of the color of the diffused light.

Shadows. You can also eliminate harsh, direct light by placing something between the sun (or other light source) and the subject to create a shadow, or by moving the subject into a shadow. This technique evens the light falling on the subject and will result in a more appealing image than one taken in direct sunlight. However, a subject in shadow is being illuminated by light reflected from something that may significantly change the color of the light, as discussed in chapter 3. Light diffused by the atmosphere will be significantly cooler than direct sunlight (see chapter 3), necessitating the use of a warming filter as discussed earlier.

Just about anything can be used to create a shadow. The collapsible reflectors discussed earlier can also be used to block light. Just about any solid object, including another person, can be used.

ON AND IN THE WATER

Photographing on and in the water can be hard on both camera gear and photographer, but can result in a variety of pleasing images. Unfortunately, most people put their cameras away and do not even consider photographing while rafting, kayaking, snorkeling, or doing other water activities. Thus, they often miss some great photo opportunities, like **Photo 5-8**.

Standard SLR and point-and-shoot cameras are meant to be kept dry but can survive a few drops of water or a bit of spray. So keep them accessible but protected. When photographing from a boat, store your camera in a sealable plastic bag, commercial dry bag, or waterproof box, as described earlier. Then, whenever there is little chance of serious dunking, you can take your camera out to photograph. If your

Photo 5-8: *Snorkeler with wild dolphin, Cayman Brac* (© Mark Gardner)

hands are wet, keep a small towel with your camera to dry your hands before shooting.

If your camera does get doused or, worse, dropped in the water, it may survive just fine. When it is wet with freshwater, open the camera, place it in a warm, dry place, but not in direct sunlight, and allow it to dry. If possible, put the camera in a sealed container with silica gel to wring out the last bit of moisture. The camera should work, but if not, it may be repairable. When the camera is wet with saltwater, you may have a much more serious problem. Saltwater is extremely corrosive and may affect the electronics and more delicate metal parts of the camera very quickly. Immediately rinse the camera thoroughly with freshwater, and air-dry it as just described. Then take or send the camera to a repair facility before using it.

A variety of options are now available for shooting in situations in which your camera is sure to get wet, whether under the water or on the surface. There are several full-featured underwater cameras that work just as standard point-and-shoots do. Such a camera can double as a backup camera for dry land. There are also a variety of "splashproof" or "weatherproof" point-and-shoot cameras on the market. These are fine for shooting in the rain, but may not withstand repeated dunking on a white-water rafting trip.

Alternatively, there are a variety of underwater housings available that are made to fit most popular digital and film cameras. Once your camera is safely inside the housing, you have enough access to the camera's functions to use it normally. These housings fall into two categories. The first includes hard cases made of tough, clear plastics or metal or both, with a lens port. These are just about bombproof if used properly and provide full access to your camera's functions. Unfortunately, they are also expensive, bulky, and difficult to travel with. Many

Photo 5-9: *Splashed, Tieton River, Washington* (© Mark Gardner)

dive shops rent housings, but a shop may not have one that fits your particular camera.

The second type of housing includes soft cases made of flexible but durable plastic. These do a good job of protecting your camera, provide full access to your camera's functions, and are much less expensive. However, they are limited to depths of 30 feet (10 meters) or so and do not protect your camera from hard impacts. But they do collapse for easy packing, so they are ideal for river rafting, snorkeling, and even shallow scuba diving. **Photo 5-9** was made with such a housing during a white-water rafting trip on which everyone, including the photographer, was repeatedly soaked by breaking waves. Without the housing, the shot would not have been possible.

Another alternative when shooting in these situations is to buy single-use underwater cameras. These are widely available in dive shops and tropical aquatic destinations. They are fun and easy to use, and take surprisingly good photographs. However, they use only print film and offer very little creative control.

Underwater photography. Serious underwater photography has always seemed a bit forbidding to many photographers—and somehow a world apart from photography in general. However, with the advent of easy-to-use underwater cameras, as well as housings to fit popular SLR and point-and-shoot cameras, underwater photography is now easier than ever. For the most part, shooting underwater is just

like above-water photography. You still use a camera much as you do above the surface, and the principles of composition still apply. But the underwater world does limit the types of images you can make.

Water affects light in several ways. Refraction causes objects under water to appear 25 percent closer than they really are. Consequently, a 35mm lens becomes a 50mm lens underwater. This means that you must shoot with wider-angle lenses than you would above the water. For example, use a 20mm lens to take photographs such as a snorkeler exploring a shallow coral reef, or a brightly colored school of fish, as in **Photo 5-10**.

The intensity of light fades very quickly underwater, losing about a stop of light for every 10 feet of depth. You should get as close to your subjects as possible, stay in relatively shallow water, and shoot at high noon. You may also have to push your film a stop or use faster film, or a higher ISO setting on your digital camera. Because light fades, you can see only 100 feet or so, even in the clearest water, so you cannot photograph big "landscapes" underwater. **Photo 5-11** is about as big an underwater scene as you can photograph.

The color of light also changes with depth, with the red end of the spectrum being absorbed first. Thus, underwater photographs often have a blue or blue-green color cast, as in Photo 5-11. This can be partially counteracted by the use of filters, special underwater film, and, for smaller subjects, the use of flash. Fill flash can restore some of the lost colors. When deeper than 20 or 30 feet, you may need to use a flash or two as the primary light. However, since the light from a flash

Photo 5-10: *Butterfly fish, Bora Bora, French Polynesia* (© Art Wolfe)

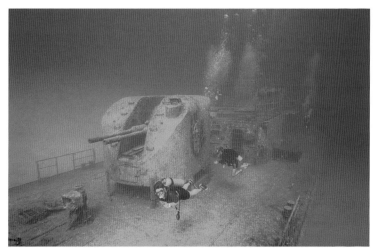

Photo 5-11: *Diving on shipwreck, Cayman Brac* (© Mark Gardner)

is attenuated very quickly, its use is limited to photographs of relatively small and close subjects.

Working underwater creates a number of additional challenges. While the underwater environment is made accessible by the use of snorkel or scuba gear, the time available to photograph is limited. You can make excellent images while snorkeling. Although you are tied to the surface, there are no bubbles to frighten the fish, and the light is best in the shallows. With scuba, you have more time to get the best images, but must be careful to dive safely.

Perhaps the biggest challenge is that you cannot change film or memory cards underwater. Serious professionals solve this by using multiple cameras. But for those of us with only one camera, this can be a real problem. Once you have shot the roll or filled the card, you are finished until you leave the water to change film or cards. So you have only as many shots as your film or memory card will hold.

With film cameras, you have at most 36 exposures. Film is cheap; always start with a fresh roll of film. If you have an unfinished roll in your camera, finish it and reload before returning to the water. With digital cameras, you can get far more images by using a larger memory card and shooting at lower resolutions. Either way, be selective and use your film or memory wisely.

Opposite: *Red Rock Camp, Utah* (© Mark Gardner)

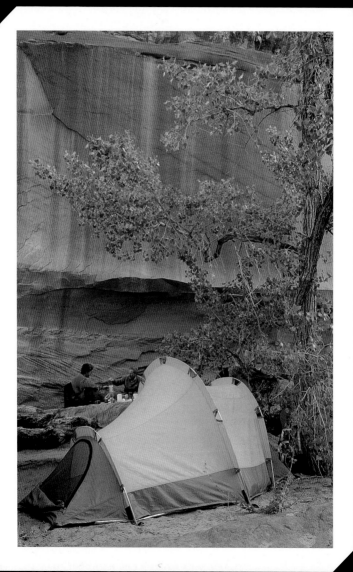

Outdoor adventure in local parks, remote backcountry, or faraway lands can provide a wide range of unique photo opportunities. The pursuit of adventure often takes you to places with outstanding scenery and wildlife that most people never see and opens a window to exotic, but often disappearing, peoples and cultures that most people only read about. The adventure itself also makes for exciting photographs. Climbing, for example, is full of great shots like a death-defying leap over a crevasse, a seemingly impossible move up an overhanging rock face, or the final struggle to a peak's summit.

Given the photo opportunities that most outdoor adventures provide, it is often worth taking the extra steps to make a great photograph rather than grabbing a quick snapshot. The shots you take along the way will last far longer than the trip itself. Moreover, you spent a lot of time and effort to be there, so taking the care and time to get the photographs you really want will be worth it in the long run. To get those shots, slow down, take the time to really see what is going on around you, and apply the principles covered in this book. This chapter adds a variety of tips, ideas, and techniques that will help you get better photographs of the people, action, scenery, flora, and fauna you experience.

The first step is to take your camera gear along and keep it at your fingertips. You cannot take pictures if your camera is buried in your backpack or luggage. After that, it is just a question of applying the techniques in this book. Find a worthy subject, which should be easy, and develop an eye-grabbing composition that best shows that subject and eliminates the surrounding clutter. Work the light, getting up early or staying late for the magic hour, looking for the drama of clearing storms, the simple interplay of light and shadow, or the soft, even light of an overcast day. Use your camera as a creative tool, not just a recorder. But remember, adventure travel can be hazardous, and taking pictures can make it more so. Focus first on your own safety, and second on getting good photographs.

Most outdoor adventures keep you moving and end far too soon, limiting the time you have for photography. To make the most of the time you do have, think before and during the trip about the shots you want to get. Then watch for opportunities along the way to get those shots. Working out the shots well before you actually take them can save a lot of time and film while you are out there. Advance research can also save time when you are traveling in new and unfamiliar locations. Look through travel guides, magazines, and coffee-table books to get ideas for locations and compositions. Once you get there, look at

postcards and promotional literature for additional information and ideas. Ask residents and other travelers for information; they are often more than happy to let you in on local secrets that are not included in guidebooks.

TELL A STORY

The shots that we take often fill scrapbooks, grace our walls, or become slide shows. Through them we get to relive the adventure and share it with others. So telling a story is often a big part of adventure photography. Two guidelines can help you tell a more entertaining and memorable story.

First, do not try to cover the whole experience in one or two shots. Rather, take a collection of photographs, each of which tells a single part or aspect of that story. When composing each shot, think of how the composition communicates its part of the story and how it fits into the story as a whole. For example, **Photos 6-1** through **6-3** tell a story about the north woods in the fall. Photo 6-1 gives the big picture of the forest. Photo 6-2 shows the forest interior, and Photo 6-3, the forest floor.

Second, when deciding what to photograph, treat your story like an adventure movie that includes all the important pieces and nothing more. Start with shots that show the setting, your travel to the setting,

Photo 6-1: *Fall colors of the north woods, Minnesota* (© Art Wolfe)

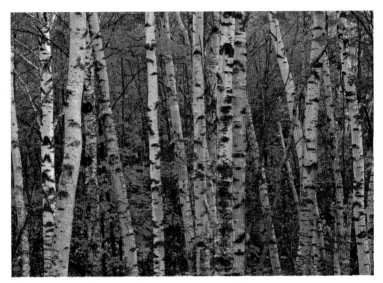

Photo 6-2: *Birch trees, Minnesota* (© Art Wolfe)

The soft, diffuse light created by mist or an overcast sky creates the best light for landscapes like this one. If it had been a bright, sunny day, the shadows and contrast would have created an image that would be much less appealing. So I waited for soft, even, indirect light, and made this image with a telephoto lens to isolate the trees, thus creating a very graphic composition. (AW)

Photo 6-3: *Forest floor, Minnesota* (© Art Wolfe)

especially if it is something as exotic as a camel train, and your starting point. Include any recognizable landmarks or features, such as a Buddhist monastery or a well-known peak, to give your story a place. Then peel back a layer to show the details of that place and your activity, including smaller-scale scenic shots, slices of life along the way, and adventure action, as well as close-ups of people and whatever defines their culture or activity. You might try switching back and forth between your adventure and the surrounding environment. End the story with some logical conclusion, such as a triumphant return to base camp or the farewell party prior to returning home.

ADDING PEOPLE

People, their activities, and the trappings of their culture are an important, if not the most important, aspect of our travels. People themselves or their emotions and actions can be the subject of a photograph, as are the sing-sing dancers in **Photo 6-4**. Or they can be a supporting element that increases the viewers' involvement with the scene, often evoking an "I wish I were there" reaction, as do the people viewing the Eiger in Switzerland in **Photo 6-5**.

Either way, including people in your photograph has a powerful

Photo 6-4: *Sing-sing dancers, Papua New Guinea* (© Art Wolfe)

Photo 6-5: *The Eiger, Switzerland* (© Mark Gardner)

impact on its composition. For example, a viewer will follow their line of sight to see what they are looking at, and their line of travel to see where they are going. Viewers will also be immediately drawn to faces to see if they are recognizable and to read the emotions revealed in their expressions. So be careful how you incorporate people into your pictures. When included appropriately, people make high-interest subjects and can play a strong supporting role, but if not, they can detract from an otherwise good composition.

People as Part of a Scene

When the objective of your photograph is to show the scenery in which your adventure is taking place or to show the adventure in the context of the surrounding environment, then include people as a supporting element. When they are close to you and will be larger in the photograph, use a wide-angle lens and place them in the foreground or off to one side as they look into the scene. Their presence will provide the viewer with a sense of scale and draw the viewer into the scene. Avoid showing faces that will draw attention away from the subject. Rather, have them looking at whatever they are doing or toward the subject itself. Try shots with people perched on the edge of a cliff or gazing at the scenery beyond them, as in **Photo 6-6**.

Photo 6-6: *Trekkers, Khumbu Valley, Nepal* (© Art Wolfe)

People as the Subject

On the other hand, when your objective is to show the people themselves, then they should clearly be the subject of the image. Fill the viewfinder with them, as in Photo 3-11, of the Kayapo mother and child. At least make them large enough in the photograph to ensure that their faces and actions are clearly visible. When people are relatively large in the scene and facing the camera, focus on the face, and try to show facial expressions. You can also make portraits of people that include the surrounding environment, which can give them context and define who they are, as in the photograph of the man in the Kashgar market, **Photo 6-7**.

People's emotions are often a big part of any adventure, and their expressions will communicate the emotions they are experiencing, such as the enjoyment shown by the kayaker in **Photo 6-8**. Capturing the tension on a climber's face after a tough move or the exuberance on the faces of rafters who have just made it through a tumbling stretch of white water can add a lot of drama to both the image itself and the story you are trying to tell. However, a relatively large face that is in full view but out of focus can detract significantly from your composition. When you

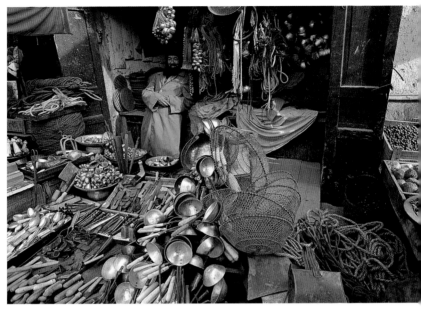

Photo 6-7: *Kashgar market, Tian Shan, China* (© Art Wolfe)

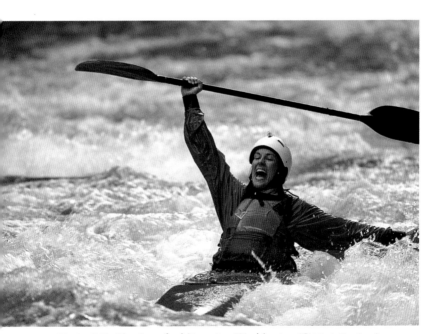

Photo 6-8: *The Joy of whitewater, Washington* (© Mark Gardner)

want to emphasize your subjects' activity rather than the subjects themselves, have them look at what they are doing rather than at the camera, as in the photograph of the Dani tribespeople, **Photo 6-9**.

People in Action

When shooting action, try positioning people in one of two ways—moving into the frame, to show where they are going, or moving out of the frame, to show where they have been. A diagonal line of travel, such as the skier's line of descent in **Photo 6-10**, will enhance the sense of movement. For example, a cyclist or hiker could be positioned in a lower corner of the image, with the trail ahead of him or her leading toward the upper part of the image. Or when shooting with a wide-angle lens to accentuate the vertical, place a climber high in the frame, with the rope trailing down the image toward the belayer at the bottom of the pitch, as in **Photo 6-11**.

> **TIP**
>
> When showing people in action, shoot from behind them, placing them low in the frame moving upward and away from you, or in front of them, placing them high in the screen moving downward and toward you.

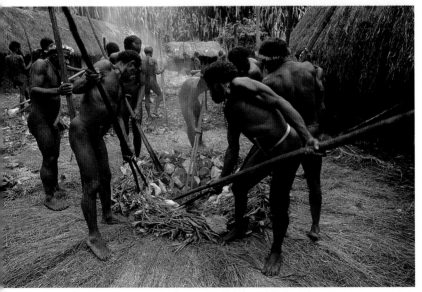

Photo 6-9: *Ceremonial feast, Dani tribespeople, Irian Jaya* (© Art Wolfe)

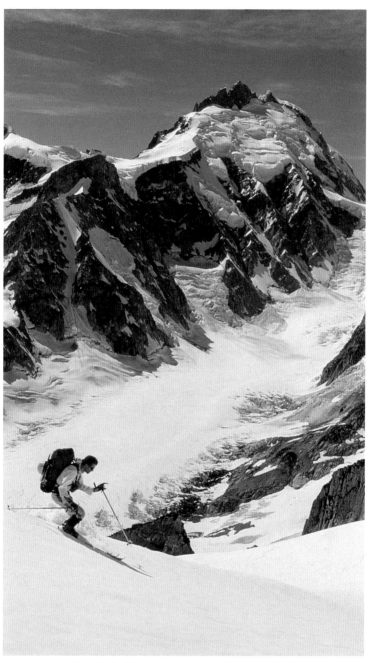

Photo 6-10: *Skier* (© Carl Skoog)

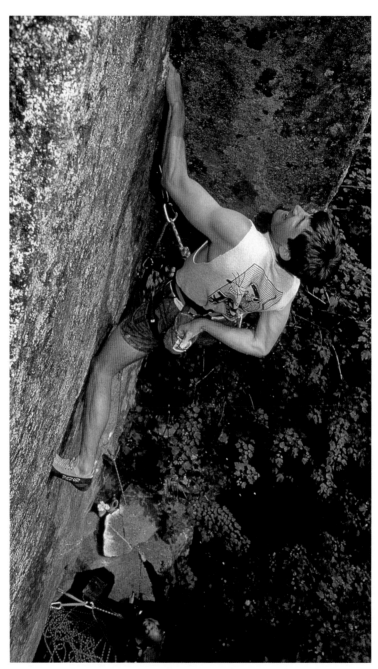

Photo 6-11: *Climber* (© Carl Skoog)

Try shots with your subject just in front of you, positioned low in the frame, like the rafters in **Photo 6-12,** as if you are looking over his or her shoulder. Alternatively, you could place your subject facing you low in the frame, showing where he or she has been, as in **Photo 6-13**. These perspectives give your viewer the feeling of being along on the adventure with you. If your subjects are farther away, position them high in the frame, moving toward you with their line of travel in front of them, or moving away from you with their line of travel behind them. For "in-your-face" action, try a wide-angle lens, have your subject moving right at you or just to one side, and wait until the last second before pressing the shutter-release button, as in **Photo 6-14**.

To create a dark backdrop against which to shoot the action, position yourself across from a sunny spot with a deep shadow behind it. Determine exposure in the sunny area, using a shutter speed to get the effect of motion that you want (see Table 2-1, chapter 2). Then shoot your subjects with a telephoto lens as they emerge from the shadows into the sun.

Using fill flash while shooting action at slower shutter speeds, like 1/30 second, can create some interesting effects, as in **Photo 6-15**. Your picture will still have the impression of action and speed, but all or part of your subject will be frozen inside the whir of mo-

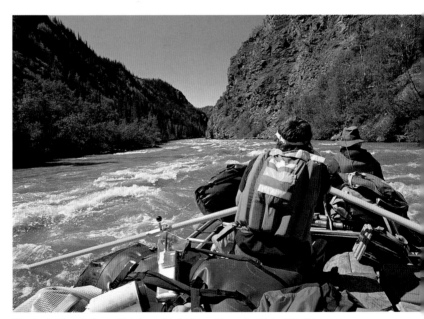

Photo 6-12: *Rafters, Tatshenshini River, Canada* (© Art Wolfe)

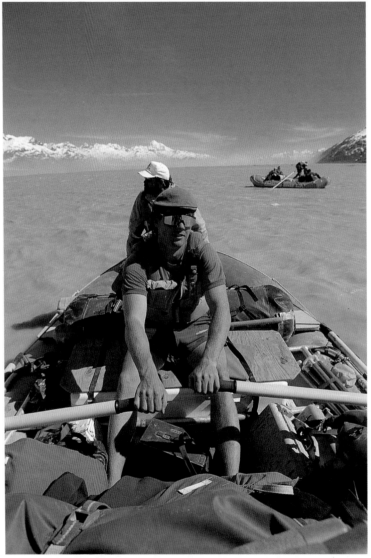

Photo 6-13: *On the Tatshenshini River, Canada* (© Art Wolfe)

tion. The flash also puts a catch-light, a tiny reflection of the flash's light, in the subject's eyes, adding more life to the photograph.

For best results, use rear-curtain synchronization if your equipment has that capability. Normally, the flash fires just as the shutter begins to open. In rear-curtain synch, the flash goes off as the shutter

Photo 6-14: *Skier, Idaho* (© Mark Gardner)

closes, leaving a trail of motion behind the subject. Consult your flash's and camera's manuals to understand how to do this with your system.

Campsites. Your campsite can provide a number of unique images. To shoot fireside scenes, put your camera on a tripod, compose the image, and focus. Then remove the camera from the tripod and move the camera close enough to fill the middle of the frame with an object, such as a person's face, that is reflecting the warm glow of the firelight. Set the exposure, return the camera to the tripod, and, using a cable release or self-timer, shoot. If you have trouble determining exposure, try a shutter speed of 1/2 second and an aperture of f/5.6 with ISO 100 film.

Combining a flash with the techniques for night scenes (see "The Sun, Moon, and Stars," later in this chapter) can result in creative images. An illuminated tent in the foreground with peaks warmed by alpenglow, star streaks, or a full moon in the background is a favorite outdoor image and is easy to shoot. To shoot a glowing tent at dusk or night, like **Photo 6-16,** simply put someone in the tent with a flash, and shoot the scene as you would without the tent being lit. While the shutter is open, have the person inside the tent pop the flash once or twice, being careful not to point the flash at the camera.

Then close the shutter. For best results, the tent should be in a foreground that is much darker than the background. Other eerie scenes can be created by using the flash, or even a flashlight, in the same way to light objects in a dark foreground.

Composition with people. When people's faces are not visible or people are relatively small in the scene, viewers recognize them as people by their shapes or forms. Be sure to show that shape distinctly; do not lose it by having all or part of it seem to merge into some other object. For example, heads and necks often seem to merge with backpacks that protrude above the shoulders. The compression effect of telephoto lenses can magnify this problem. Check the background to make sure there is no object of a tone similar to that of the subjects, to prevent having the subjects merge with that object in the resulting photograph. To make people really stand out, have them wear bright, contrasting colors such as yellow or red. Many professional adventure photographers even carry a packable red or yellow windbreaker for just that purpose.

Be careful how you position people near the camera when shooting with a wide-angle lens. The distorting effect of a wide-angle lens will make whatever is closest to the camera appear much bigger in proportion to the rest of their bodies. Unless you want the distortion, position them farther from the camera, or keep their bodies in a single plane parallel to the camera lens. Avoid having them extend an arm

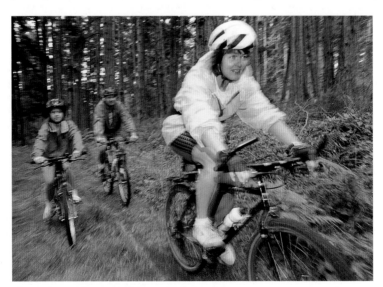

Photo 6-15: *Mountain bikers* (© Mark Gardner)

Photo 6-16: *Night camp and star trails, Utah* (© Mark Gardner)

toward the camera or bend over with their backsides toward the camera, a position that will make them appear unflatteringly large. For example, when photographing climbers, shoot down or across at them, avoiding the inevitably bad "butt shot" from below.

Local people. When traveling in unfamiliar lands, be sensitive to the values and mores of the local people. Avoid being too obtrusive or too sneaky. Even in societies in which photography is familiar and accepted, people may feel that you are invading their privacy, and they may mistrust your presence. Always ask permission to take close-up photographs of people. If your potential subject declines, respect his or her wishes. If a subject asks for a copy, record his or her address, and do not forget to send the picture. In many places, especially those with plenty of tourist traffic, subjects may request payment. If you feel that your subjects are indeed providing you a service, then a small gratuity or donation may be just fine. However, if they are obviously trying to take advantage of you or you simply cannot afford their request, then thank them and find something else to photograph.

Once you have your subjects' permission, then gain their acceptance. When you approach people with a camera, their first instinct is either to hide or to pose, neither of which makes for great images. Give them time to relax and get to know you and your intentions. Even if you are posing your subjects, allow them time to work into the situation and develop a more natural position. Keep a comfortable distance from your subjects by using a medium-length telephoto lens. Otherwise your subjects will be too affected by the presence of the camera, and your objective will be compromised. Once they forget about you and your camera, you will usually get better photographs.

PHOTOGRAPHING LANDSCAPES AND SCENICS

When shooting open landscapes with a wide-angle lens, put something interesting in the foreground to provide a sense of scale and a connection between the viewer and the landscape, such as the moose antlers in Photo 3-5. Use a small aperture, f/16 or smaller, to ensure enough depth of field to keep both foreground and background in focus (see chapter 4). Wildflowers, animals, weathered wood, rocks, and even people can work. Use lines, either implied lines like a person's line of sight, as in Photo 6-6, or explicit lines like the driftwood on the beach in Photo 2-14, to lead your viewer through the image toward the subject. However, be sure not to overwhelm the image with a foreground element that distracts the viewer from the landscape itself.

> **TIP**
>
> When shooting landscapes with a wide-angle lens, include something interesting in the foreground and use an aperture of f/16 or smaller.

Do not limit yourself to wide-angle lenses when shooting landscapes; lenses with medium to long focal lengths can also produce very pleasing, but different, images. Shorter-focal-length, or wide-angle, lenses open up a scene and emphasize its vastness. Longer focal lengths compress the elements in a scene, giving the resulting image a more intimate feel. This compression can be used, for example, to make a building storm cloud appear to loom broodingly above a farmhouse or town in the foreground. Telephotos are also a great way to extract interesting compositions from a landscape, to eliminate distracting clutter, and to isolate one particular subject within a bigger scene.

If your image has a horizon line, position it to best support the composition. At a minimum, make sure that it is parallel to the bottom of the frame. Even a slightly slanted horizon line that obviously should be straight is very distracting. Focusing screens with an architectural grid and small bubble levels that attach to your camera's hot shoe can help align your camera. Place the horizon high in the image when you want to emphasize the foreground and low in the image when you want to emphasize the background or the sky itself. Avoid placing it in the middle of the frame, where it creates a more static image, much like a subject right in the middle. However, there are times when a middle placement makes sense—for example, when you are shooting a subject and its reflection, or when there are interesting elements in both the foreground and background.

Excessive contrast is a problem in many landscape and scenic shots, especially during the midday hours, when there are deep shadows and bright highlights. Often a landscape scene has a relatively bright upper half, usually filled with sky or brightly lit by the sun, and a darker lower section unlit by the sun or still in the shadows. This uneven lighting is common, for example, when the low-angled sun casts its warm light on the peaks of a mountain landscape but not on the foreground or the valleys between the peaks. The difference in brightness between the well-lit peaks and the dark foreground often exceeds the range of film, creating a vexing exposure problem.

There are three ways to handle such excessive contrast. First, put as much of the scene's lighter part in the frame as you can, and expose for that lighter part, perhaps underexposing by a half stop to better saturate

the scene's colors. The darker parts of the scene will recede into blackness in the resulting photograph.

Alternatively, put as much of the scene's darker part in the frame as you can, and expose for this darker section. The lighter parts will be a distracting white highlight in the resulting photograph, so eliminate as much of the brighter parts as possible. The first approach is usually better unless you can completely eliminate the distracting brighter section.

The third approach is to use a split or graduated neutral-density filter if feasible (see chapter 5). These filters cut the amount of light from the brighter part of the scene, thus balancing the contrast between bright and dark sections.

Forests and Foliage

Taking pictures inside a forest can be a real challenge. Light levels drop considerably between the forest canopy and the forest floor, making tripods or fast film, or both, essential. In addition, sunlight peeks through the canopy, creating high contrast, with deep shadows and bright highlights, especially in the canopy itself. To make the most effective images, shoot on overcast days, when the contrast and deep shadows found inside the forest are reduced, as in Photo 3-10 or Photo 6-2.

The right exposure for the forest interior will turn even the smallest patches of sky into very distracting highlights. Worse, the sky may fool your camera's light meter, resulting in an underexposed scene. To avoid these highlights, aim your camera low to keep the sky out of the shot, move around until you find the position where the trees and canopy block most of the light patches, or position yourself as high as possible and shoot toward the ground.

Use an 81A or 81B warming filter even on sunny days to counteract the bluish cast to the reflected light bouncing around inside the forest. Such filters bring out the colors of the foliage, especially fall reds and yellows. Foliage itself is also quite reflective, especially when wet, and those reflections can wash out the colors within the forest. Use a polarizer to eliminate this glare and better saturate colors. Unfortunately, a polarizer also cuts one to two stops of light, making a tripod essential.

> **TIP**
>
> When shooting inside of forests, aim the camera low to eliminate the sky peeking through the canopy and include something colorful such as a person with a red jacket.

Forests can be a jumble of chaos that seems impenetrable. But a good photographer somehow finds order and creates good compositions. Try an unusual point of view, such as lying on the ground, and shoot up through the canopy, as in **Photo 6-17**. Or look for silhouetted shapes of trees, as in **Photo 6-18**, and patterns in the repetitions of tree trunks, as well as the textures of the trunks themselves, as in Photo 6-2. Layers of mist can create a sense of mystery and depth, as well as hide much of the chaos, as in the Costa Rican cloud forest in Photo 3-10. Use medium-length telephotos to extract simpler images from the forest, or wide-angles to open up the forest.

The high contrast found inside the forest can also be used to your advantage. Bring colors and brighter objects forward by using darker shadows, which will go completely black, as a backdrop. Interject some color. Most forests are monotonously green and brown. When shooting forest interiors, find a colorful wildflower, or put a person dressed in red or yellow in the foreground, looking into the forest.

Fall, with its riot of color, provides incredible photo opportunities. You can shoot close-ups of bright red or yellow leaves against a green,

Photo 6-17 : *Aspens, Banff National Park, Canada* (© Art Wolfe)
In this photo, I am shooting straight up the trunks of the aspen trees with a wide-angle lens. This is an unusual perspective compared with a more typical shot made straight through a forest, as in Photo 6-2. I used a polarizer, which enabled me to darken the sky, creating a pleasing contrast between the yellow fall foliage and the blue sky. And I stopped down to f/22 to ensure that all the tree trunks were in sharp focus. (AW)

Photo 6-18: *Sunset, Okavango Delta, Botswana* (© Art Wolfe)

out-of-focus backdrop or big landscapes showing the patterns of color on distant hillsides, with individual trees in the foreground. Use warming and polarizing filters, even on overcast days, as well as a highly saturated film to make the fall colors really pop out.

> **TIP**
> To saturate the colors of vegetation, use a polarizing filter.

Backlighting can make fall colors look as if they are almost on fire. Try taping a colorful leaf on a window and shooting it from indoors with the sun directly behind it. To shoot bigger scenes with a wide-angle lens, put colorful trees in the foreground between you and the sun. Or shoot hillsides full of color with a telephoto when the sun is low in the sky and opposite your position. Meter on the foliage itself as a medium tone and keep the sky out of the scene. Shade the front of your lens with your hand or hat to prevent flare.

Snowscapes
As with forest scenes, capturing satisfying snowscapes, like Photo 4-6, is a challenge because of the excessive contrast between white snow and deep shadows, as well as because of the way your camera's meter works. Photographing when the light is the most even, on overcast days or early or late in the day, produces the best results. Use a low-

contrast film with a neutral-to-cool color bias to ensure white snow and reduce contrast in your photograph.

Exposure on snow can be tricky. If the frame is mostly filled with snow and you use the exposure indicated by your camera's light meter, the snow will be gray in the resulting picture. People's faces and other light- to mid-toned objects will also be underexposed. To ensure a proper exposure, meter highlighted snow and open up one to two stops. One to one and a half stops will preserve detail in the snow but lose detail in the shadows and dark objects. Two stops will produce bright white snow, without detail, and leave more detail in darks. Experiment to get a feel for the difference and see what you like best. The same techniques also apply to scenes filled with light-colored sand, such as dunes or beaches.

Making a Blue Sky Blue

Washed-out skies are the scourge of many otherwise good photographs. Several techniques can really bring out the blue in the sky. First, use a polarizing filter, which eliminates the scattered white light that washes out the blue. For best results, keep the sun at your left or right shoulder, and be careful at higher elevations, where a polarizing filter can make the sky go almost black. Haze and UV filters also work, especially at higher elevations. Second, use a film with saturated colors that brings out the blue in the sky. Third, meter on the medium tone of the blue sky itself, well away from the sun, or try underexposing a half stop, to darken the sky. Finally, choose the right times and places: shoot early or late in the day and away from cities, where increased pollution scatters light even more.

Cloudy bright conditions are ideal for landscape photography. However, the sky in your photograph will be a big, bright highlight that will detract from the composition. Thus, you should minimize or eliminate the sky when it is overcast but bright. If the sky is unavoidable and it is two or more stops brighter than the rest of the picture, then use a graduated neutral-density filter to even out the contrast. Doing so can also create a more brooding or stormy feeling in your photograph.

The Drama of Bad Weather

Lightning storms are best shot against a dark sky of twilight or night, as in **Photo 6-19**. Before shooting, watch the lightning, noting where it is striking and how much time there is between bolts, so that you can anticipate where to aim your camera and when to open the shutter. Reacting to the lightning will usually not work; it will be gone by the time the shutter opens. With your camera and a normal or wide-angle

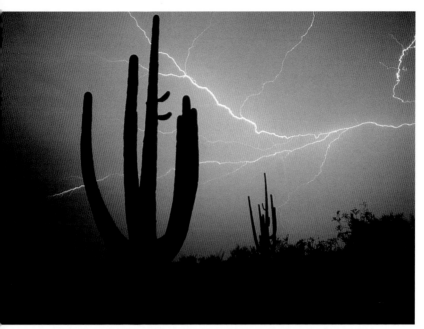

Photo 6-19: *Lightning over cacti, Saguaro National Monument, Arizona* (© Art Wolfe)

lens mounted on a tripod, compose your image with some foreground and plenty of dark sky, focus at the hyperfocal distance for your lens or at infinity, set the shutter speed to B, and select a relatively large aperture, such as f/5.6 with ISO 50 to ISO 100 film or f/8 with ISO 200 film.

Anticipating the next strike, open the shutter, using a shutter-release cable, long enough to record several strikes, usually 10 to 30 seconds. If it is really dark out, you can leave the shutter open for longer periods to record multiple strikes, covering the front of the lens in between strikes. This technique also works well for fireworks and night traffic. During the day, add a polarizing filter to darken the scene sufficiently. If it is raining, use a lens shade and an umbrella to keep water off the lens and camera.

To show the rain itself, position yourself so that the rain is strongly backlit or sidelit, preferably against a darker background. Try underexposing by one-half to one stop to let the rain really stand out. Use a shutter speed of 1/125 second to show the raindrops, or 1/30 second or slower to get backlit streaks. Rain softens scenes photographed at very slow shutter speeds, often creating unique images.

When the sun comes out during or at the end of a storm, lighting conditions can be intensely dramatic, especially late or early in the day.

The light itself can take on unusual colors and create unusual patterns on the landscape. Look for intensely sidelit or front-lit subjects with dark, purple clouds as a backdrop. Meter on the subject or parts of the scene that are in the sunlight, letting the unlit background become broodingly dark. Also look for sun rays piercing the cloud cover as it breaks apart.

Rainbows, as in **Photo 6-20,** are a delightful side effect of clearing storms, morning mist, and waterfalls. Meter the sky on each side of the rainbow, and underexpose by one-half to one stop to saturate the colors in the rainbow. If the sky behind the rainbow is very dark, underexpose by one to one and a half stops. Use a polarizing filter to make the rainbow really stand out with richer colors, but be careful not to overpolarize and lose the rainbow. To get an entire rainbow in a 35mm frame, use an ultrawide-angle lens, 20mm or shorter.

The Sun, Moon, and Stars
Including the sun in a photograph can make great images like Photo 6-18, but determining exposure with the sun in the image can be tricky. If the sun is in the middle of the image or is a large part of the overall

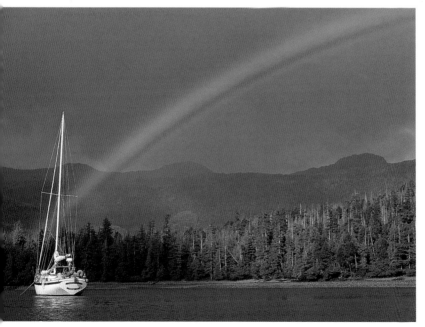

Photo 6-20: **Adventuress** *under a rainbow, Queen Charlotte Islands, Canada* (© Art Wolfe)

scene, it may overpower your camera's meter. To meter properly, swing the camera to the left or right of the sun, eliminating it from the frame. Determine exposure and move the camera back into position. Bracketing will produce lighter and darker images with very different effects. From the original exposure, underexpose by one-half to one stop to saturate the colors, creating a darker, more moody image, or overexpose by one-half to one stop for a lighter, more delicate quality.

To make the sun as big as possible, use a telephoto lens, as big as you have or can create with *teleconverters,* and shoot when the sun is very low in the sky. Set the aperture wide open; the sun may turn into an unnatural polygon if you use any other aperture. Then focus on a subject in the foreground with hard edges such as a tree or a deer. The result will be a striking silhouette against a large sun.

Sunbursts, as in **Photo 6-21**, are also an intriguing addition to a scenic shot and are easy to photograph. First, use a fixed-focal-length lens—zooms usually cause too much flare—and set the aperture to the smallest f-stop. Then position yourself so that you barely see the sun peeking out behind whatever you are photographing. Set the exposure to get the image you want, making sure that the sun does not overwhelm the meter reading.

Photographing the full moon is also quite easy. For a sharp moon with detail, shoot on a clear night with a mid-range aperture and the fastest possible shutter speed (remember, the moon is a moving target). With a telephoto lens, try f/8 at 1/125 second with ISO 100 film, and bracket by one-half to one stop.

If the moon is not in the position you want, move it with a double exposure, or make two images and combine them in the digital darkroom. In the first exposure, photograph the moon as just described, with a telephoto lens, positioning it in the frame as you want it in the final image. Include only the moon and the black sky, which will not be exposed in this shot. Then photograph the second scene, keeping in mind where the moon will be in that image. Determine exposure for the second shot as you would without the moon, perhaps underexposing by one-half to one stop if the scene is relatively bright. For best results, the area where the moon will be should be very dark in the second exposure. In between exposures, you can change lenses, add filters, or reposition to get the final image that you want. For example, use a long telephoto for a big, imposing moon, and then switch to a wide angle and recompose for the second exposure.

Rising full moons at sunset and setting moons at sunrise create very dramatic landscapes. The combination of a full moon low in the sky and a scene lit by the warm light of a sun low in the opposite sky is powerful.

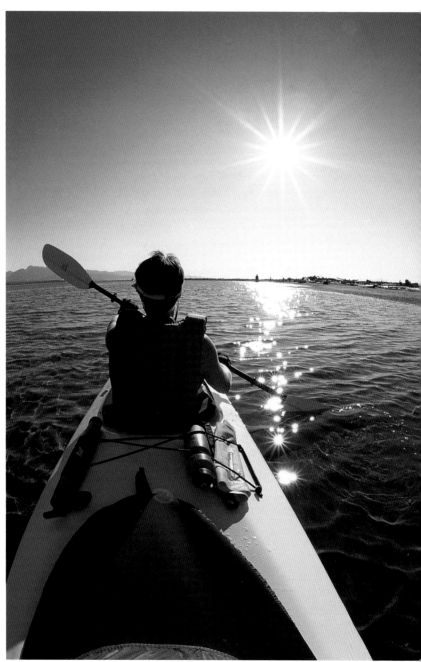

Photo 6-21: *Paddler and sunstar, Washington* (© Mark Gardner)

A scene with a rising moon is best shot around sunset on the day before the full moon. A scene with a setting moon is best shot around sunrise on the day after it is full. Consult the local newspaper for the date of the full moon as well as the times when the sun and moon will rise and set. Determine exposure as you would for any other front-lit scene.

Scenes lit by the light from a full moon, but without the moon in the frame, can create eerie and haunting photographs. Try a shutter speed of 8 minutes and an aperture of f/4 with ISO 100 film. If a lot of snow or clouds make the scene lighter, halve the shutter speed to 4 minutes. If the moon is less than full, leave the shutter open for 12 to 16 minutes, depending on its brightness. Bracket to ensure that you get a good exposure.

To create a sky full of star trails, like Photo 6-16, pick a clear night with no moon or clouds, away from bright city lights. For star circles in the Northern Hemisphere, aim the camera at the North Star, which is in the Little Dipper; in the Southern Hemisphere, aim at the Southern Cross. With your camera mounted on a tripod, compose your image before it gets too dark to see. Set the focus at the hyperfocal distance or at infinity, the aperture to the largest opening (smallest f-stop number), and the shutter speed to B, and attach a locking shutter-release cable. Finally, put a hood on the lens and a plastic bag (shower caps work well for this) over your camera to keep dew off. Then wait.

Several hours after sunset, when the night sky is darkest and the stars brightest, open the shutter by depressing the cable release and locking it down. Leave the shutter open for an extended period, from 15 minutes to 6 hours. Shorter periods turn the stars into streaks, while longer exposures create long curves or circles. It takes about 2 to 3 hours to make complete circles when you are using a telephoto lens, and 5 to 6 hours with a wide-angle lens. To protect your camera from moisture, leave the plastic bag on the camera but not covering the front of your lens. The lens hood will keep moisture off the glass.

You can create interesting star streak compositions in a variety of ways. First, include objects in the foreground, such as trees, rock formations, or even mountains, that will make silhouetted shapes in shorter exposures or dimly lit forms in longer exposures. To incorporate mountains lit by alpenglow, make a double exposure. Shoot the first one after sunset, when alpenglow is at its peak, exposing normally or perhaps underexposing by one-half to one stop to darken the alpenglow's red. Then cover the lens. When the sky is completely dark, remove the cover to add the star trails. Use the same approach to put a firelit scene in the darkness below a sky filled with star trails.

Finally, include tents, people, cactus, or other smaller but interesting

objects in the foreground below the night sky, as in Photo 6-16. Then, while the shutter is open, recording the star trails, paint whatever is in the foreground with light. You can use a flash, not connected to the camera. Point the unit at the object, and fire away. One or two pops may be sufficient. When including tents, pop the flash inside each tent. When using a flashlight, shine it on the subject, moving it around to shower the subject completely with light for several minutes. The amount of light will depend on how close the light source is and how dark the objects are. Experiment on a dark night in your backyard to determine how much light to use.

Capturing eerie images of the pulsating northern (or southern) lights is essentially the same as shooting lightning. Put your camera on a tripod, open the aperture wide, focus to infinity, and set the shutter speed to B. With a cable release, open the shutter for 15 to 45 seconds with ISO 50 film or 8 to 30 seconds with ISO 100 film.

Reflections and Waterfalls

Reflections, such as those in **Photo 6-22**, can make very appealing images in both calm and running water. When photographing a reflection in still water, try placing the horizon or the line between the subject and its reflection in the middle of the frame, but with the subject off center. Avoid cutting off part of the subject or reflection if possible. Move closer or farther from the water and lower or raise your camera to get the right amount of the reflection in the frame. If you cannot get all of both the subject and its reflection, try removing the subject completely to create an interesting abstraction in which the subject appears in the image without actually being there. Reflections in pools or puddles are great for this, especially if the reflection is much brighter than the surrounding area, which will then appear as a dark frame around the subject's reflection.

Rapidly moving water distorts reflections, transforming them from recognizable objects to interesting abstractions filled only with shapes, patterns, and colors, like **Photo 6-23**. Look for a reflection of golden sunlit rocks, bright green foliage, a tree full of red leaves, or some other interesting but distorted subject, and photograph it at slow shutter speeds, underexposing one-half to one stop to saturate the colors. Zoom in close to eliminate the subject, leaving only the reflection itself, perhaps including a dark rock off center or floating leaves in the reflection.

Look for bright, warm reflections in dark, cool water. Typically, a reflection is about one stop darker than the object reflected. Thus, expose for the subject itself, which results in a darker reflection with well-saturated colors. If the reflection is more than one stop darker

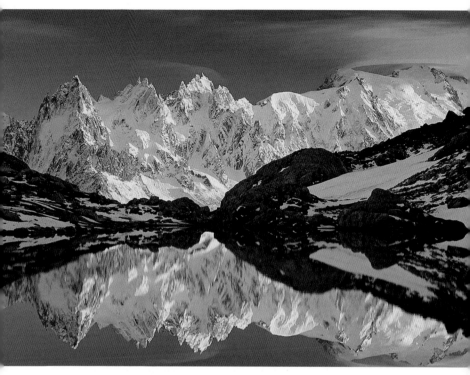

Photo 6-22: *Chamonix needles, France* (© Art Wolfe)

than the subject and you want to even out the light difference between the subject and the reflection, use a graduated neutral-density filter.

Photograph the cascading water of waterfalls and rapids in two ways that can result in very different images of the same landscape. To achieve a silky smooth flow, as in Photo 6-23 or Photo 2-11, use a tripod and shutter speeds of 1/4 second to 1 second. Try a warming filter to counteract the bluish cast that may reflect from the water. Alternatively, to record the power of a raging torrent, use a fast shutter speed to stop the water's motion. In either case, try a polarizer to eliminate unwanted glare from both the water's surface and any surrounding areas wet from spray. Also, look for the rainbows that often accompany waterfalls.

> **TIP**
>
> Use shutter speeds of 1/4 second to 1 second to create silky smooth waterfalls and running water.

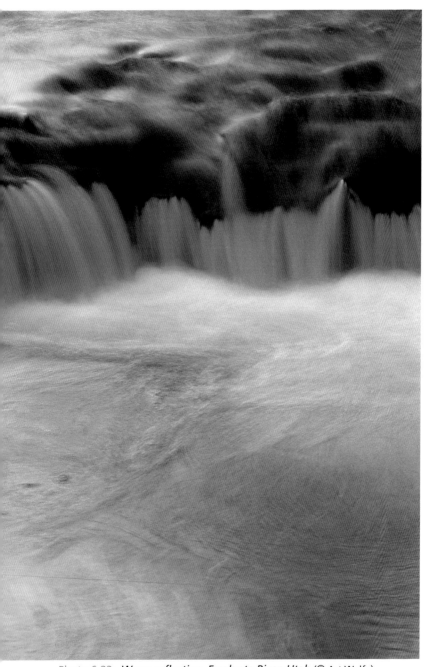

Photo 6-23: *Warm reflection, Escalante River, Utah* (© Art Wolfe)

Removing reflections. Polarizing filters remove glare from water's surface, enabling you to photograph subjects that are underwater, as in tide pools or streams. In some cases, the filter eliminates reflections altogether, allowing you to shoot what is beneath the surface. In others, the polarizer saturates the colors of both the underwater subject and the reflection. Experiment with the polarizer and your position to get the effect that you want.

CLOSE-UPS AND MACROPHOTOGRAPHY

Close-ups and macrophotography allow you to record the smallest details and tiny slices of the surrounding environment. Inside this lilliputian world there are myriad hidden compositions on lichen-covered rocks, weathered tree trunks, the ground at your feet, and just about anywhere else you can imagine. These compositions include individual shots of small subjects such as insects, as in **Photo 6-24;** pictures within pictures, such as a small section of a forest flower, as in Photo 6-3; and more complex macroscapes filled with patterns, textures, and colors— like landscapes, only smaller—such as the tundra flowers in **Photo 6-25.** All you need to shoot these is a bit of patience, some extra gear, and an eye for the not-so-obvious.

Gear

Photographing small scenes and subjects requires enough magnification to fill the frame with them at close range. Standard lenses usually do not have enough magnification without help from accessories. True macro lenses can be used like any other lens, but also provide the magnification and close focusing needed to photograph even the smallest bugs and flower parts. A macro lens can replace a normal lens, and excellent "macro zooms" are now available with a close-up capability that approaches that of true macro lenses.

Most lenses provide a magnification of $1/10$, or 1:10. That is, the subject can be only as big as one-tenth life size on the slide or negative. This magnification means that you can fill a 35mm frame with a subject that is about 10 inches by 15 inches or bigger. To photograph small scenes, such as a cluster of flowers, you need a magnification between 1:10 and 1:4, or one-tenth to one-fourth life size. Individual flowers, bugs, and other small subjects, like the insect in Photo 6-24, require magnification of about 1:4 to 1:1, or one-fourth life size to life size. For example, at a magnification of 1×, or 1:1, you can fill the frame with something as small as a nickel. Really small subjects, such as a feeding mosquito, require magnifications greater than 1:1, for which you need specialized gear as well as more time and patience than most of us can afford.

Photo 6-24: *Succulent katydid, Tambopata Region, Peru* (© Art Wolfe)
The succulent katydid is a whimsical creature. Using a 100mm macro lens and a flash, I was able to fill the frame, making a small insect appear huge. The round ivory eyes and graceful antennae stand out because of the black background. To properly expose the katydid, I used a center-weighted meter reading and shot on automatic with my flash. (AW)

Magnifications in the range of 1:4 to 1:2, which are sufficient for most close-up photography, can be easily obtained without a true macro lens. Any lens can provide this level of magnification if you add one of several relatively inexpensive accessories. Extension tubes, which fit between your camera and your lens, allow a lens of any focal length to focus closer. These glassless tubes come in a variety of lengths and can be stacked to obtain the extension needed to get the shot you want. With greater extension, the magnification increases. Macro tele-converters are also now available with variable-length extension built in, and provide a complete range of magnification in one accessory. These also fit between the camera and the lens, enabling the lens to focus closer, and magnifying the focal length, thus increasing the size of the subject in the frame.

Both of these work well with fixed-focal-length lenses but can be tricky to use with zoom lenses. However, close-up lenses, or diopters, can be easily used with both types of lenses. These lightweight accessories look like thick filters and screw onto the front of your lens just like any other filter. They are available in a variety of magnifications and can be stacked to increase power. Use only the higher-quality, more expensive models; cheap ones save a few dollars but can noticeably degrade image quality, especially at the edges. Diopters are usually available in one or two filter sizes, so you may have to use a step-up ring to fit them to your particular lens.

Photo 6-25: *Saxifrage, Somerset Island, Northwest Territories, Canada* (© Art Wolfe)

Focusing

One of the biggest challenges in close-up photography is producing an image in which the subject is completely in focus. The closer you get to your subject, the more narrow the depth of field and, thus, the harder it is to have your subject completely in focus. However, several tricks help overcome this problem and produce more satisfying pictures.

First, use a tripod or other camera support. It is very difficult, if not impossible, to hold a camera steady enough to get sharp images when depth of field is very narrow. When shooting at ground level, your support should put the camera as close to the ground as possible. Getting close to the ground is difficult, if not impossible, with most tripods unless the legs of the tripod can spread completely. To get even lower, use a clamp with a small ball head attached to a tripod leg or some other ground-level support. When working at ground level, use a closed-cell foam pad to keep your knees clean and comfortable.

Second, maximize depth of field by using the smallest aperture possible, no larger than f/16.

> **TIP**
>
> For close-up shots, use an aperture of f/16 or smaller, focus on the subject's front or most important parts, and make sure the camera back is parallel to the plane of the subject.

Third, keep the film plane—that is, the back of the camera— parallel to the plane of the subject. For example, if you are photographing a wildflower, keep the vertical axis of the camera parallel to the vertical line made by the stalk and flower. Once you have set up your shot, step to one side of the camera, and see if the subject and the back of the camera are parallel.

Finally, minimize subject movement. For example, when shooting flowers in a meadow (Photo 6-25), use your jacket, a ground sheet, or a pack to block the wind. Flash can also be used to freeze motion.

When you cannot get the subject entirely in focus, focus on the most important part of the subject, such as its eyes as in Photo 6-24, or the front of the subject, and let the rest of the image recede into a blurred background. For example, when photographing wildflowers, make sure that the nearest petals or flowers are in focus, with ones farther away out of focus. You can also create unique images by focusing on one element, such as one flower among flowers of a different color or a tiny spider on one flower, and purposely limiting the depth of field. The one element in focus will stand out dramatically from an often mysteriously blurred background.

Managing Light

Even, diffuse light like that found in shadows or on overcast days is best for close-up shots. However, you can still take satisfying images in the bright, contrasty light of midday by shooting in the shadows or by managing the light that is falling on or behind your subject, as described in chapter 5. Because macrophotography subjects are small, it is easy to diffuse or block light that is falling on the subject or, unless the subject is attached to something, to move it into better light.

To better isolate and emphasize your subject, look for a darker, contrasting background. If you cannot find one, create one by casting a shadow behind the subject with a pack or jacket. Or position the pack or jacket—or anything else made from a dark, nonreflective fabric—well behind the subject. Then adjust your depth of field so that the item provides an unrecognizably blurred background.

Always use your depth-of-field preview button to see what is really going in your photograph before you actually take it. Make sure the right parts of the subject are in focus, and look for any distracting, out-of-focus highlights in the background. Unfortunately, the viewfinder will become very dim when you are shooting at the small apertures often used in close-up photography, making it more difficult to see what is in focus. When this happens, cup your hands around the eyepiece to block outside light, and wait until your pupils dilate. After a brief period, you will be better able to see.

PHOTOGRAPHING WILDLIFE

Wildlife is often an exciting part of backcountry or exotic adventure. To maximize your chances of getting great shots, research the animals and the area that you plan to be in. Public libraries are full of books and magazines that can help you learn about an animal's preferred habitat, behaviors that may make the animal easier to photograph—such as the rutting of elk or the mating displays of sage grouse on a lek—and other information that will make wildlife easier to capture on film.

A variety of government agencies, at the national, state or provincial, and local levels, that manage parks, refuges, and resources can provide information on the animals and lands under their stewardship. Contact the administrative offices nearest you or in the area you plan to visit, to find out how to get any available publications that may be helpful. Also talk with rangers and biologists, who are often more than happy to share their knowledge with you. The more you learn about the animal you want to photograph, and its habitat, the greater your chances of taking successful photographs.

Wildlife portraits are most easily taken in the many zoos, game farms, and game parks where animals are more habituated to people. Check to see if there are any in the vicinity where you will be traveling. Such places offer relatively easy access to animals that might otherwise be impossible to photograph in the wild. However, shots of listless animals behind bars will not be very pleasing. Also be careful of the background, avoiding obvious human-made distractions and unnatural surroundings.

Approaching Animals

In the field, once you have found the wildlife you want to photograph, wait and watch before approaching. Observing the animal's movements and behavior can help you best position yourself and anticipate the best shot. Consider photographing before you approach, when the animal is a relatively small part of the image and the surrounding environment is equally important. Some of the best wildlife shots show animals as a part of their habitat.

Before approaching, evaluate the best direction of approach. Consider the direction of light and the backdrop that will produce the most effective image, and consider the terrain itself, looking especially for any hazards. Approach wildlife slowly and casually, avoiding direct eye contact, quick movements, or any other behavior that might be considered threatening. Do not try to sneak up on animals or surprise them. Rather, let them see you and get accustomed to your presence. If you approach too quickly or closely, animals become agitated and may flee.

At that point, back off a bit and wait before approaching again. Eventually, you will learn how close you can get and can work yourself into the best position.

A few words of caution: never get too close or corner a wild animal. Even a seemingly benign backyard squirrel can inflict serious injury. Be sure to leave escape routes for both yourself and the animal. More important, be careful around animals with eggs or young. Jumpy mothers may abandon or defend their young. If you are photographing an animal as it moves to a feeding area or a nest, watch how the animal comes and goes. Then position yourself so that you do not block that route.

Concealing yourself near a nest, den, watering hole, game trail, or feeding area and waiting for animals to approach can result in excellent images. Cars make excellent blinds, especially in parks. When shooting from your car, use a window clamp or beanbag to support the camera. A variety of blinds are commercially available or can be made from camouflage materials. However, tents, thick vegetation, dark shadows, or just about anything else that conceals your form and hides your movements also works quite well. A blind may not be enough for the most wary animals. You may also have to cover your scent with one of the many animal scents available in hunting stores.

Techniques

An animal's eyes add life to the picture and are usually the first thing that people notice in a photograph of an animal. As long as the eye is sharply in focus, then the photograph can be successful even if the parts of the animal farthest away are less sharp. So when photographing an individual animal, focus on its eyes, as in **Photo 6-26,** and with a group of animals, focus on the eyes of the most prominent or closest individual. Focusing on the eyes is especially important when you are shooting with telephoto lenses over longer distances, because the depth of field is often smaller than the animal.

> **TIP**
>
> When photographing wildlife, focus on the eyes, or just in front of the eyes.

The best types of light for wildlife photography are the diffuse light of a bright but overcast day, and the warm sidelight of early morning and late afternoon. Such light brings out the detail in animals' faces and accentuates their color. Avoid the top light of a harsh

midday sun, which casts shadows across animals' faces and creates too much contrast for appealing photographs.

Adding a touch of flash can greatly enhance animal portraits, even at longer distances with the use of telephoto lenses. Try fill flash to open up facial shadows, add a sparkle to the eyes, and add warmth to the photograph. Flash can also be an effective way to stop the action of smaller, quicker animals such as songbirds. But be careful not to startle the animal or black out the background. If your flash allows, reduce the output from the flash by one and a half stops when taking daylight pictures, to create a more natural-looking image. Using flash with animals can result in red-eye, especially if it is relatively dark and the flash becomes the primary light source. To avoid this, move the flash a foot or two to the side of the camera, aiming it at the animal, before taking the picture.

Photo 6-26: *Tiger, India*
(© Art Wolfe)

TIP

When photographing animals, position them so that they are moving into or looking into the frame.

To freeze the motion of a walking animal, shoot at 1/125 second or 1/250 second. For a flying or running animal, shoot at 1/500 second. (See Table 2-1, chapter 2, for guidelines.) You can use much slower shutter speeds if you track the animal with your camera mounted on a tripod, waiting for it to stop moving before shooting. You can even get it to stop by snapping your fingers or making clicking or kissing sounds as it is moving around. When it stops to identify the source of the noise, take the picture.

When the light is too low to use stop-action shutter speeds of 1/125 second or faster, it is difficult to get sharp portraits of moving animals. Slightly fuzzy animal shots are very distracting to the viewer. So slow the shutter down to capture blurred impressions of animals, which can be a very effective way to show speed and motion, as discussed in chapter 1. Try using automatic fill flash or rear-curtain synch flash, if your camera has such features, with slow shutter speeds to create very interesting effects, such as a running deer followed by the blur of its motion.

Animal photographs that show humanlike expressions or behaviors, especially humorous ones, are often the most effective. For example, the mother bear's look of concern adds impact to the photograph in Photo 3-9. Pictures of a fierce grizzly bear scratching itself with a look of sheer bliss on its face, a lion licking its chops before dining, or a mother marmot and her baby touching noses as if kissing will always captivate your viewer. Before pressing the shutter-release button, watch the animal, looking for behaviors or actions that will produce at least interesting pictures and, at best, ones with amusing expressions.

Avoid placing the animal in the center of the image. Rather, position it at one of the rule-of-thirds intersection points discussed in chapter 2. In frame-filling portraits, position the animal's eye at one of the upper intersection points. Try to have the animal looking into the frame or at the viewer; an animal gazing out of the frame will lead your viewer right out of the photograph. Or have the animal turning and looking back at you. The same is true for moving animals; try to shoot them moving into the frame rather than out of it. Finally, look for simple, contrasting backgrounds that will accentuate the animal. Watch for background distractions, especially when using telephoto lenses, which compress the scene and may make branches behind the animal look as if they are going in one ear and out the other.

Gear

You do not have to have an extremely long telephoto lens to get good wildlife shots. A 200mm to 300mm lens is ideal for including wildlife as part of a scene, like the whale in Photo 2-10, as well as full-body shots of bigger animals, such as the bears in Photo 3-9. With patience and the right position, you can even get smaller and more skittish animals. However, a 400mm or longer lens may be required for smaller animals, frame-filling portraits of bigger ones, and full-body shots of animals that are difficult to approach, like the lynx in Photo 4-1. Such lenses are expensive to buy, but they can often be rented from camera shops.

Two accessories expand the range of animals that you can shoot with a telephoto lens. Focal length can be extended with a teleconverter, which is available in 1.4× and 2× configurations. While these may extend the reach of your telephoto, their use results in a loss of light and quality. Using a 1.4× teleconverter results in a one-stop loss of light and a small, but usually acceptable, reduction in image quality. However, using a 2× converter results in a two-stop light loss and a generally unacceptable reduction in quality. Because of this light loss, you may not be able to use teleconverters in low-light situations. Their use is limited to relatively fast lenses, with maximum apertures of f/4 or bigger, although a 1.4× teleconverter may work acceptably with a good-quality 400mm f/5.6 lens. Stick with the converters designed for your lens. Use of other teleconverters can result in poor quality and vignetting, which makes the corners of your photograph noticeably darker than the rest of the image.

Whereas teleconverters extend the reach of telephotos, extension tubes bring their range closer to the camera. Most telephotos will not focus close enough to make full-frame shots of small subjects such as sparrows, butterflies, or field mice. But adding extension tubes between the camera and the lens decreases the minimum focusing distance and allows you to shoot such small subjects. However, use of extension tubes results in some light loss (but no reduction in image quality), making them difficult to use with slower lenses and in low-light situations.

GLOSSARY

Aperture: The size of the lens opening through which light passes into the camera, usually measured in f-stops or f-numbers.

Aperture-priority mode: An automatic exposure mode in which you select the lens aperture and the camera selects the appropriate shutter speed. Consult your camera's manual for how to use this mode with your camera.

Aspect ratio: The ratio of the width of an image or display to its height. A 1:1 ratio is square, while 3:2 is the ratio for most 35mm cameras.

Automatically balanced fill flash: Either a built-in flash or a separate unit mounted on your camera's hot shoe that communicates with the camera to get exposure settings and ambient light level, as read by the camera's through-the-lens (TTL) light meter, and then calculates the appropriate flash output. When you take the picture, the flash reads the light reflecting back to the camera and shuts the flash off when the correct light level has been reached. This is a type of TTL flash.

B or bulb setting: A shutter speed setting that keeps the shutter open as long as you hold down the shutter-release button, either manually or with a cable extension.

Backlighting: Lighting from a source behind the subject and in front of the photographer.

Bit depth: The number of bits per pixel, which determines the number of colors that can be recorded or displayed. A minimum of 24 bits are needed for photographic-quality imaging.

Bracketing: Taking a series of shots under and over the initial exposure you determined to be correct.

CCD: Abbreviation for *charge-coupled device,* a light-sensitive device that captures the image in a digital camera.

Center-weighted meter: A type of light meter that assigns more importance to the light in the center of the scene, an area usually outlined by a large circle in viewfinder, than the light from the surrounding area.

Contrast: The difference in brightness between the lightest part of a photograph or a scene and the darkest. Low contrast is a narrow range of tones, with everything in a scene more or less the same tone. High contrast is a broad range, with tones at both ends of the spectrum, black and white.

Depth of field: The zone of acceptably sharp focus in front of and behind the subject or the point at which the lens is focused. Everything in front of and behind this zone is out of focus.

Depth-of-field preview button: A camera feature that allows you to view the image through the aperture setting you have selected. When you look through your viewfinder without this feature, you see the image as it looks through the largest aperture. This lets in more light, making it easier to see and focus on what you are photographing, but does not show you

the actual depth of field. Thus, your picture may not look like what you saw through the viewfinder. Depth-of-field preview allows you to see what your photograph will actually look like.

Depth-of-field scale: A scale marked on the barrel of some lenses that indicates the depth of field for the particular aperture at which the lens is set and the distance at which the lens is focused. Many modern autofocus and zoom lenses omit this scale.

Digital darkroom: The combination of image-editing software, a personal computer on which to run that software, a photographic-quality printer, and perhaps a film or print scanner.

Digital sensor: In a digital camera, the array of sensors, usually CCDs, that record a scene by converting light into electricity. It is the equivalent of film for a digital camera.

Digital zoom: A feature of digital cameras that enlarges a part of a digital image by using interpolation. It mimics a zoom lens but reduces the resolution of the enlarged image.

Direct light: Light that travels from the sun or another light source directly to the subject or scene without being significantly altered along the way.

Dpi: Abbreviation for dots per inch, a measure of the resolution of a scanner or printer. The higher the number, the higher the resolution and the higher the quality of the scanned or printed image.

Evaluative meter: A type of light meter that reads the central area in the viewfinder much as a center-weighted meter does, but also divides the surrounding area into zones that are evaluated in relation to each other and to the central area. Also called a matrix meter. See *Center-weighted meter.*

Exposure: The amount of light allowed to fall on the film or digital sensors, usually expressed as an aperture and shutter speed combination at a given film speed, or as an exposure value (EV). The correct exposure is the amount of light required to record the image you want on film.

Exposure compensation: An increase or decrease in exposure to adjust for the calibration of your camera's light meter. Light meters provide exposure settings that result in medium-toned photographs. Those settings will make darker items appear too light or lighter items too dark. To compensate, you let in more light than indicated by your meter when metering a light-toned subject, and less light when metering dark objects.

Exposure guidelines: Estimated exposure settings, expressed in terms of shutter speed and aperture, based on general light conditions rather than light meter readings. For example, the sunny–f/16 rule is a guideline for exposure under a bright sun.

Fill flash: Flash used in conjunction with sunlight, or another primary light source, to fill in any shadows or highlight the subject.

Film speed: The sensitivity of film to light. Low-speed films are less sensitive and require more light to record an image; high-speed films are more sensitive and require less light. (See *ISO rating.*)

Filter: An accessory, made of glass, plastic, or resin, placed in front of the lens to

filter the light entering the lens, thus changing the character of the light that strikes the film.

Flare: Non-image-forming light caused by scattering and reflecting of light inside the lens, which results in odd shapes and spots of light on a photograph.

Focal length: The distance between the optical center of the lens and the film when the lens is focused to infinity.

Focusing screen: The screen inside the camera's viewfinder on which the image is focused.

Frame: The boundaries of the rectangle defined by the camera's viewfinder, or the edges of the resulting photograph.

Front lighting: Lighting from a source in front of the subject and behind the photographer.

f-stop: An indicator of aperture size, also written *f/stop,* based on the ratio between the aperture and the focal length of a lens. The larger the stop—the number after or under the *f*—the smaller the aperture. For example, f/22 is a very small aperture, while f/2 is a very large aperture.

GIF: Abbreviation for *graphics interchange format,* a file format commonly used for storing digital images for display on the web. More appropriate for simple graphics than for photographs.

Graduated neutral-density filter: Rectangular filter in which one half is clear and the other half is darker by one, two, or three stops, allowing you to balance bright highlights and dark shadows, or scenes in which the background is bright and the foreground darker.

Gray card: A card colored with the standard gray tone, called 18 percent gray, which represents the medium tone to which light meters are calibrated.

Haze filter: A filter that removes light in the blue-to-ultraviolet spectrum, thus eliminating or reducing atmospheric haze.

Hyperfocal distance: The focus distance that puts everything from half that distance to infinity in focus.

Image stabilization (IS): Technology that counteracts slight camera movement when you are hand-holding a camera. IS enables you to make acceptable photographs when shooting at slower shutter speeds without a tripod.

Indirect light: Light that has been deflected, scattered, or reflected so that it seems not to come from any one direction and therefore illuminates a subject very evenly.

Interpolation: A process that enhances the resolution of a digital image by means of software to increase the apparent quality of the image.

ISO rating: In film cameras, an indicator of film speed. The higher the number, the faster the film and the less light required to make a given photograph. In digital cameras, an indicator of the sensitivity of the imaging sensor to light. The higher the number, the more sensitive the sensor, and the less light required to make a given image.

JPEG: Abbreviation for *Joint Photographic Experts Group,* a file format commonly used for storing digital images that are meant to be displayed on computer screen.

LCD screen: A small screen on a digital camera that displays the images stored on the camera's memory card or the image seen through the camera's lens. *LCD* stands for *liquid crystal display.*

Lens-shutter camera: See *Point-and-shoot camera.*

Light meter: A device that measures the amount of light traveling through the lens to the camera's viewfinder, which in an SLR is effectively the same as the amount of light striking the film once the reflex mirror flips up and the shutter opens.

Low light: Light levels that are dim enough to require the use of slow shutter speeds (less than 1/60 second), wide apertures, tripods, or fast film. These usually occur early in the morning, in the evening, inside thick forests, under heavily overcast skies, and indoors.

Macro lens: A lens that can be focused close enough to photograph small subjects such as individual flowers and insects. A true macro lens can make near life-size or larger images on film, filling a 35mm frame with a subject the size of a small coin.

Magic hour: The best time to photograph on sunny days, lasting from about a half hour to an hour before and after both sunrise and sunset.

Matrix meter: Same as *Evaluative meter.*

Medium tone: A tone that is neither very light nor very dark, but midway between these extremes—for example, the medium gray, in a tonal range from black to white, of the standard gray card.

Megapixel: One million pixels, used to denote the resolution of a digital image. The larger the number, the higher the quality of the image, and the larger the print that can be made from the image.

Memory card: The removable, digital medium on which images are stored in a digital camera.

Metering: Measuring the amount of reflected light that is entering the camera's lens. To meter on an object is to measure the amount of light reflecting off that particular object.

Multiple exposures: Multiple images recorded on the same frame of film.

Natural light: Light from a natural source, such as the sun, moon, or stars. In most photography, natural light comes primarily from the sun.

Normal lens: For a 35mm camera, a lens with a focal length between 40mm and 60mm.

Opening up: Increasing the size of the aperture, thus letting more light pass through the lens and reducing the depth of field. For example, increasing the aperture from f/22 to f/5.6 would be opening up.

Optical zoom: The magnification of an image by the optics of the lens rather than the software in a digital camera. See *Digital zoom.*

Overexposure: Too much light reaching the film, making your subject or key objects in your photograph appear lighter than you wanted them to.

Panning: Moving the camera to keep a moving subject in the viewfinder while shooting.

Pixel: The smallest unit, or dot, in a digital image. Has both tone and color. A digital image consists of thousands to millions of pixels.

Point-and-shoot camera: A completely automatic camera with which you often have limited control. The camera reads the speed of the film you load in, and then sets the aperture and shutter speed based on its meter reading. Also called a lens-shutter camera.

Polarizing filter: A filter that removes light waves not traveling straight through the lens (along a plane perpendicular to the front of the lens), thus reducing glare, reflections, and haze, as well as saturating colors.

Print film: Film that produces a negative, from which prints are made.

Program mode: An automatic exposure mode that selects both shutter speed and aperture. Consult your camera's manual to learn how to use this mode with your camera.

Pushing film: Deliberately underexposing film, enabling the photographer to use a faster shutter speed in low light or with a slow film. The underexposure is corrected in the lab when the film is processed.

Reciprocity: The relationship between the variables of shutter speed and aperture, both of which are calibrated in stops, whereby an increase in one variable combined with a comparable decrease in the other results in the same exposure.

Resolution: A measure in pixels of the level of detail recorded in an image. The greater the number of pixels, the higher the resolution and the more detail or information recorded.

Shutter-priority mode: An automatic exposure mode in which you manually select the shutter speed and the camera selects the appropriate aperture.

Shutter-release cable: A cable that attaches to the camera body and is used to release the shutter without pressing the shutter-release button.

Shutter speed: The amount of time the shutter remains open, and thus the amount of time the film or digital sensor is exposed to the light coming through the lens.

Sidelighting: Light coming predominantly from one side of the subject.

Single-lens reflex: A camera that uses a single lens and has a reflex mirror inside, which reflects the light coming in through the lens up to the viewfinder, allowing you to see what will actually be photographed. When you press the shutter-release button, the mirror swings out of the way.

Skylight filter: A filter that eliminates light waves in the blue-to-ultraviolet spectrum and adds a very slight pinkish, or warm, cast to the image.

Slide film: Film that produces transparent images, which must be illuminated from behind for viewing.

SLR: See *Single-lens reflex.*

Spotlighting: Light that illuminates a subject with a single beam of light emerging from a hole in cloud cover, forest canopy, structures, or some other barrier.

Spot metering: A type of light metering in which the meter evaluates only the light intensity in a small circle in the center of the viewfinder.

Stop: A relative measure of the quantity of light, in which any given value is twice as much light as the preceding value and half as much light as the

next value. F-numbers, shutter speeds, and film speeds (ISO numbers) are all calibrated in stops. For example, an aperture of f/5.6 lets in twice as much light as f/8 but half as much as f/4, and a shutter speed of 1/250 second lets in twice as much light as 1/500 second and half as much as 1/125 second.

Stopping down: Decreasing the size of the aperture, thus reducing the amount of light passing through the lens and increasing depth of field; for example, reducing the aperture from f/5.6 to f/22 would be stopping down.

Sunny–f/16 rule: The guideline that the correct exposure, for any film, when you are photographing a front-lit subject on a sunny day is an aperture of f/16 and the shutter speed nearest 1/ISO, where ISO is the speed of the film in your camera.

Teleconverter: An optical accessory placed between the camera's body and the lens that increases the magnification by 1.4× to 2×.

Telephoto lens: A lens with a focal length longer than 70mm.

TIFF: Abbreviation for *tagged image file format*, a file format commonly used for storing digital images that are meant to be printed or displayed with the highest possible quality.

Tone: The shade of a color, or how dark or light an object is.

Top lighting: Light coming from above the subject.

TTL: Abbreviation for *through the lens*, referring to the light that is actually coming through the lens to strike the film. TTL light metering measures the light coming through the lens to the film. A TTL flash uses the light reading from the TTL light meter to control flash output.

Ultraviolet (UV) filter: A filter that eliminates light waves in the ultraviolet spectrum, which you do not see but which the film records as a slight bluish cast.

Underexposure: Too little light reaching the film, making your subject or key objects in your photograph appear darker than you wanted them to.

USB: Abbreviation for *universal serial bus*, a popular, high-speed connection between a digital camera or scanner and a computer.

Vignetting: A darkening at the corners of slides or prints, usually caused by using teleconverters or lens hoods that do not match the lens to which they are attached, or by stacking too many filters on the front of the lens.

Warming filter: A filter that adds a slight yellow-amber cast to an image.

White balance: A feature found in some digital cameras that adjusts the color balance of an image to one based on a truly white light. This enables a digital camera to emulate the use of certain filters in traditional photography.

Wide-angle lens: A lens with a focal length less than 40mm.

Zoom lens: A lens with a range of focal lengths.

BIBLIOGRAPHY

For an in-depth discussion of Art Wolfe's approach to nature photography, see *The Art of Photographing Nature,* by Martha Hill and Art Wolfe (New York: Crown Publishers, 1993).

Bidner, Jenni. *Digital Photography: A Basic Guide to New Photography.* Rochester, NY: Silver Pixel Press, 2000.

Eastman Kodak. *The Joy of Photography.* New York: Addison-Wesley, 1979.

———. *More Joy of Photography.* New York: Addison-Wesley, 1988.

Fielder, John. *Photographing the Landscape.* Englewood, CO: Westcliffe Publishers, 1996.

Freeman, Michael. *The Complete Guide to Digital Photography.* Rochester, NY: Silver Pixel Press, 2001.

Kohler, Annemarie, and Danja Kohler. *The Underwater Photography Handbook.* Mechanicsburg, PA: Stackpole Books, 1999.

Krist, Bob. *Secrets of Lighting and Location.* New York: Amphoto Books, 1996.

———. *Spirit of Place: The Art of the Traveling Photographer.* New York: Amphoto Books, 2000.

McDonald, Joe. *The Wildlife Photographer's Field Manual.* Amherst, NY: Amherst Media, 1992.

Peterson, Bryan F. *Learning to See Creatively.* New York: Amphoto, 1988.

———. *People in Focus.* New York: Amphoto, 1993.

Rowell, Galen. *Galen Rowell's Inner Game of Outdoor Photography.* New York: Norton, 2001.

———. *Galen Rowell's Vision: The Art of Adventure Photography.* San Francisco: Sierra Club Books, 1993.

———. *Mountain Light.* San Francisco: Sierra Club Books, 1986.

Shaw, John. *Closeups in Nature.* New York: Amphoto, 1987.

———. *Nature Photography Field Guide.* New York: Amphoto Books, 2000.

INDEX

ABOUT THE AUTHORS

MARK GARDNER has been actively pursuing adventures with his camera in hand for more than twenty-five years. An avid skier, mountain biker, hiker, scuba diver, fisher, and sea kayaker, he has published numerous images from his adventures, and has taught photography for The Mountaineers. He lives on San Juan Island, Washington, and recently published a book of images of the San Juan archipelago.

ART WOLFE travels the world nearly nine months each year on a personal mission to document nature on film. In April 2000 he was awarded the coveted Alfred Eisenstaedt Magazine Photography Award. He was named Outstanding Nature Photographer of the Year in 1998 by the North American Nature Photography Association and Photographer of the Year in 1996 by **Photo**Media magazine. He is the author of more than forty books.

Art Wolfe

Mark Gardner

THE MOUNTAINEERS, founded in 1906, is a nonprofit outdoor activity and conservation club, whose mission is "to explore, study, preserve, and enjoy the natural beauty of the outdoors. . . . " Based in Seattle, Washington, the club is now the third-largest such organization in the United States, with 14,000 members and seven branches throughout Washington State.

The Mountaineers sponsors both classes and year-round outdoor activities in the Pacific Northwest, which include hiking, mountain climbing, ski-touring, snowshoeing, bicycling, camping, kayaking and canoeing, nature study, sailing, and adventure travel. The club's conservation division supports environmental causes through educational activities, sponsoring legislation, and presenting informational programs. All club activities are led by skilled, experienced volunteers, who are dedicated to promoting safe and responsible enjoyment and preservation of the outdoors.

If you would like to participate in these organized outdoor activities or the club's programs, consider a membership in The Mountaineers. For information and an application, write or call The Mountaineers, Club Headquarters, 300 Third Avenue West, Seattle, WA 98119; 206-284-6310.

The Mountaineers Books, an active, nonprofit publishing program of the club, produces guidebooks, instructional texts, historical works, and natural history guides, and works on environmental conservation. All books produced by The Mountaineers Books fulfill the club's mission.

Send or call for our catalog of more than 500 outdoor titles:

The Mountaineers Books
1001 SW Klickitat Way, Suite 201
Seattle, WA 98134
800-553-4453
mbooks@mountaineersbooks.org
www.mountaineersbooks.org

The Mountaineers Books is proud to be a corporate sponsor of Leave No Trace, whose mission is to promote and inspire responsible outdoor recreation through education, research, and partnerships. The Leave No Trace program is focused specifically on human-powered (nonmotorized) recreation.

Leave No Trace strives to educate visitors about the nature of their recreational impacts, as well as offer techniques to prevent and minimize such impacts. Leave No Trace is best understood as an educational and ethical program, not as a set of rules and regulations.

For more information, visit *www.LNT.org*, or call 800-332-4100.